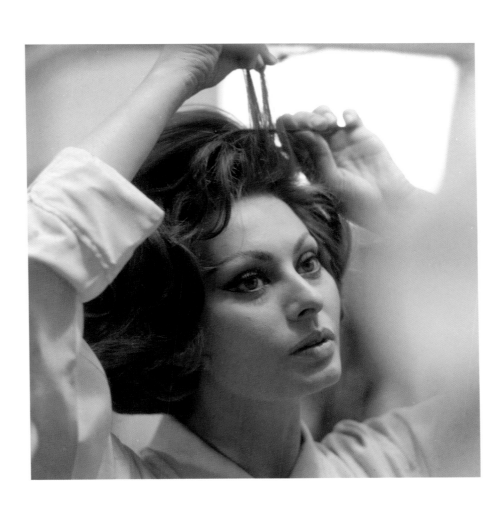

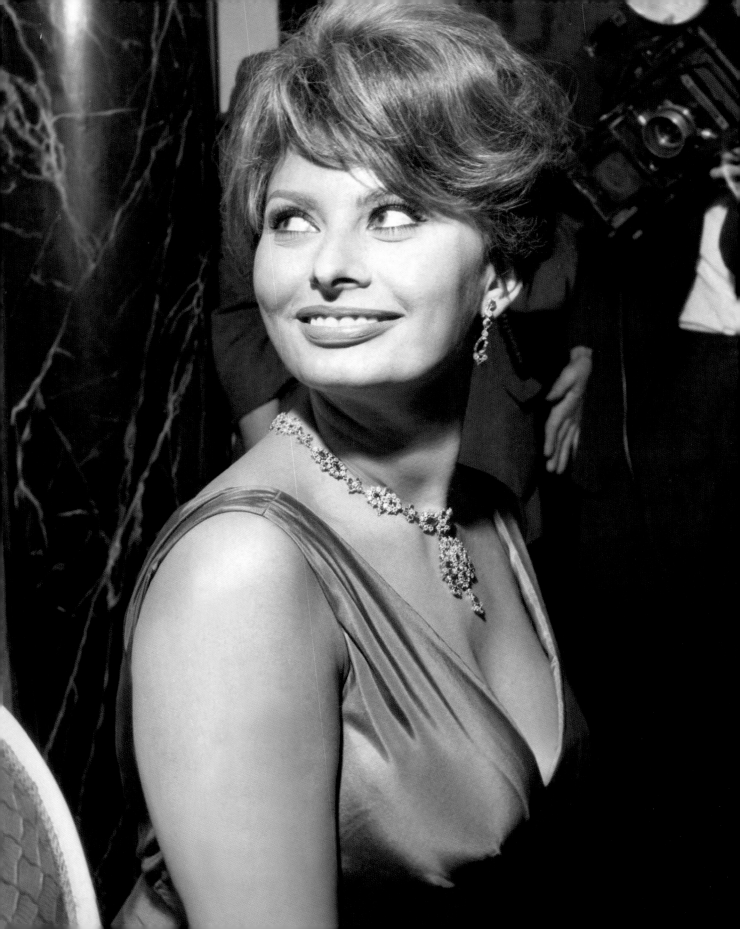

Sophia Loren

Movie Star Italian Style

Cindy De La Hoz

RUNNING PRESS
PHILADELPHIA

To my love, Frankie, and the amazing
Italian family I've inherited from him.

Running Press
Hachette Book Group
1290 Avenue of the Americas, New York, NY 10104
www.runningpress.com
@Running_Press

First edition: September 2017

Published by Running Press, an imprint of Perseus Books, LLC, a subsidiary of Hachette Book Group, Inc.

The Hachette Speakers Bureau provides a wide range of authors for speaking events. To find out more, go to www.hachettespeakersbureau.com or call (866) 376-6591.

The publisher is not responsible for websites (or their content) that are not owned by the publisher.

Additional copyright/credits information is on pages 250-254.

Print book cover and interior design by Josh McDonnell

Library of Congress Control Number: 2017936639

ISBN 9780762461318 (hardcover), ISBN 9780762461325 (ebook)

Printed in China
1010

10 9 8 7 6 5 4 3 2 1

Photos: Cover: During the making of *More Than a Miracle* (1967). Back cover: On the set of *The Pride and the Passion* (1957). Page 1: On the set of *A Countess from Hong Kong* (1967). Page 2: Sophia, 1960. Page 5: Sophia, 1957. Page 8: On the set of *Boccaccio '70* (1962). Page 264: Sophia in Los Angeles, 1960.

CONTENTS

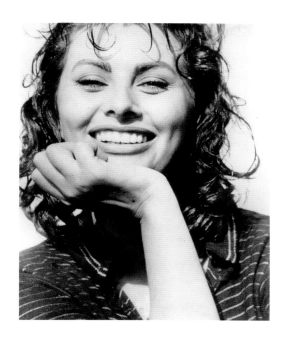

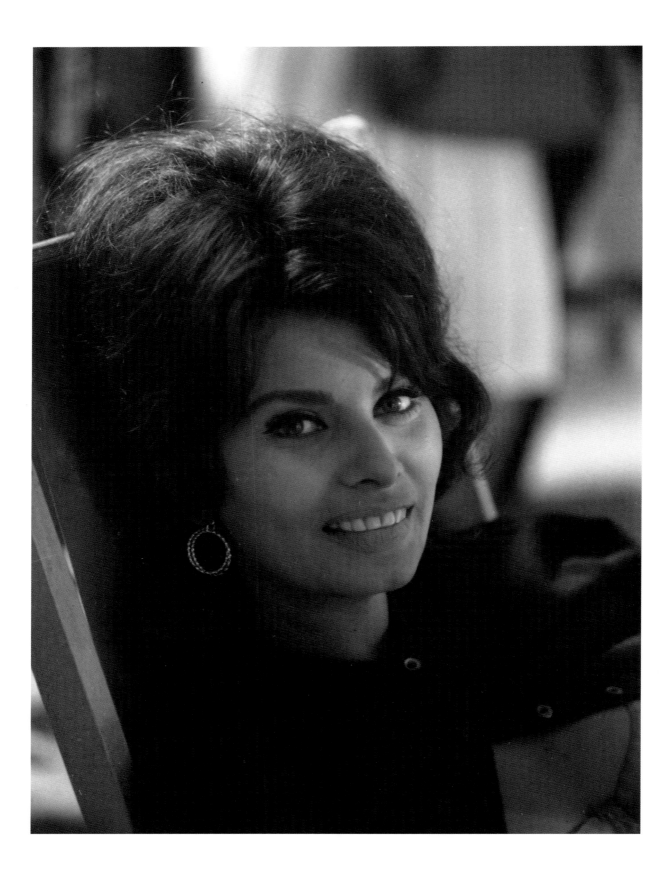

Though she is often thought of as a Hollywood screen goddess of the Golden Age (the American Film Institute even named her to its list of Greatest *American* Screen Legends), it was roles that embodied the Italian spirit that truly made this star shine. Hollywood could not deny her impact. It is little wonder that the Academy of Motion Picture Arts and Sciences awarded her its first Academy Award for Best Actress in a Leading Role given to the star of a foreign film, for her heart-rending performance in *Two Women*. In her native Italy, Sophia holds the record for Best Actress David di Donatello Award wins (at six), and she has received major accolades from nearly every corner of the world.

The international icon grew up in a small Neapolitan town ravaged by war, with no connection to the film world whatsoever (except for the fact that her mother bore a striking resemblance to Greta Garbo). Her mother conveyed all her own ambition onto Sophia, propelling her on to a career in Italian films and, inevitably, in Hollywood and onto the world stage.

From then on Sophia had extraordinary success working in both American and European productions. She starred in some of the most epic blockbusters of the '50s, '60s, and '70s; impressed in moving dramatic roles opposite the likes of Cary Grant, Paul Newman, Peter Sellers, Anthony Quinn, John Wayne, Gregory Peck, Marlon Brando, Peter O'Toole, Richard Burton, and Clark Gable; and turned heads in enduring classics like *Houseboat*, *The Millionairess*, *Arabesque*, and *Heller in Pink Tights*.

Yet all roads led home for Sophia. Her best roles were indomitable women of Italy—usually Neapolitan, frequently a mother fighting for her family, and always full of life, passion, and strength. In Italy she also had her finest collaborators in director Vittorio De Sica and costar Marcello

Mastroianni, not to mention Carlo Ponti, her husband and the producer of many of her films, including such classics as *Yesterday, Today and Tomorrow*; *Marriage Italian Style*; and *A Special Day*.

Whether at home or abroad, in a career spanning close to seven decades, Sophia has had one of the most varied and interesting paths in motion picture history. A beauty with a distinct lack of vanity when it comes to her art, she has embraced age, not shying away from public events and certainly not from film cameras in her later years, instead still enjoying a creatively fulfilling career and continuing to take home awards.

Sophia Loren: Movie Star Italian Style is a tribute to the matchless actress, both exploring and illustrating the varied aspects of her life and work. Part One is biographical, recounting through text, quotes from those who knew her best, and a stunning array of photos her life story from Pozzuoli through stardom and on to life in her mideighties. Part Two covers her cinematic legacy through images, behind-the-scenes stories, trade reviews, memories from both Sophia and her collaborators, and plot summaries (particularly helpful since a great deal of her films are not readily available in the United States, and some of those spoken in Italian have not yet been made available with English dubbing or subtitles). Many of her Italian films have indeed been voiced over into English (often by Sophia), yet many of even her dearest admirers here in the United States have not seen those films due to their inaccessibility. That is unfortunate since they are among her best works. The hope is that these images and descriptions will inspire a bit of foreign exploration. In all, this book is a celebration of the rich contribution to cultural history that Sophia has given the world and an homage to the extraordinary star and the home she holds so dear.

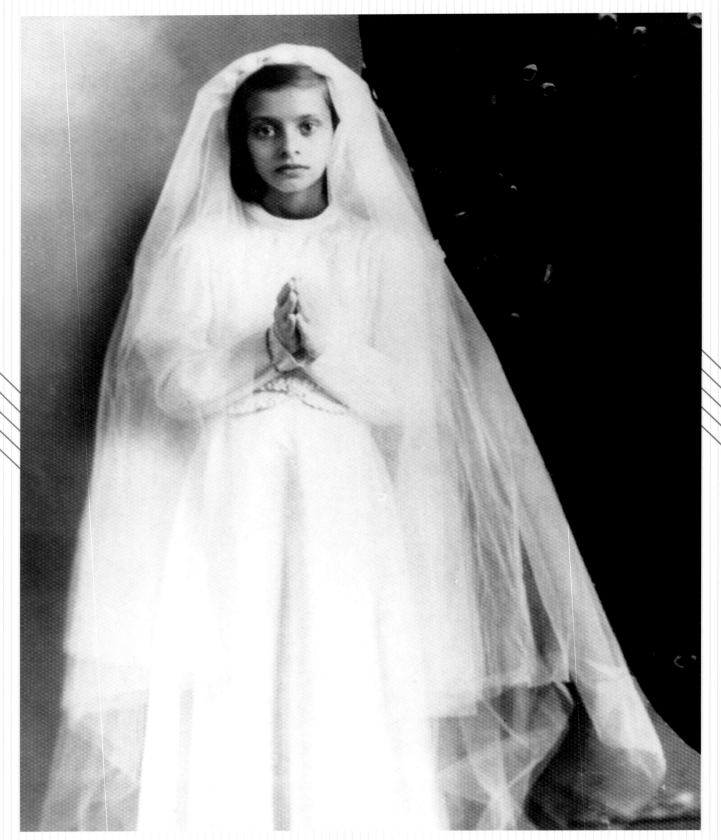

Sofia Scicolone, age nine, on the day of her First Communion. Growing up in Pozzuoli during the war was often terrifying. Her Communion service was interrupted by a bombing, with one explosion only a few hundred yards from the church.

PART 1:
Biography

Princess of Pozzuoli

O ver the years Sophia has often likened the story of her life to a fairy tale. No one would have guessed that the *stuzzicadente* (toothpick), as she was called as a thin child growing up in a small seaport town outside of Naples, would one day be an international movie icon. But she did have the genes for it.

"**Looking back on the child I was, my life seems a fairy tale.**"

—Sophia

Beauty was an attribute passed down by her mother, Romilda Villani, a pianist whose talent earned her a scholarship to enroll in a conservatory of music in Naples, not far from her small hometown of Pozzuoli. Musical ability did not fulfill Romilda's artistic aspirations, however; recognizing her own considerable physical gifts, she entered a contest to find the woman in all of Italy who most closely resembled Hollywood's most celebrated beauty, the "Swedish Sphinx" herself, Greta Garbo. Romilda was thrilled to win and was eager to cash in on her reward—a ticket to the dream factory, MGM Studios. However, the realities of her life in Pozzuoli prevented that from coming to fruition: her parents, Domenico and Luisa Villani, refused to send their seventeen-year-old daughter a world away to California.

Romilda decided to make strides on her own a little closer to home by looking for work in Rome, the site of Cinecittà, center of the Italian film industry. One evening in the fabled Eternal City she met Riccardo Scicolone, a handsome young man with a distant noble lineage who captured Romilda's attention by telling her that he worked in movies (though he did not). She bought his line and fell head over heels in love. Their first daughter, Sofia, was born in a charity ward for unwed mothers on September 20, 1934. She was named after Riccardo's mother, Sofia, and Riccardo signed the certificate to grant the child his last name, although she had been born out of wedlock. Sofia remembered her Nonna Sofia as "cold, distant," but even colder was Riccardo himself, whose plans for his life in Rome did not include marrying Romilda or making a home for her, baby Sofia, or their second daughter, Maria, born four years later. Romilda kept trying to win a place in his heart, but by the time Maria was born, Riccardo Scicolone was no longer willing to share his name

officially to give the girl legitimacy, a situation that dogged Maria throughout her childhood and Sofia would remedy years later as a rising star.

Scicolone refused to marry Romilda, so the young woman returned to the home of her parents in Pozzuoli, where she and her daughters were welcomed with open arms. It was a full house, complete with Sofia's aunt and two uncles. Sofia was sickly and the family had very little money, but Mamma Luisa, as Sofia called her grandmother, always managed to make meals out of seemingly nothing. The sights and aromas coming from Mamma Luisa's kitchen planted the seeds of Sofia's own lifetime passion for cooking.

Food became truly scarce, and the family experienced its greatest hardships during World War II. They would huddle closer than ever during those years of privation and horror in a country besieged by war. Italy's allies, the Germans, were the first troops to march into Naples. Soldiers were an ominous, ever-present sight and terrified Sofia, who was just six at the outbreak of the war. The presence of a naval base and the fact that it was a port city made Naples a key target to the Allied forces. The sounds of air-raid sirens blazed through the air at a shocking rate, sending Sofia and throngs of innocent civilians to run for cover in a railway tunnel, where they would spend hours waiting for the "all clear" signal to sound and send them back to seek some semblance of normalcy. The Villanis eked out a meager existence amid bombs, infestation, and disease until October 1943, when Allied forces entered and liberated Naples from Nazi occupation. The tide had turned, and the family looked to a future beyond war and hunger.

Opposite: Young Sofia with her mother, Romilda Villani. Her father's abandonment of and hostility toward them and Sofia's sister, Maria, played a major role in her life.

"The two big advantages I had at birth were to have been born wise and to have been born in poverty."

—Sophia

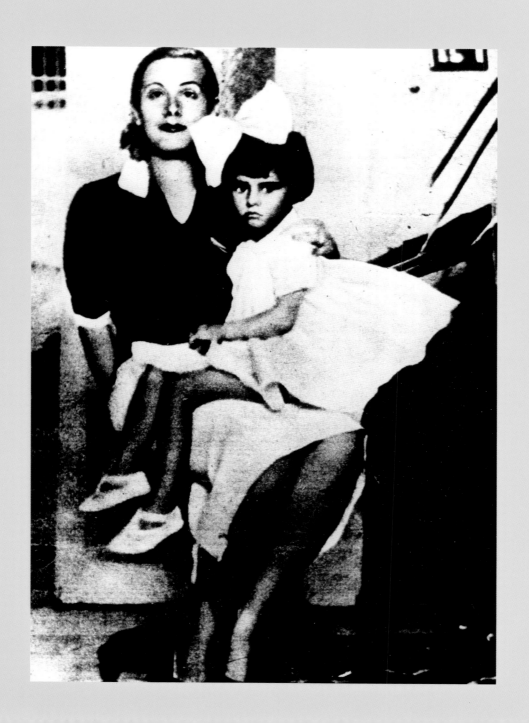

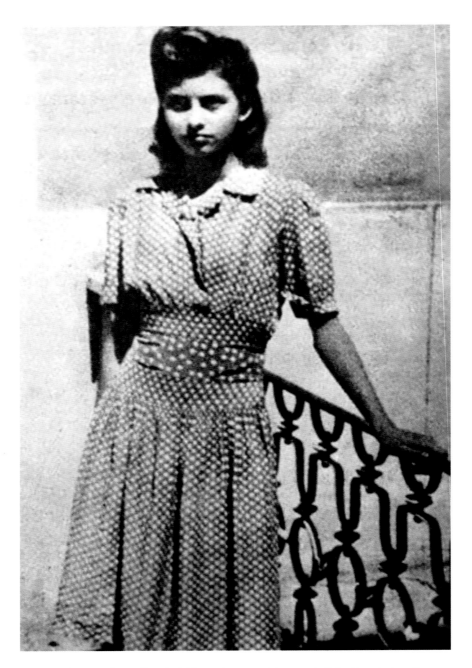

Sofia, or *Stuzzicadente* (Toothpick), as she was nicknamed. Privation during the war years did not help her small frame, but her growth was not stunted for long.

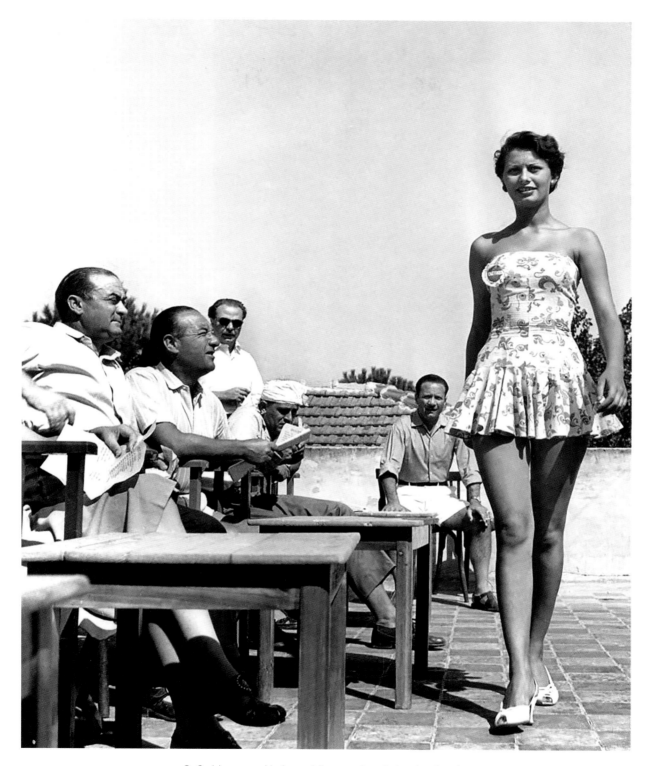

Sofia blossomed in her midteens, already turning heads.

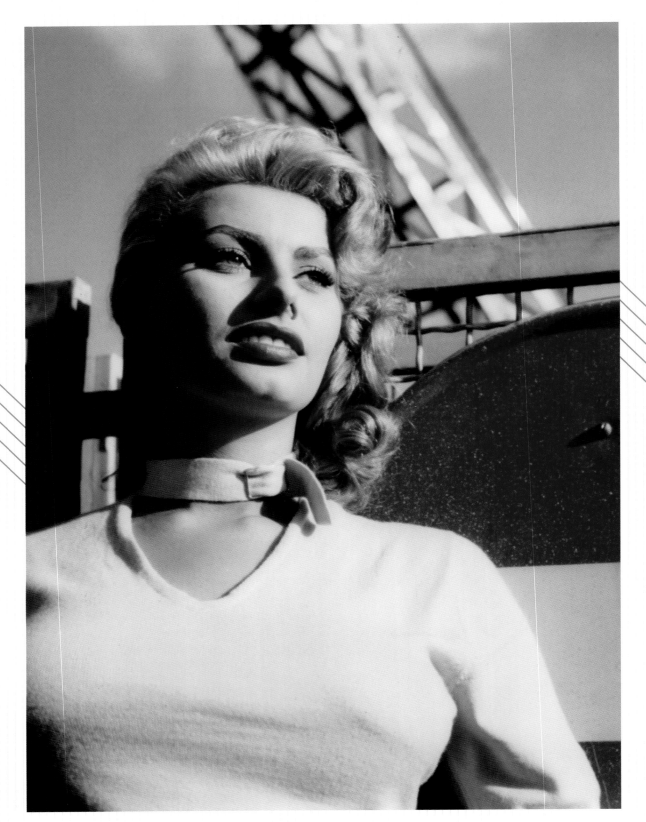

Sophia, 1956.

A Ticket to Rome

Postwar Pozzuoli slowly came alive again. School reopened, as did the local theater, and Sofia spent countless hours in the darkened cinema, developing a deep appreciation for American films like *Blood and Sand*. She was entranced by the picture's handsome star, Tyrone Power, and the beauty and sophistication of his leading lady, Rita Hayworth, in all her Technicolor glory, left a deep impression. It was perhaps this picture that led young Sofia to scrawl an immortal line into her school notebook:

"Sofia Scicolone is going to be an actress one day."

—Sophia

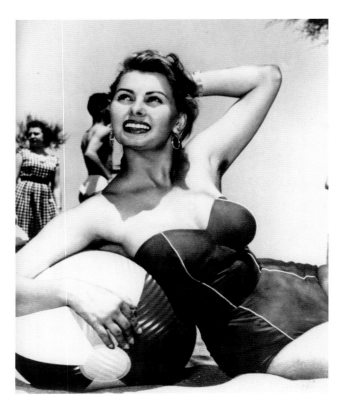
Sophia, soon after her arrival in Rome.

appear relaxed and enthusiastic when speaking to the judges, Sofia was selected as one of the "princesses of the sea" (though not the queen) and took part in a grand celebration of the crowned beauties of Naples. Sofia was thrilled with her prizes—among them rolls of wallpaper, a tablecloth, and a small sum of cash—but most attractive to Romilda was a train ticket to Rome.

The instructor of an acting school in Naples in which Sofia had been enrolled informed her that MGM was filming *Quo Vadis* (1951) in Rome and looking for extras. That was all Romilda needed to hear. Leaving a young and sickly Maria behind with her parents, she and Sofia headed to the Italian capital to pursue a potentially golden opportunity in the spring of 1950. But a passport to fame was not the only lure for Romilda in Rome. Riccardo Scicolone had a home there, though it was not open to her or Sofia, as he had since married and had two other children. Romilda was disheartened, but she and Sofia stayed with relatives and began making rounds seeking work.

The film industry was thriving in postwar Rome, outputting quite a distinct strain of films from American producers. Neorealism was at its most evocative in a city still recovering from the ravages of war, and the likes of Roberto Rossellini, Vittorio De Sica, and Luchino Visconti were producing realistic films that garnered worldwide acclaim and admiration. American studios were also lured by the "Hollywood on the Tiber" that was Cinecittà; Italy's tax laws benefitted US studios' bottom lines, and its beautiful geography and architecture were particularly apropos and authentic for the epic historical productions churned out at an increasing rate by an industry competing with the rise of television.

Quo Vadis, a tale of early Christianity and ancient Rome during the reign of Emperor Nero, was to

The statement could have come from any young girl infatuated by the image of glamorous Hollywood, but Sofia had unique gifts. As a child she was teased for her rail-thin frame, but the girl nicknamed "Toothpick" blossomed in her midteens. As she grew into the body of a woman, Sofia began attracting attention from men. Inside she was still an innocent girl, and she was justifiably shocked when her physical education teacher showed up at the Villani home one day and declared that he wished to marry Sofia. Romilda politely declined on her young daughter's behalf.

In 1949, a unique opportunity presented itself in the form of a beauty pageant run by a local newspaper. Still harboring regret from her own lost dream of the glamorous life of an actress, Romilda turned her ambitions to Sofia and coaxed her into entering the contest. Wearing a dress fashioned out of the family window curtains and mustering all her courage to

be among the most impressive period pieces of all. Masses gathered in the hopes of being chosen as an extra for the film's many crowd scenes. Both Sofia and Romilda made the cut, earning them eighty dollars and the hope that Sofia may really succeed in this fairy-tale world that had eluded Romilda. Sofia quickly developed ambition of her own, enjoying her pursuit of an acting career, and the next year she met a man who would alter the course of her life forever.

A beauty pageant was taking place at a restau-

cinema, had been instrumental in the careers of stars such as Gina Lollobrigida and Sofia's idol, Lucia Bosé. He was married and thirty-eight, much older than seventeen-year-old Sofia. Romance would come later, but first they became close friends. Carlo invited her to make a screen test. Sofia obliged, arriving promptly at the Ponti-De Laurentiis studio the next day, but from there everything went wrong. Asked to appear on camera by herself and smoke a cigarette—neither of which Sofia had attempted

"Everything was in excess in her. They thought that she was good looking, but impossible."

—Suso Cecchi D'Amico, screenwriter

rant near the Colosseum one evening in September 1951. Sofia was content attending as a spectator until a waiter handed her a note from one of the judges encouraging her to join the contest. Thinking this indicated she would be a shoo-in to take first place, Sofia went ahead and joined the other ladies. She did not win after all, but the judge who had coaxed her to enter the contest, producer Carlo Ponti, would become one of the driving forces in her life from that moment on.

Ponti, one of the top producers in international

before—she was nervous and it showed. The situation went from bad to worse when the cameraman began complaining that she was impossible to photograph—her face too short and her features, particularly the nose, too long. Sofia owned her distinctive features and bristled at any suggestion of altering the natural form of her face. She loathed screen tests from that moment on. The poor tryout notwithstanding, Sofia and Carlo remained in touch, and Sofia's career was soon thriving due to another form of media.

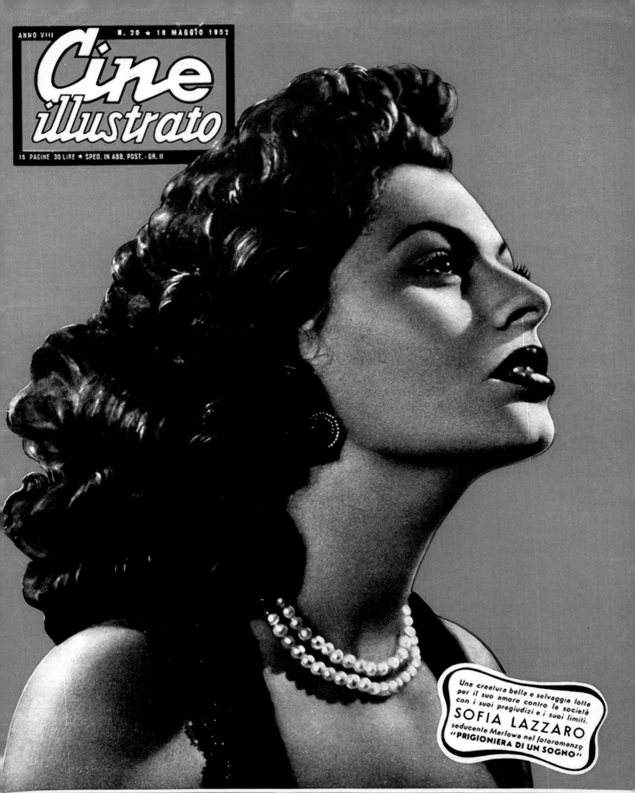

ANNO VIII N. 20 ★ 18 MAGGIO 1952

Cine illustrato

16 PAGINE 30 LIRE ★ SPED. IN ABB. POST. - GR. II

Una creatura bella e selvaggia lotta
per il suo amore contro la società
con i suoi pregiudizi e i suoi limiti.
SOFIA LAZZARO
seducente Marlowa nel fotoromanzo
"PRIGIONIERA DI UN SOGNO"

SETTIMANALE DI FOTOROMANZI

Sofia was discovered by the director of *Sogno*, one of the most popular photo-romance magazines. Appearing in these popular comics was not only a major progression in her career, making her face familiar to households all over Italy; the format also proved invaluable training for Sofia in the art of emoting for the camera.

A vital stepping stone in Sofia's rise was appearing in *fumetti*, or "photo-romances," a hybrid of romance novels and comics, with emotional stories of tortured love and adventure told through photographs and speech bubbles coming from the mouths of highly expressive actors. Though at first condemned by the church for their tales of intrigue, these magazines were harmless, escapist fare beloved by the Italian public in their day. The director of *Sogno*, one of the leading photo-romance publications, discovered Sofia, and her popularity in these stories shot her to national fame. It also paid the bills in Rome and gave her more experience in acting than a dozen bit parts could have. Renamed Sofia Lazzaro because her "beauty could raise the dead," Sofia's face became familiar to the masses. This interlude came to an official end when, in 1953, her retirement from photo-romances was announced. By then she had become in demand for movies.

In the first three years of the 1950s, Sofia's small roles in films like *Tototarzan* (1950), *Milan Billionaire*, *Anna* (both 1951), and *The Dream of Zorro* (1952) earned her recognition within the Italian film industry and led to roles of increased significance. In *The Favorite* and *Aida* (both 1953), though dubbed in singing by Renata Tebaldi and Palmira Vitali Marini, respectively, she was given lead roles. *Two Nights with Cleopatra* (1954) gave her *two* starring parts, as she played both Cleopatra and a commoner who bears an uncanny resemblance to the Egyptian queen.

Sofia's work was steady, and as soon as she earned enough, she moved herself, Romilda, and Maria into a place of their own. Taking care of family was of utmost importance to Sofia. One matter she wanted settled concerned Maria and the intense shame and misfortunes she had suffered all her life from not having the last name of her father. Sofia confronted Riccardo Scicolone and got him to agree to grant Maria his last name in exchange for one million lire—money earned from one of Sofia's first substantial roles. Maria would never suffer the sting of illegitimacy again.

The circumstances of Sofia's own budding relationship with the married Carlo Ponti deeply concerned Romilda. Ponti's marriage to his wife, Giuliana Fiastri, had ended years ago, but they had not been divorced—a status that would not be possible in Italy until 1970. Romilda did not want to see her daughter suffer from an impossible love in the way that she had with Scicolone. Though the screen test experience had proved disastrous, Ponti continued to mentor Sofia, advising her on how to grow as an actress and to lose the accent of her home region in order to open up more opportunities for herself. Their friendship turned into love, and their enduring marriage eventually proved to her mother that not all stories have the same ending.

Another filmmaker made an impact on Sofia during this period. Producer Goffredo Lombardo wanted her for his next film, *Africa Under the Seas* (1953, also known as *Woman of the Red Sea*). She cinched the role by lying about knowing how to swim. After learning from a stagehand how to survive in water, Sofia would spend much of the running time of this light comedy wearing a swimsuit, much to the delight of her growing legion of male admirers. Most significant, though, was Lombardo's suggestion of a new name for Sofia—simply changing the spelling of her first name to Sophia, and, inspired by Swedish actress Märta Torén, the surname of Loren was born. From then on, Sofia would be known as Sophia Loren.

Opposite: Sophia photographed at home in 1952.

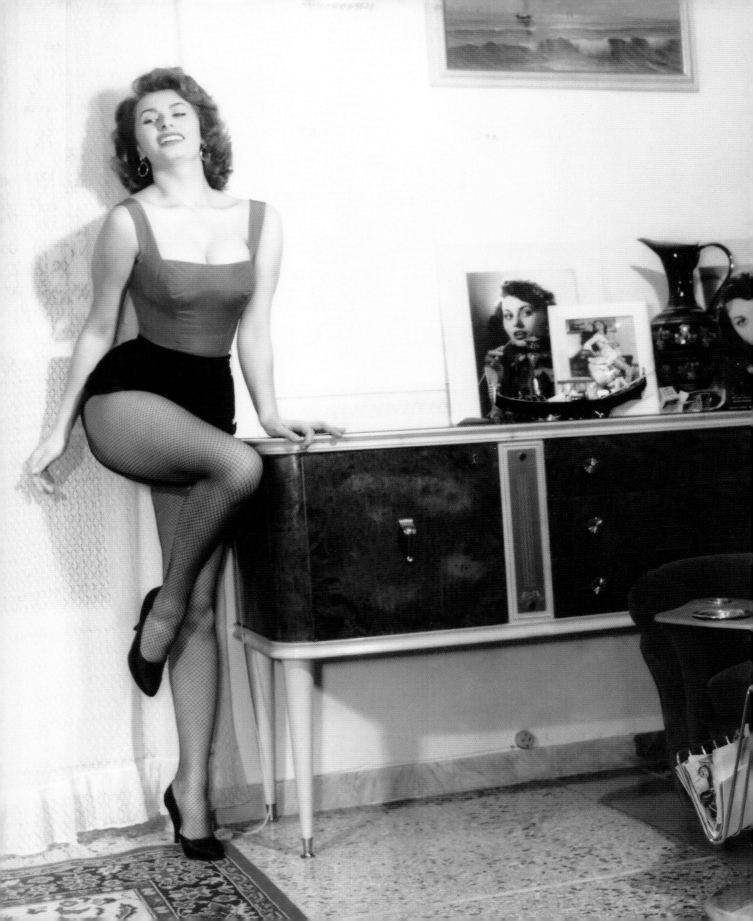

"**Without De Sica I would never have become what I am, I would never have found my true voice.**"

—Sophia

Opposite: Making a splash as the voluptuous pizza girl in *The Gold of Naples* (1954).

Right: At the Cannes Film Festival, 1954.

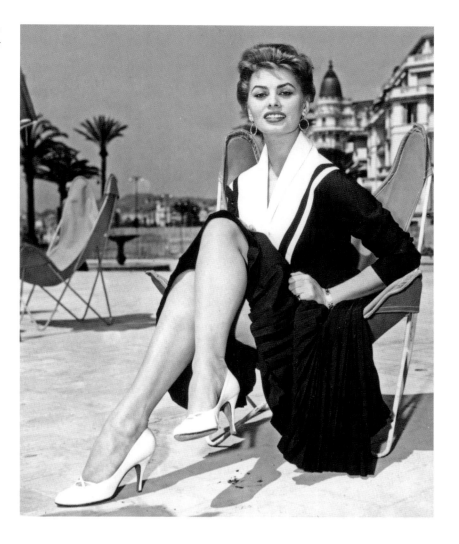

pregnant. Sophia looked to Romilda and the struggles she had faced as inspiration for the role. It would be the heaviest part she had yet played, and the project scared Sophia, but she was buoyed by Carlo's faith in her and a stellar cast and crew. Director Basilio Francina was a blessing for her. She said, "Like all real friends he offered me the greatest gift: he encouraged me to be myself." Offscreen, Basilio became a dear friend; Sophia considered him family.

Sophia was making films at a rapid-fire pace in this period, appearing in twenty pictures in the span of three years, among them comedies and dramas, showcasing Sophia's increasing talent and ease before the camera. *Too Bad She's Bad*, *Woman of the River*, and *Scandal in Sorrento* (1955, again with De Sica) were particularly well-received additions to her growing list of credits. She was also winning accolades both from the film community in Italy and around the world.

Lucky to Be a Woman (1956) was a charming comedy again directed by Alessandro Blasetti and costarring Mastroianni. Hollywood had taken notice of Italy's hottest rising star, and the highest heights of international stardom lay ahead.

> " **The camera loves her and she loves the camera. And the camera can't make a mistake, and she can't make a mistake.** "
>
> —Sam Shaw

With Vittorio De Sica in *Scandal in Sorrento* (1955). He was celebrated not only in Italy but around the world for his work both in front of and behind the camera. His groundbreaking neorealist films had a major impact on world cinema. De Sica considered his authentic approach the "cinema of the poor;" he and contemporaries like Visconti and Rossellini shot in the streets—using real houses and often nonactors as stars—among the ruins of postwar Italy.

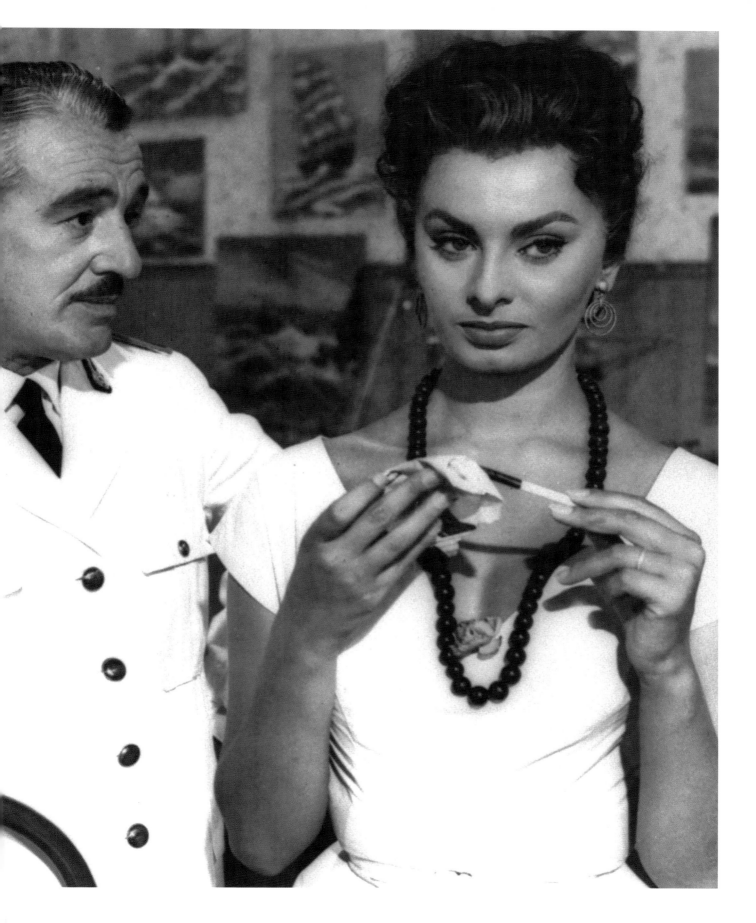

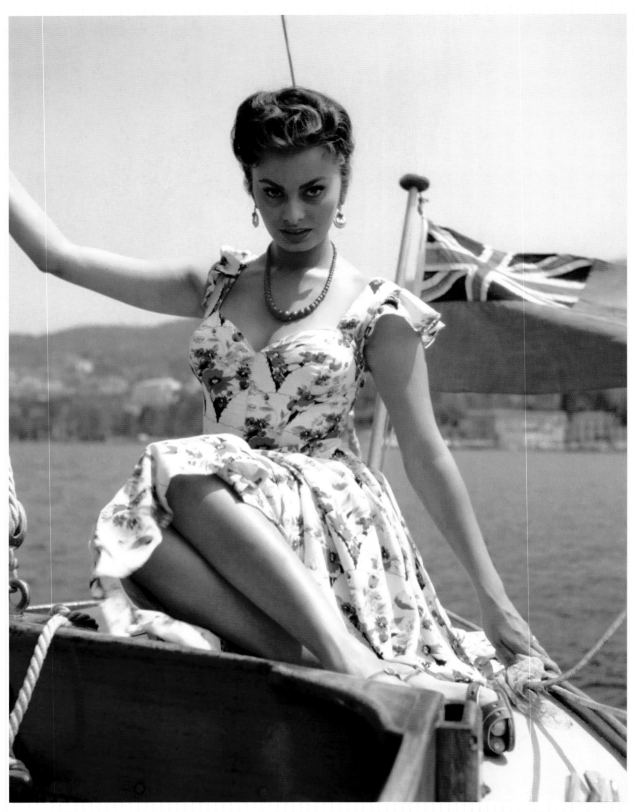

During the making of *Scandal in Sorrento* (1955), one of Sophia's many popular Italian films of the era.

Hollywood Royalty

"I'd never been so nervous in my life."

—Sophia, on the reception given in her honor for the
start of filming *The Pride and the Passion*

At her love and mentor Carlo Ponti's urging, Sophia had begun studying English with a coach on set during breaks even before securing a role in her first American film, knowing it would be key to expanding her career beyond Italy. She took to the new language quickly, making her a perfect candidate for producer Stanley Kramer, who was looking for someone to replace Ava Gardner as the female lead in his upcoming epic set during the Napoleonic wars, *The Pride and the Passion* (1957). Gardner and her husband, Frank Sinatra, were on the outs at the time, and the leading lady backed out. Filming would take place in Spain, and there Sophia met her two costars, Frank Sinatra and Cary Grant.

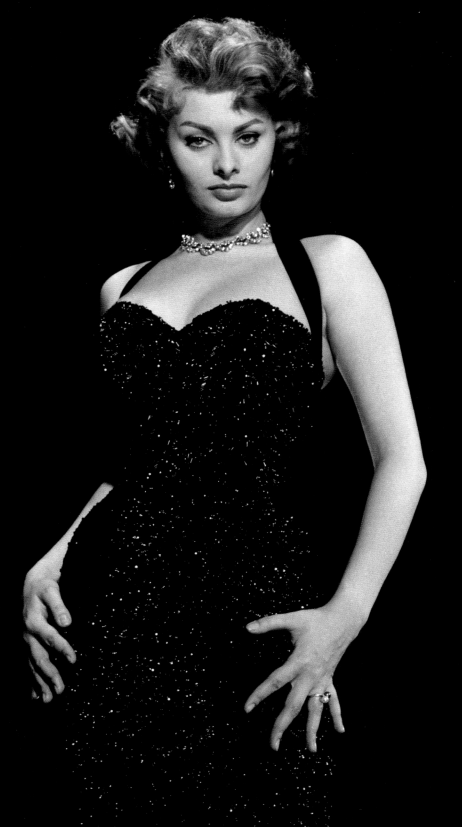

Sophia, 1957.

Sophia, away from home and out of her element, found the scale of the gargantuan production of *The Pride and the Passion* overwhelming. She was often nervous and unsure of her English, but Cary put her at ease. Their friendship took a romantic turn, and by the end of the production, Grant asked her to marry him. Sophia was in turmoil. She had formed strong feelings for Grant but was still very much in love with Carlo—he represented home to her, even if his marital status caused the pair distress and prevented them from marrying. She knew she could not marry Grant; the next day she left for Greece to film *Boy on a Dolphin* (1957). Carlo visited during filming and assured Sophia that he was working on a remedy for their situation.

Even though they were not acclaimed films, Sophia made a strong impression in both *The Pride and the Passion* and *Boy on a Dolphin*. Hollywood had a taste for European female stars in a way it had not since the early 1930s. The likes of Gina Lollobrigida, Brigitte Bardot, and Anita Ekberg were enticing audiences not just in America but all over the world. A new dawn of international female stars had arrived, and Sophia, who with Carlo Ponti had entered into a production deal with Paramount Pictures, was poised to lead the pack.

Though not prepared to leave Italy entirely, Sophia and Ponti prepared to take up residence in California in 1957 after Sophia finished filming *Legend of the Lost* in Africa with John Wayne and Rossano Brazzi. Paramount threw a grand reception to welcome her to Hollywood. It was a star-studded

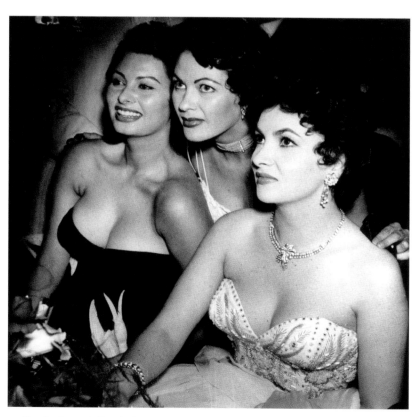

With Yvonne De Carlo and Gina Lollobrigida, her supposed rival for the title of Italian film goddess.

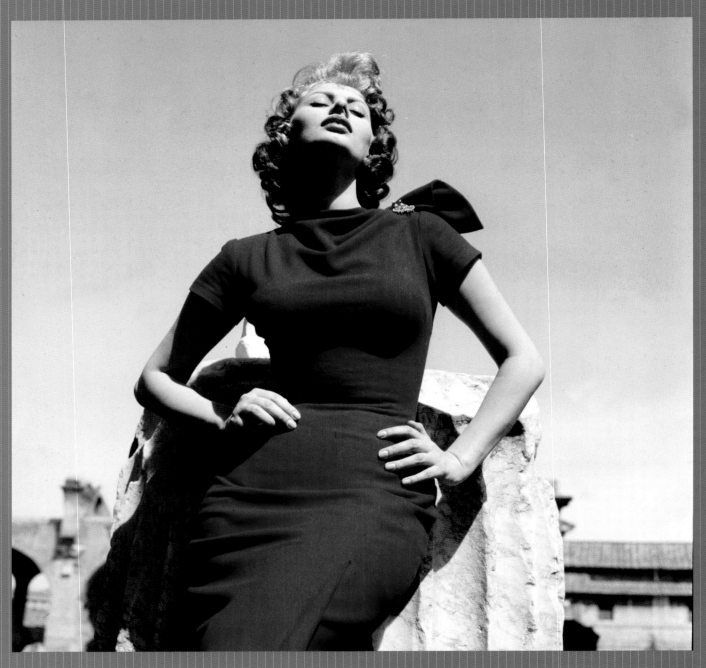

Maggiorata was what they called Sophia's shapely type in Italy. They called her a bombshell in Hollywood. Sophia was never one to fuss over her weight; she never wanted to be "clothes-hanger" thin.

"I think that she had the same kind of thing that Cleopatra must have had—she had a commanding presence."

—Anthony Quinn, costar in *The Black Orchid*

"Ordinary people just didn't seem to exist in Hollywood."

—Sophia

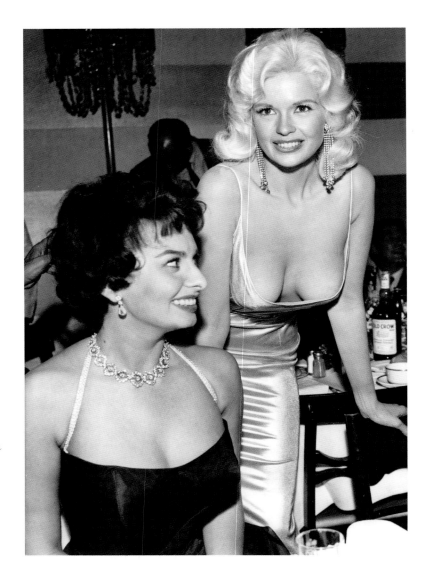

Above: Sophia's infamous photo series with Jayne Mansfield. Pictures from the event caught her looking askance at Mansfield's cleavage. Asked about this moment many times over the years, Sophia has said she was just fascinated to know, technically, how Mansfield kept the dress so strategically placed. Although Italy was known for its fair share of shapely stars, the incident at Sophia's welcome party illustrates what a shock Hollywood was to her system.

Opposite: With her sister, Maria, who lived with Sophia for a time when she first relocated to Los Angeles in 1957.

event, one immortalized by press photos displaying Sophia's obvious wonder at the sight of the buxom Jayne Mansfield spilling out of a gravity-defying dress. Hollywood—and, indeed, the English language—would take getting used to on Sophia's part, but she turned her focus to what brought her to America: work.

Desire Under the Elms (1958), based on a 1924 play by Eugene O'Neill, was an intense melodrama that placed her in a love triangle with Anthony Perkins and Burl Ives. Though the pacing was slow and lacked the charm of her Italian films, Sophia gave a compelling performance in her first made-in-Hollywood production. This was closely followed by *Houseboat* (1958), opposite Cary Grant, who was still deeply in love with Sophia. The "magic" between them had faded for Sophia, but their connection remained strong, and the two would be close

friends until the end of Grant's life. Sophia would later credit Grant with giving her "the courage to fight for a normal life with Carlo."

Houseboat ends with a wedding between the leads. Offscreen, the marriage Sophia longed for—to Carlo—took place under the most unlikely circumstances: by proxy in Mexico. Carlo had tasked his lawyers with finding a solution for his situation with Sophia since a divorce from his wife in Italy was not possible and annulment was denied, and Sophia and Carlo were shocked to learn that this was the option carried out by his attorneys. According to Sophia, they learned about their marriage from Louella Parsons's column in the newspaper. Throughout most of the world the union would be recognized, but in an Italy ruled by the doctrines of the Catholic Church, it was a scandal. Sophia and Carlo were vilified in the press and faced charges of bigamy and

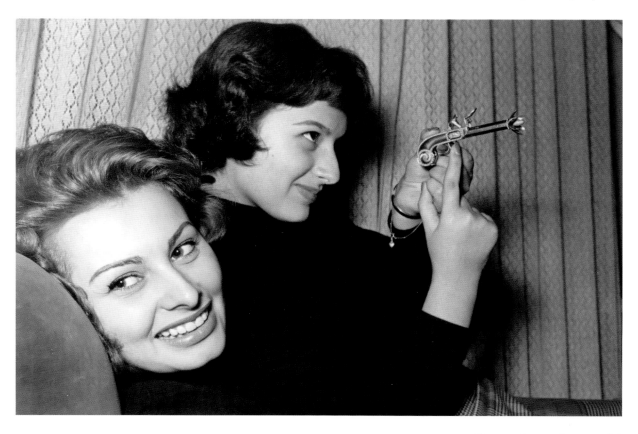

"**This girl will explode within two or three years as the world's greatest actress. I've worked with some great talents but in this twenty-two-year-old youngster I see the greatest of them all.**"

—Stanley Kramer, director of *The Pride and the Passion*

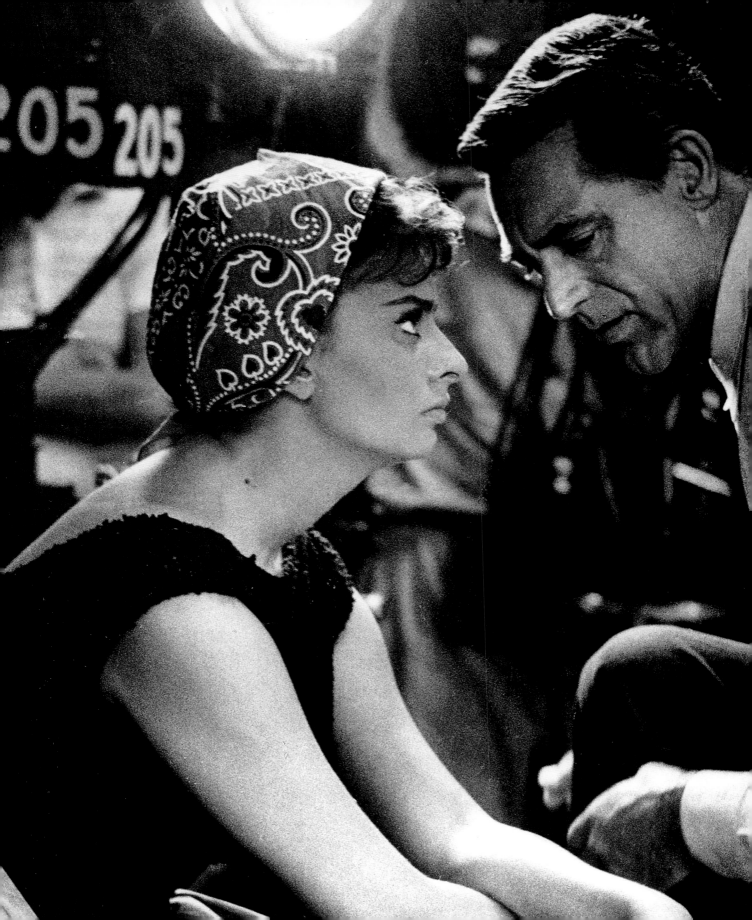

With Cary Grant on the set of *Houseboat* (1958). Their romance had ended, but Grant still had hope. Sophia was married to Carlo Ponti by the end of production.

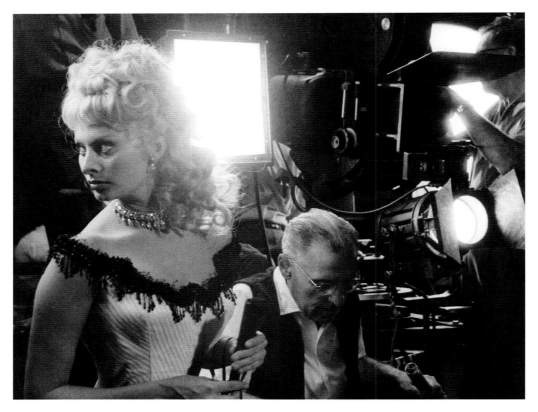

Sophia and director George Cukor between takes of *Heller in Pink Tights* (1960).

concubinage brought by a moral watchdog group. The couple would deal with the consequences for years to come.

Sophia and Carlo temporarily avoided the situation by staying out of Italy and becoming citizens of the world. They traveled to London for the filming of *The Key* (1958), then on to their home in Bürgenstock, Switzerland, in time for the holidays. In January 1958 they returned to Los Angeles, where Sophia was to make *The Black Orchid* (1958) with Anthony Quinn. *A Breath of Scandal* (1960) was filmed in Austria, *That Kind of Woman* (1959) took her to New York, *The Millionairess* (1960) was shot in England, and it was back to Hollywood for one of her favorite films, *Heller in Pink Tights* (1960). For all the professional success and in spite of the fact that they could now live together openly, it was a painful time for the Pontis. They missed home and wanted a

marriage and family that would be accepted in Italy.

Finally, *It Started in Naples* (1960) took them home. The movie was a whimsical comedy opposite Clark Gable about a staid American who travels to Naples and falls in love with a vivacious, mambo-dancing nightclub entertainer (Loren). Being back in Italy seemed to bring a special spark to her performance, but in reality her and Carlo's predicament had yet to be remedied and caused them great stress. The Italian court brought charges of bigamy against Carlo, but at last they were back to face the music and resolve their affairs. *It Started in Naples* fulfilled Sophia's contract with Paramount Pictures, and the couple was home to stay. Professionally, too, their return would be a boon to Sophia. She was about to make what is arguably the finest film of her career.

Opposite: Sophia, an international star by 1957.

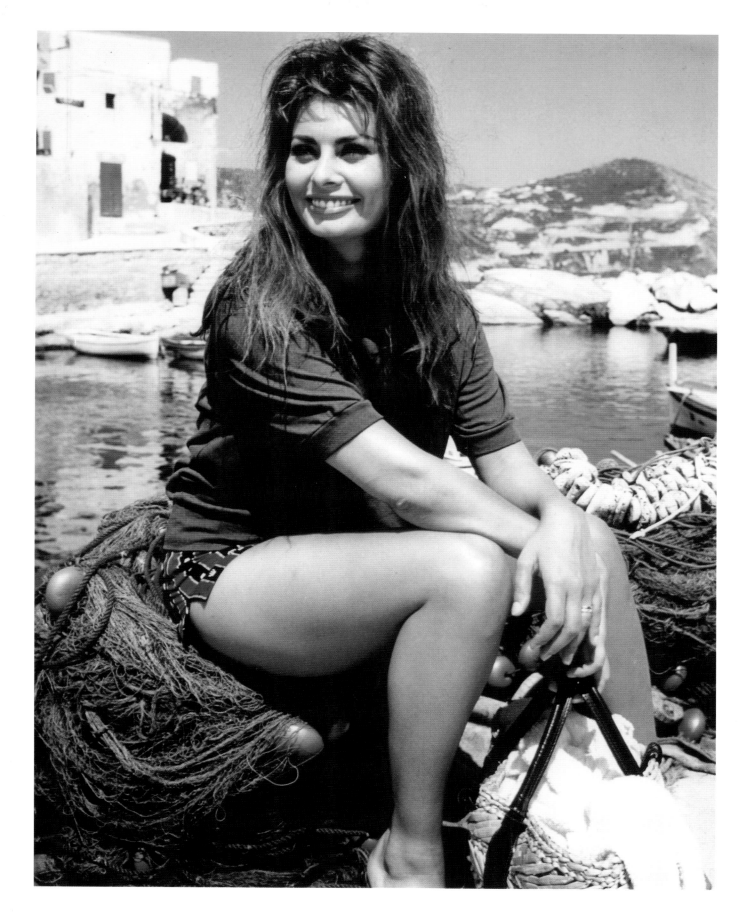

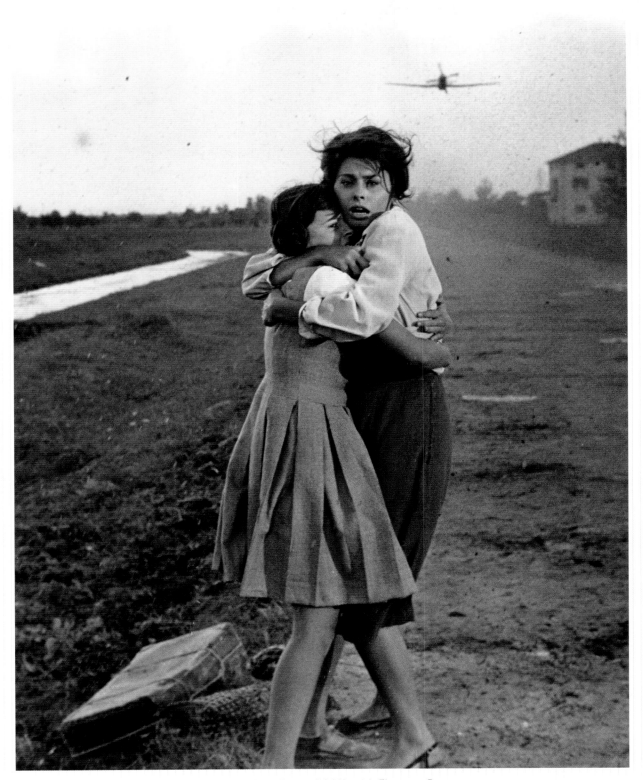

A scene from *Two Women* (1960), with Eleonora Brown.

Best Actress

Two Women (1960), originally a novel by Alberto Moravia, is the story of a mother and daughter struggling to survive in an Italian countryside besieged by bombings and foreign soldiers during World War II. Before optioning the rights, Carlo asked Sophia to read the book and let him know her thoughts. She was intensely moved by the story and identified deeply with its characters.

"If Vittorio thinks you can do it, it means you can."

—Carlo Ponti on Sophia playing Cesira in *Two Women*

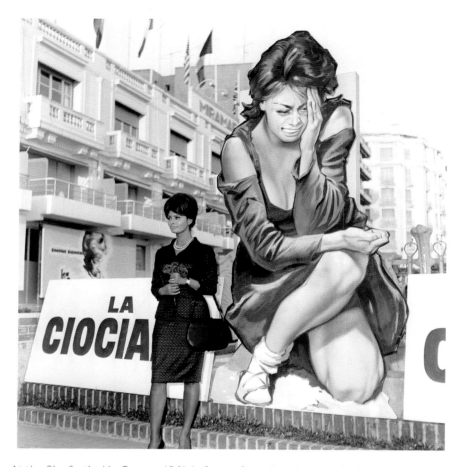

At the film festival in Cannes, 1961, in front of an advertisement for *Two Women* (1960).

Carlo secured the film rights and began mounting the production. It would be directed by George Cukor and star Anna Magnani as the mother, Sophia as the daughter. When Magnani backed out, feeling that she and Sophia would simply not be a convincing mother-daughter pair, Cukor also left the production and Vittorio De Sica came on board to direct. A plea to Magnani to return ended with the acclaimed actress off-handedly suggesting that Sophia play the mother instead. De Sica thought it a stroke of genius—they would simply need to make the twenty-six-year-old Sophia appear slightly older and make the daughter younger than in the original story. Sophia was less sure, but supported by De Sica's confidence, she embraced the role with all the passion she had to give. As production went on, the director observed that she was inspired by her return to Italy. "Though I taught her, directed every move, when the tears came and the anguish in the film, it was her heart, her soul, her own experience that she was drawing on. And when I saw it, I realized that she had come back to Italy. She had come back to me with this vital desire to re-express herself in her own language."

Sophia's performance earned worldwide acclaim—and the first Academy Award for Best Actress given to a performer in a foreign film. Too nervous to attend in person, Sophia and Carlo anxiously awaited the results at home in Italy on the night of the Academy Awards ceremony. Sometime after 6:00 in the morning, Cary Grant phoned to deliver the news that she had won. She also won the nation's highest acting honor, the David di

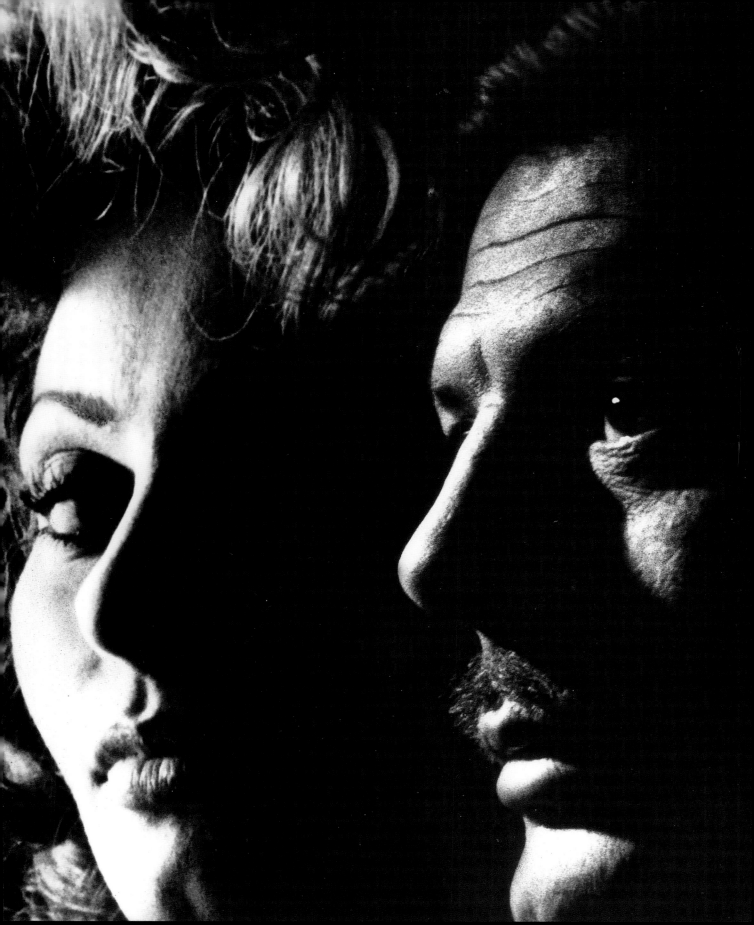

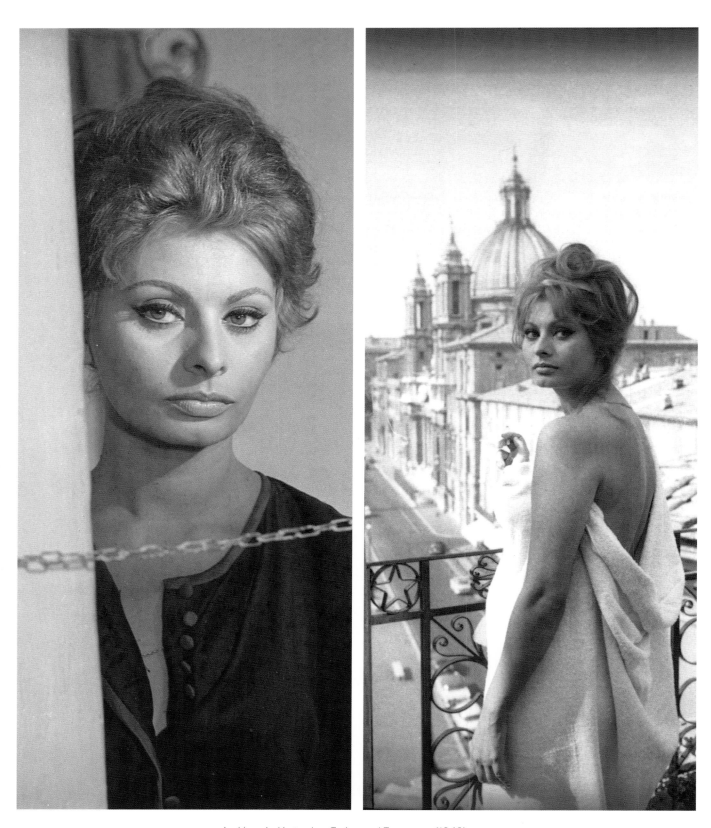

As Mara in *Yesterday, Today and Tomorrow* (1963).

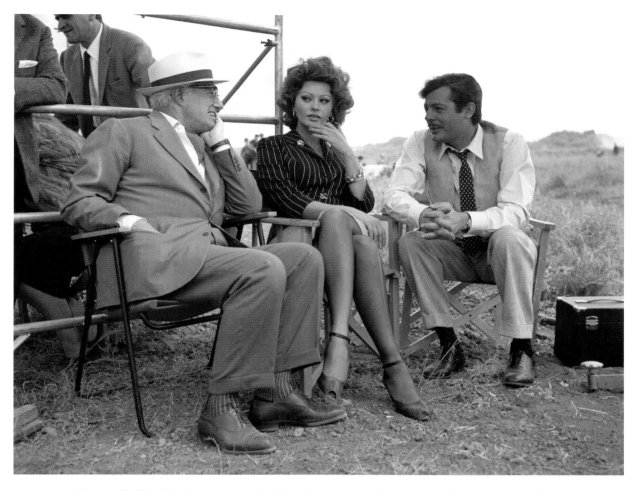

Vittorio De Sica, Sophia, and Marcello Mastroianni, during the making of *Marriage Italian Style*.

Donatello, as well as numerous other international awards for her performance. Sophia was no longer a pariah in Italy; the country was proud of her and her undeniable talent.

Two Women gave Sophia enormous confidence as an actress and was the start of a tremendously fruitful time for her professionally as well as personally. Her triumph was followed by several films made in quick succession, including *El Cid* (1961) with Charlton Heston, the all-star *Boccaccio '70* (1962), and *The Condemned of Altona* (1962) for which she won her second David di Donatello Award. Best of all, Sophia was soon reunited with Marcello Mastroianni and Vittorio De Sica for *Yesterday, Today and Tomorrow*

(1963). Filmed in the summer of 1963, it was an episodic film in which Sophia and Marcello each played three distinct characters. It would win the year's Best Foreign Film Academy Award.

The chemistry exhibited between Sophia and Marcello shown nearly a decade earlier in *Too Bad She's Bad* had not been a fluke. In their long and distinguished careers, they had no better screen partner than each other. A close friendship offscreen helped them appear totally at ease, and the enjoyment they shared working together is apparent. There is no greater example of that than the famous striptease Sophia's character performs for Marcello in *Yesterday, Today and Tomorrow*. To execute the routine, Sophia

had been coached in the art of striptease by the choreographer of the famed Crazy Horse cabaret in Paris. In the movie, Marcello howls with delight at the delicious results of Sophia's training.

Sophia next teamed with Marcello and De Sica for *Marriage Italian Style* (1964), based on a hit play by Eduardo De Filippo from 1946. She played with passion Filumena Marturano, a beloved character in Italy who suffers greatly because of her love and steadfast devotion to a cad named Don Dummì (Mastroianni). "It's hard to imagine a role closer to my heartstrings," Sophia later said.

Meanwhile, Sophia's marriage Mexican style, to Carlo, was still not recognized in Italy. Divorce remained illegal, and Carlo and wife Giuliana's numerous appeals for annulment were denied. Sophia and Carlo could live neither in constant fear from the law nor in a self-imposed exile from the land they loved. At last, a way became clear to them. After obtaining French citizenship, Carlo and Giuliana could get a proper divorce in France, and Sophia and Carlo could then marry. Of the first Mrs. Ponti, Sophia said, "She was a woman without a trace of bitterness or hostility in her, a woman who, having accepted the fact that her marriage was over, tried to make the transition as easy on herself and her children and on Carlo as she possibly could."

After years of suffering the sting of an "illegitimate" union, Sophia and Carlo were wed in a small ceremony in Paris on April 9, 1966. Now no court in the world, including Italy, could deny their marriage.

The Ponti home would expand in the coming years. After suffering two devastating miscarriages in the mid-'60s, Sophia feared she would never fulfill her cherished dream of becoming a mother. However, when she became pregnant for a third time in 1968, a specialist in Geneva gave her hope. Taking no chances, Sophia confined herself to bed for most

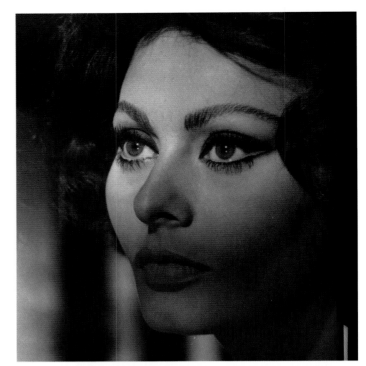

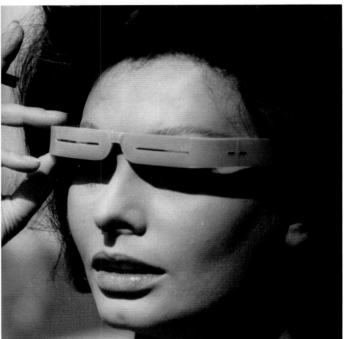

Above: Shot for *Arabesque* (1966). She is just thirty-one and only seemed to be getting more beautiful, but of an era when that was no longer considered young, Sophia called her thirtieth her hardest birthday.

Opposite: With her mother, Romilda Villani, during the making of *More Than a Miracle* (1967).

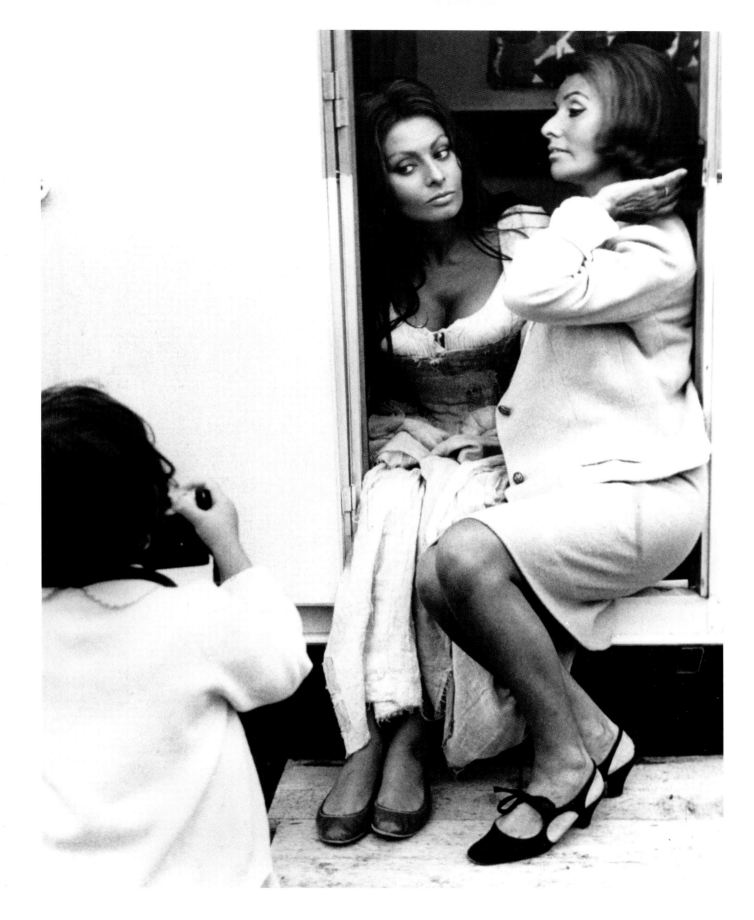

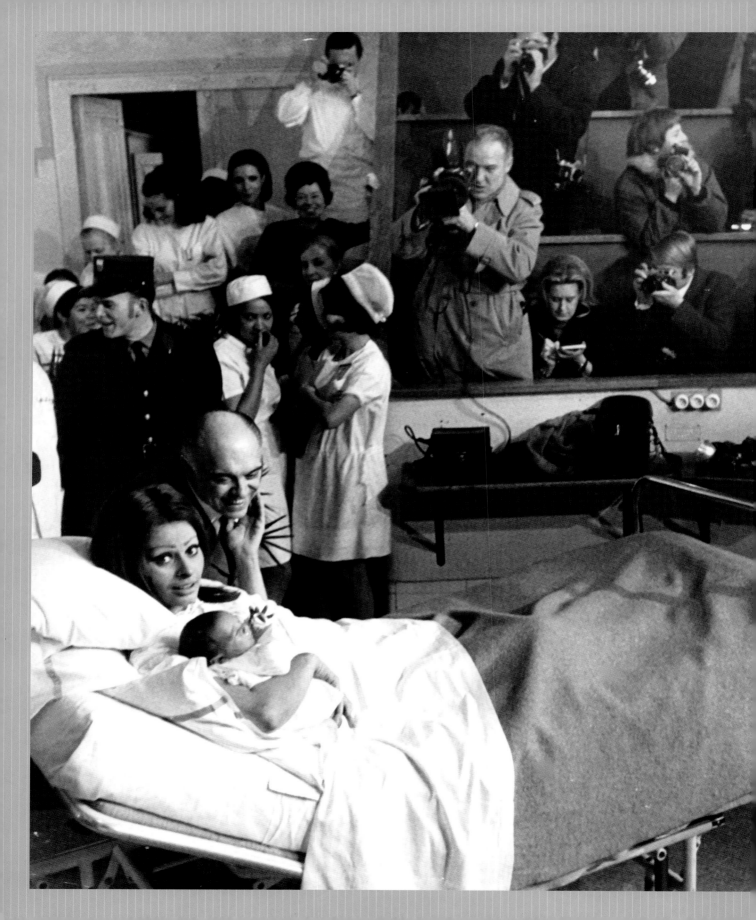

> "The birth of my first child was to me the most longed for and joyful event in my life."
>
> —Sophia

At a press conference welcoming baby boy Carlo Ponti Jr. to the world in Geneva, Switzerland on January 4, 1969. After he was born, Sophia stayed in the clinic for fifty days incubating with her baby.

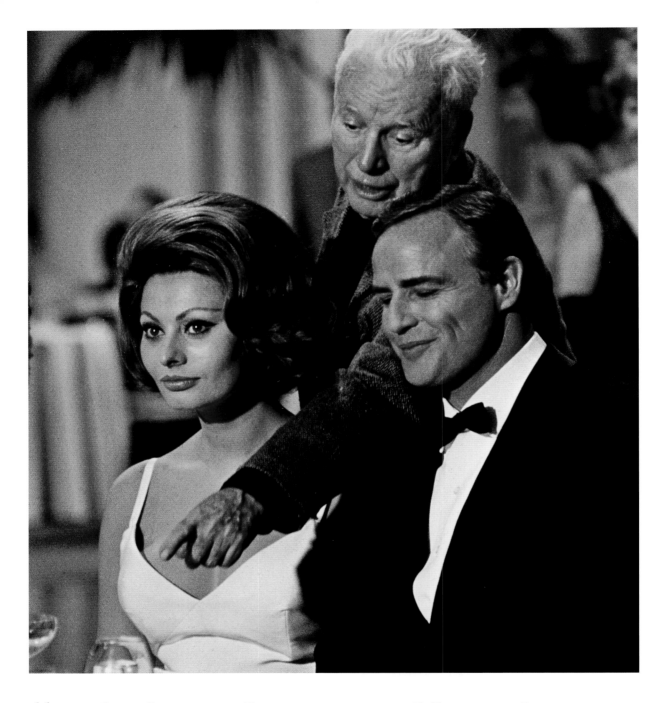

"Under his guidance, I would even have been willing to recite the telephone directory."

—Sophia on Charlie Chaplin

of her pregnancy under the close care of her doctor. Finally, on December 29, 1968, Sophia gave birth to a healthy boy, Carlo Ponti Jr. At age thirty-four, with the birth of their son, Sophia felt that "for the first time in my life I had everything I wanted."

— ● ● ● —

In the mid- to late '60s, an era of monumental cultural shifts, fashion revolutions, and political unrest on an international scale, Sophia and Carlo continued making films across Europe and America. She had scaled the highest heights of success as a world-famous, renowned actress, starring in a series of movies with the top leading men of the day.

Dressed to the nines in the latest Christian Dior, she did a unique turn on the '60s spy genre opposite Gregory Peck in *Arabesque* (1966). Paul Newman was her leading man in *Lady L* (1965), a film that required her to age fifty years on-screen. *More Than a Miracle* (1967) found her trading eggplant recipes on the set with costar Omar Sharif.

A Countess from Hong Kong (1967) was a special joy for Sophia because it gave her the opportunity to work with Charlie Chaplin in what would ultimately be the comedic legend's final film. She was fascinated by him and instantly said yes when Chaplin asked her to star in the film. "He was a whirlwind—a great, imaginative storyteller, absorbed by his own magic," she later said.

Right: At a London press conference for *A Countess from Hong Kong*. In the fashion of the day, Sophia used to draw tiny strokes upward in her eyebrows with a brow pencil.

Opposite: With Charlie Chaplin and Marlon Brando, between takes on *A Countess from Hong Kong* (1967).

"She is the icon of Italian style, elegance, and sensuality."

—Giorgio Damiani, Italian jeweler

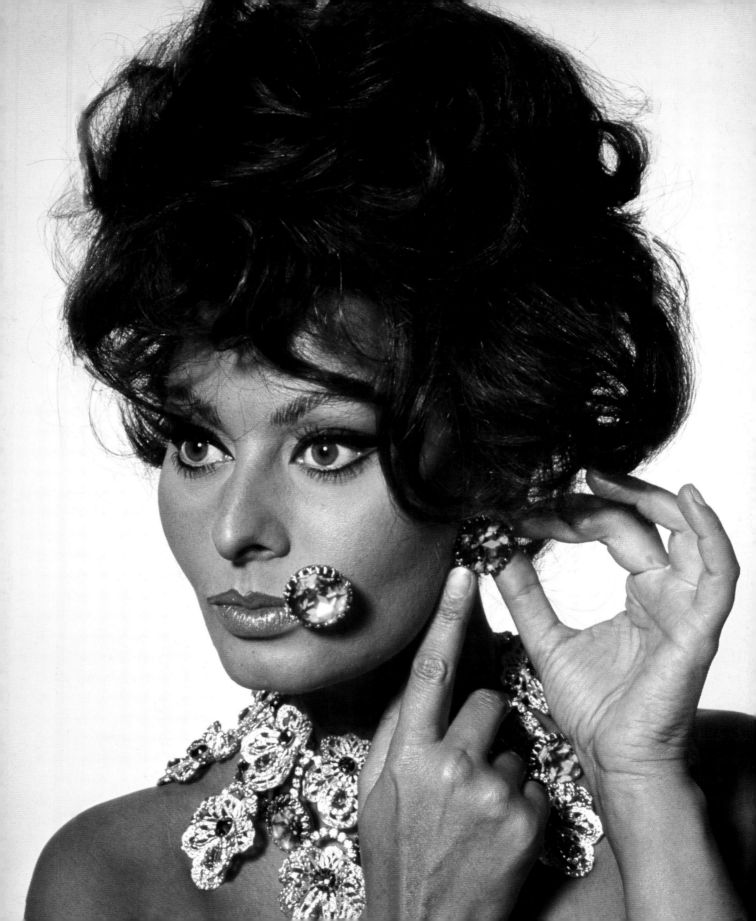

"Sophia is the only honest-to-God international movie star."

—Charlton Heston

World Favorite

*S*unflower (1970), filmed between Milan and Russia in the fall of 1969, brought Sophia together with director De Sica and costar Mastroianni again. A stirring drama about lovers separated by war, Carlo Jr. makes a cameo appearance in the film as Sophia's own child. The actress was at her best under De Sica's direction and earned another David di Donatello as Best Actress. *Sunflower* would be the final teaming of De Sica, Mastroianni, and Loren, and it turned out to be one of their finest.

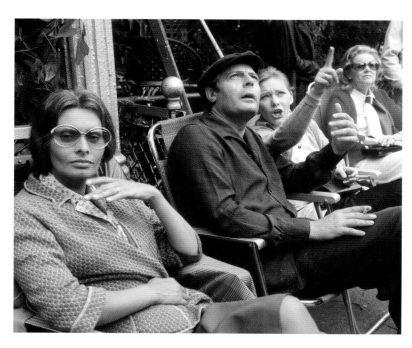

In her aging makeup on the set of *Sunflower* (1970) with Marcello Mastroainni.

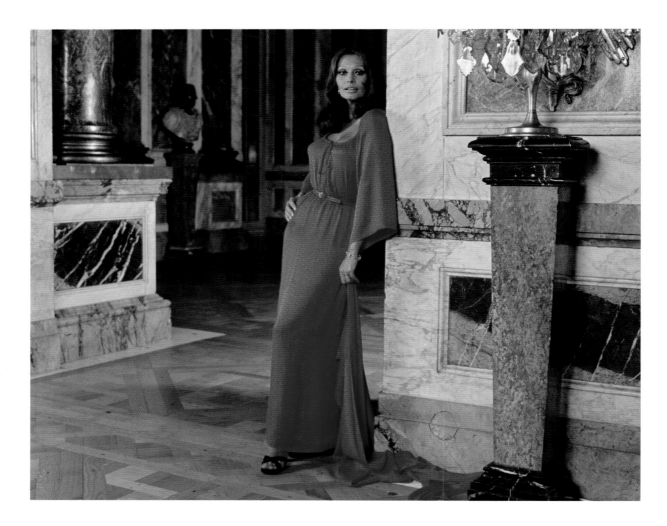

De Sica would make only one more film with Sophia, *The Voyage* (1974), costarring Richard Burton. The story of a woman dying of an incurable disease, art mirrored life as De Sica was by then terminally ill with lung cancer. Months after filming, he was gone. It was a devastating blow for Sophia to lose this great friend whose singular influence brought out the finest in her as an actress. She carried on his memory in the films she selected in years to come, though, as she would later describe it, "I was more of a mother than an actress" after the birth of her first child. A year earlier, Sophia had given birth to a second son, Edoardo. While mainly based at their home outside of Rome, Sophia and Carlo continued making films both in Italy and across Europe.

A Special Day (1977) is one of Sophia's most haunting films and seems to be an homage to De Sica's memory. Her Antonietta is cut from the same cloth as the strong and passionate women of Italy she played to perfection under De Sica's direction numerous times before. Again the story brought back the war, as it was set around the day Mussolini welcomes Hitler to Rome in 1938. Marcello played her neighbor, an out-of-work, homosexual radio broadcaster whom she falls into an impossible love with as war-hungry fascists parade upon the city. Sophia won plaudits around the world for her performance.

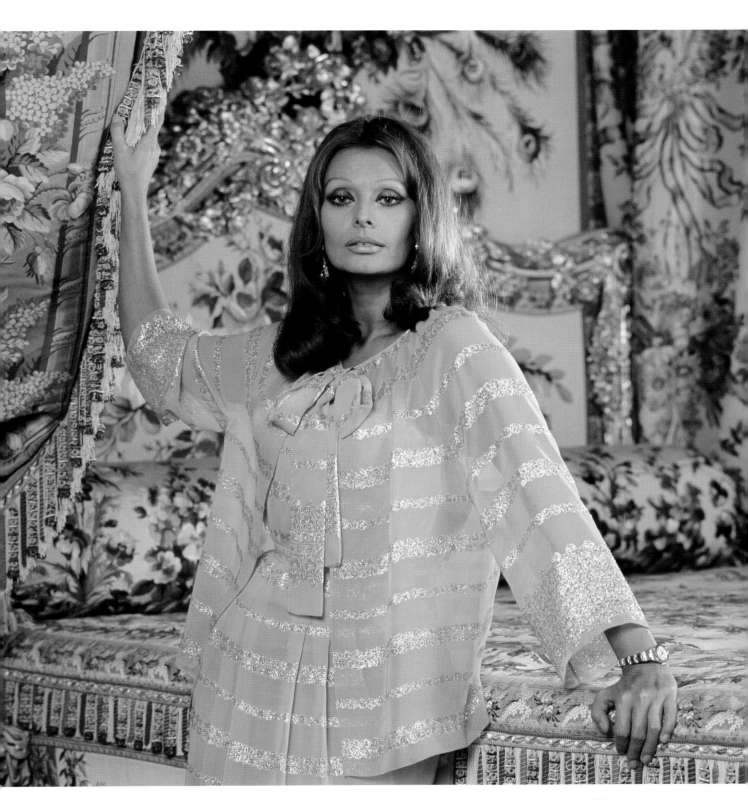

Opposite and above: Shots from a photo session at the Salle des Glaces in Versailles, Paris, 1976.

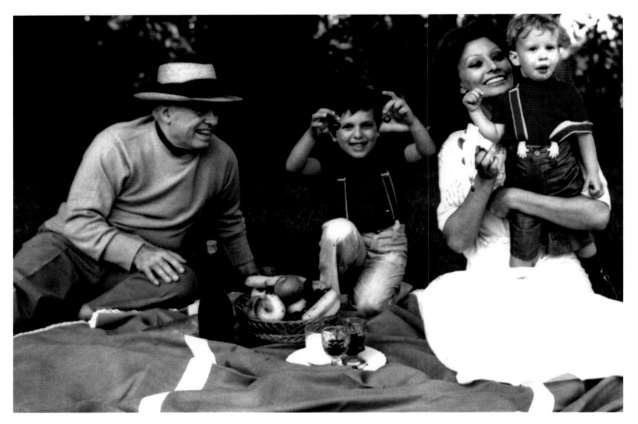

The Pontis and their two young sons, Edoardo and Carlo Jr.

"Hearing children laugh is like listening in on heaven."

—Sophia

By the late '70s, when she was in her midforties, Sophia's status as a legend was cemented, marked by the publication of an autobiography written with A. E. Hotchner in 1979. The book served as the basis for a film, *Sophia Loren: Her Own Story* (1980), in which Sophia played herself as well as the role of her mother, Romilda. With the launch of a perfume and a line of eyeglasses around this time, Sophia also cemented herself as a businesswoman and a brand.

This period was also marked by more legal woes for the Pontis. They were cleared of charges of "unlawful currency dealings" stemming from the international coproduction of films, but the worst was yet to come for Sophia for alleged tax evasion. Sophia never dealt with financial matters—her accountants did. Her international residency status throughout the late 1950s and early '60s made tax reporting a complex matter. Her accountant at the time handled her reporting, and a later accountant handled it in a manner that made it appear that she was not living abroad during that period and therefore evaded paying taxes in Italy. In 1982, Sophia found herself facing a thirty-day prison sentence. She was given the choice between serving her term or being exiled from Italy. Thinking of being separated permanently from her homeland and never being able to visit her family there again, the choice was clear to Sophia. In May 1982, she flew to Italy from Paris (where the Pontis had been living at the time) to serve her sentence. She emerged seventeen days later with a clean slate on Italian soil and applauded worldwide for her bravery. Many years later, in 2013, she would be completely vindicated, with the court

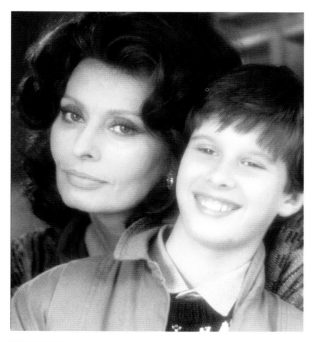

Top: Sophia and her son Edoardo Ponti during the making of *Aurora* (1984).

Bottom: Large lenses became a trademark for far-sighted Sophia. She saw them as a fashionable accessory for women and even launched her own line of eyeglasses with Zyloware.

A 1986 photo shoot in London. By this time Sophia insisted on doing her own makeup for photo sessions and films. She knew her face better than anyone, and she felt that it hurt her acting if she was overly done or did not look like herself.

officially agreeing that she had not violated the law.

Compared to the rapid-fire pace of her work in preceding decades, Sophia made relatively few films in the ensuing years, with her focus turned more on family and home and her work as a goodwill ambassador for the United Nations. A cinematic highlight in these years was *Aurora* (1984), in which an eleven-year-old Edoardo Ponti made his film debut, playing the lead's blind son. With Sophia's help coaching him along, Edoardo won a Young Artist Award

Robbins, Rupert Everett, and Kim Basinger. The highlight was a re-creation of Sophia's striptease from *Yesterday, Today and Tomorrow*. Instead of howling with abandon as in the original, the aged Marcello falls asleep during Sophia's performance. After twelve films and fifty years of close friendship, *Ready to Wear* would be Sophia and Marcello's final film: Marcello died two years later.

Marcello's death was not the only major blow of the '90s. Romilda Villani passed away a few years

"She is an adorable woman with a great sense of humor, overwhelming humanity, and charisma."

—Gianfranco Ferré, designer, *Ready to Wear* (1994)

for his work. Edoardo's growing passion for films would develop into a long and thriving career as a filmmaker. Carlo Jr., meanwhile, took to music and eventually became an equally successful orchestra conductor.

Film opportunities for both the big and small screen continued to come Sophia's way as she approached sixty, including a return to her signature role of Cesira in *Running Away*, a 1989 remake of *Two Women*. A few years later, Sophia and Marcello Mastroianni proved the magic between them was still alive in *Ready to Wear* (1994), directed by Robert Altman. They stole the show among an all-star cast that included Julia Roberts, Lauren Bacall, Tim

Goodwill ambassador Sophia in 1992, on a four-day trip to Somalia and a refugee camp in Kenya.

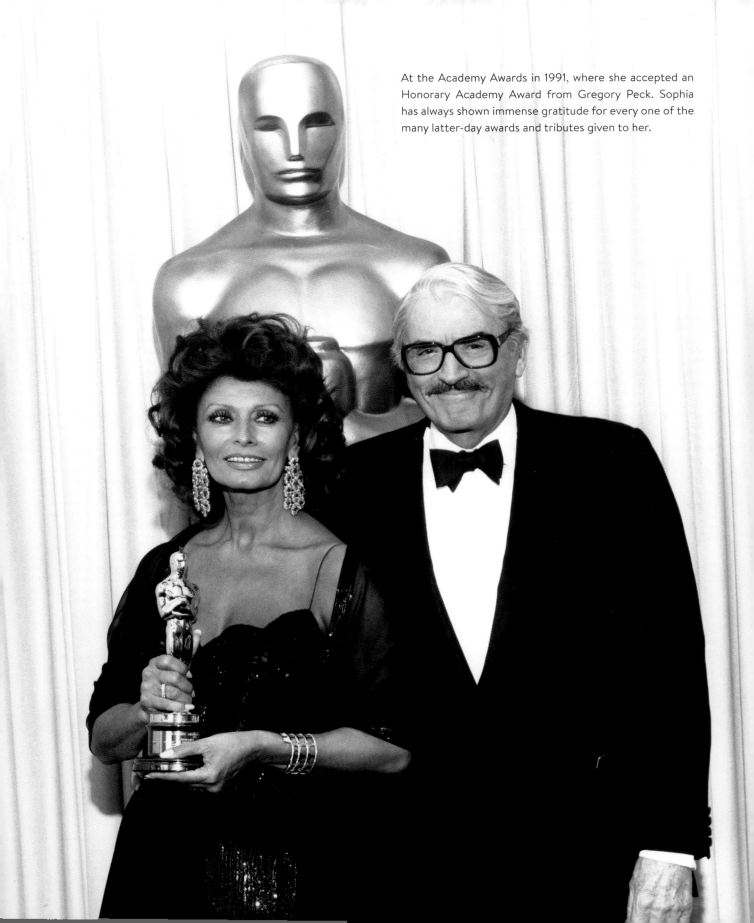

At the Academy Awards in 1991, where she accepted an Honorary Academy Award from Gregory Peck. Sophia has always shown immense gratitude for every one of the many latter-day awards and tributes given to her.

prior, in 1991. Perhaps no other person in Sophia's life had left a greater influence, not only personally but professionally, as Romilda had when she thrust her daughter in the direction of acting in the first place. Thinking of Romilda's passions and the way she lived her life inspired many of Sophia's most compelling performances. Sophia would later write, "Looking back on our lives, maybe she, not I, was the real star." And she told interviewer Barbara Walters that her mother was "the real Sophia Loren." Sophia's sister, Maria, would later publish a novel inspired by their lives. When it was later adapted into a TV miniseries, *My House Is Full of Mirrors* (2010), Sophia would again portray Romilda as she had in the film version of her own autobiography.

• • •

Sophia has chosen film roles selectively from the mid-'90s to the present, mostly Italian productions. A hit for her in the United States was her wonderful appearance as Walter Matthau's love interest/rival in *Grumpier Old Men* (1995). As with most legends, this was also a time of career tributes and collecting awards, including an Honorary Academy Award, the Golden Globes' Cecil B. DeMille Award, Berlin's Golden Bear, and many more honors from around the world in recognition of her body of work.

One of the films closest to Sophia's heart in her later years has been *Between Strangers* (2002), which was written and directed by Edoardo Ponti. It was challenging to be directed by her son because she was nervous for him but also wanted to give him her best work. She overcame that fear when she witnessed Edoardo's talent and professionalism on the set.

Another highlight performance in recent years was *Nine* (2009), director Rob Marshall's adaption of a musical inspired by the classic Fellini film of

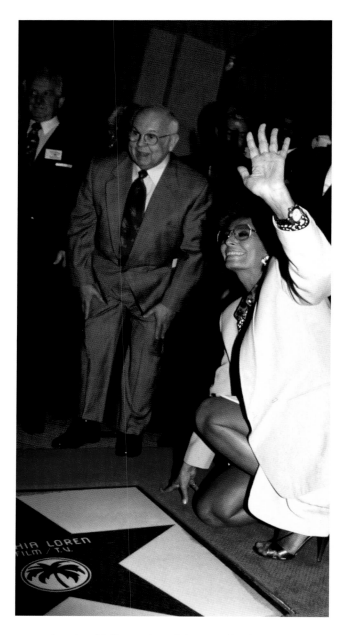

Above: Another Hollywood tradition: getting her star on the Walk of Fame, 1994.

Opposite: The memory of the food of Sophia's childhood, from the kitchen of her grandmother, remained with her all her life—"recipes are memories," she said. An avid chef herself, Sophia published her first cookbook in 1998. She stretched her business wings in the 1980s and '90s with branding businesses in eyewear, perfume, and the publication of not one but two cookbooks.

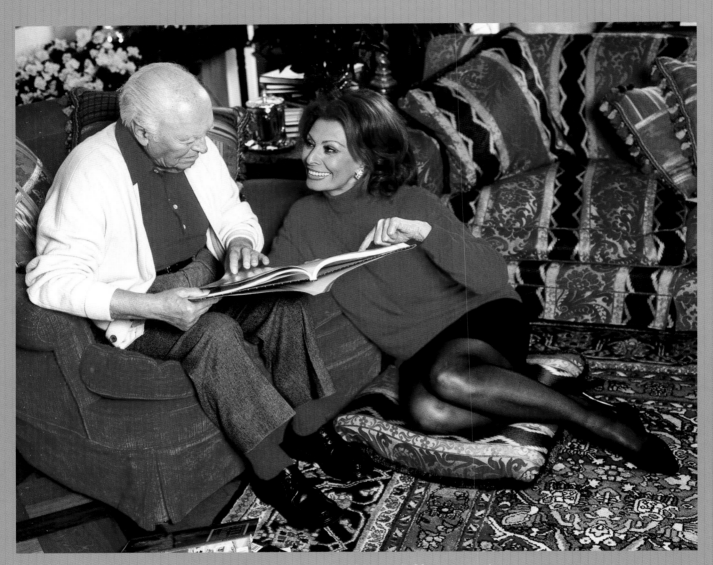

With Carlo Ponti, forty years into their nearly fifty-year marriage.

1963, *8½*, which had starred Mastroianni. The film had a stellar cast—which collectively went on to be nominated for a Screen Actors Guild Award— including Daniel Day-Lewis, Penélope Cruz, Marion Cotillard, and Nicole Kidman, but Sophia, who portrayed the director's mother, was a standout in this tribute to her era of Italian cinema.

Still another hit directed by Edoardo was the short film *Human Voice* (2014), based on the play by Jean Cocteau. A star turn for any actress, it was the story of a woman driven to a mental breakdown from despair over losing her lover. Sophia, who had wanted to play this touching portrait of a woman since she had seen it performed on the stage as a girl, was thrilled to work on it with her son. Sophia won her latest David di Donatello Award for *Human Voice*, making her the most honored recipient of this prestigious prize. At the rate Sophia works and the level of talent she maintains, it may not be her last.

After fifty-six years by Sophia's side, Carlo passed away at age ninety-four in 2007. She attributes the longevity of their relationship to "serenity, harmony, and trust."

Sophia has not been lonely since her husband's passing. She is extremely close with her two sons and calls herself the world's happiest grandmother. She remains active professionally as well, publishing an updated autobiography in 2015 and touring with a question-and-answer interview series called "An Evening with Sophia Loren" in 2016. She has said, "Living means setting new goals to strive for each and every day." With a sharp mind, eternal beauty, and an infectious spirit, she proves that age is merely a state of mind.

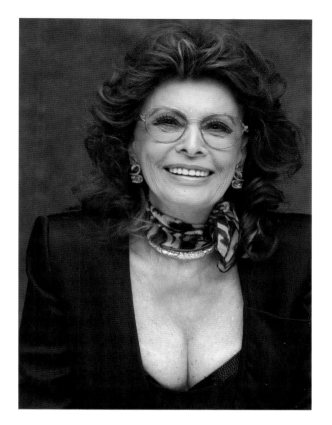

At a promotional event for *Nine* (2009).

Right: Sophia and son Edoardo at the Venice Film Festival, where the film that they made together, *Between Strangers* (2002), was shown.

Below: Sophia, Carlo Jr., Carlo, and Edoardo at the wedding of eldest son, Carlo, now a famed conductor, to violinist Andrea Mészáros in Budapest, 2004. Sophia has said that while happiness is love when one is young, it is in family as one ages. Her sons have given her four beloved grandchildren.

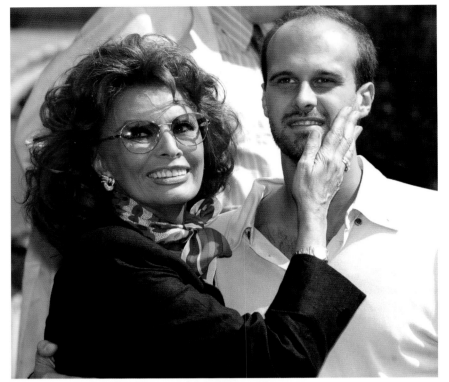

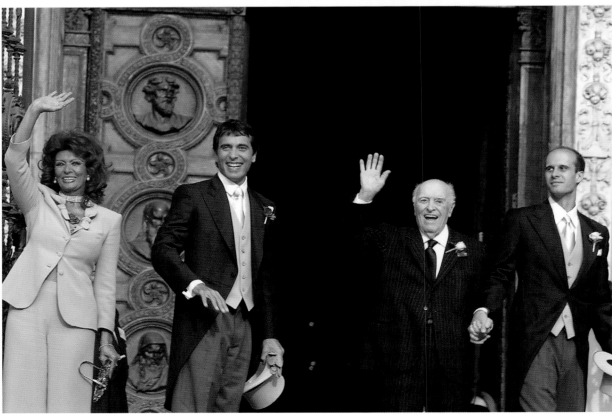

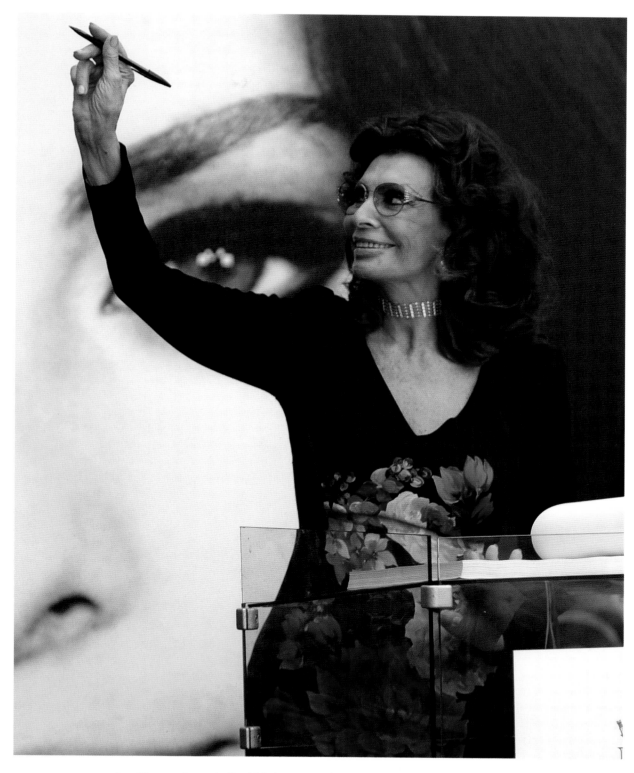

As with most legends, Sophia's later years have been a time of being celebrated. Always returning to her roots, here she is made an honorary citizen of Naples in 2016.

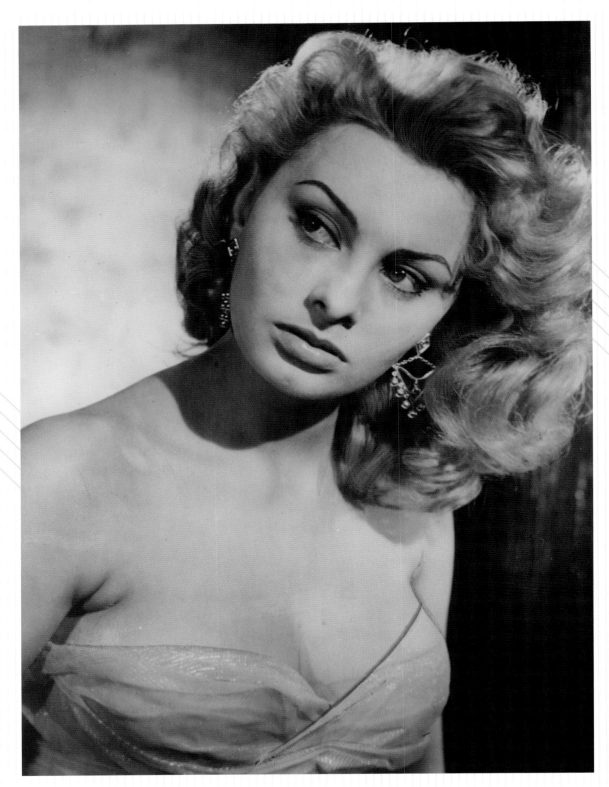

Sophia in early 1950s Rome, a starlet on the rise.

PART TWO:
The Movies

A Foot in the Door

Sofia began landing small roles in films even before she and Romilda traveled to Rome to try out for *Quo Vadis* at Cinecittà in 1950. With the help of her acting school teacher in Naples and sometimes through Romilda's efforts, a young Sofia Scicolone had the opportunity to gain a little experience before the camera in films like *Hearts at Sea* (1950) and *The Vow* (1950).

Once in Rome, Sofia landed a quick succession of bit parts in films of all genres, every minute absorbing knowledge and watching the pros in action. She was well liked and her magnetism was undeniable, so it was not long before she began to rise in the ranks, taking on roles of increasing importance. The star of Italy's immensely popular photo-romances came to life on the screen, sometimes billed as Sofia Lazzaro, the moniker given to her in the magazines. She was soon earning enough money to sustain herself and to help support her family, a fact which brought Sofia enormous joy.

Bluebeard's Six Wives

Le sei mogli di Barbablù (1950) :: DIRECTED BY Carlo Ludovico Bragaglia

This is a comedy starring Italy's "Prince of Laughter," Totò. Sofia had adored the comedic master for many years and had an encounter with him once before, sneaking onto the set of one of his films to watch him work. Totò noticed the charming young girl in his midst and rewarded her appreciation of his craft by slipping 100,000 lire into her hand. In those poverty-stricken postwar years in Pozzuoli, it was like manna from heaven for the Villani family. Sofia left an impression.

Totò remembered her when she appeared on the set of *Bluebeard's Six Wives*. She said he "was the first person I met at Cinecittà. He is the one who gave me a hand and allowed me to make my first appearance in a film."

Though merely an extra in this and *Tototarzan*, another Totò comedy of 1950, Sofia would have the opportunity to work with him in a more rewarding capacity a few years later, in their episode of *Anatomy of Love* (1954).

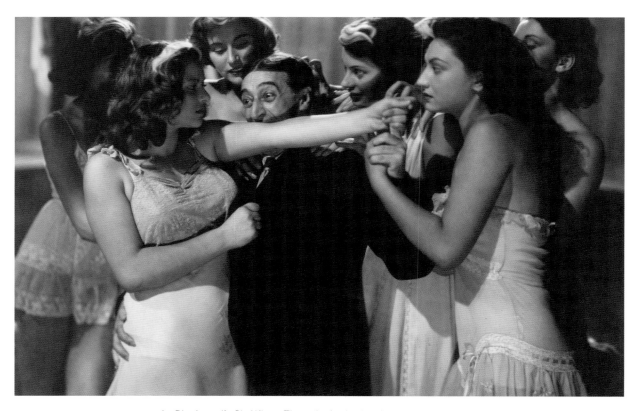

In *Bluebeard's Six Wives*. Though she had only a very small role,
Sofia was thrilled to be working with the Italian comic legend Totò.

Tototarzan

(1950) :: DIRECTED BY Mario Mattoli

Totò starred in this satirical spin on Edgar Rice Burroughs's *Tarzan of the Apes*. Bikini-clad Sofia was an extra.

Hearts at Sea

Cuori sul mare (1950) ::
DIRECTED BY Giorgio Bianchi

In her screen debut, Sofia had an uncredited role as a restaurant patron in this film about two friends who find adventure on the high seas and fall for the same woman (Doris Dowling). Marcello Mastroianni, Sofia's great future costar, played one of the two seaman friends, though they did not meet at this time.

The Vow

Il voto (1950) :: DIRECTED BY Mario Bonnard

Still prior to her move to Rome, Sofia Scicolone was an extra at a feast in this comedy.

Variety Lights

Luci del varietà (1951) :: DIRECTED BY Federico Fellini and Alberto Lattuada

Federico Fellini made his debut as a director with *Variety Lights*, the story of a traveling group of vaudevillians. Sofia had an uncredited role as a ballerina.

White Leprosy

Lebbra Bianca (1951) :: DIRECTED BY Enzo Trapani

Using the name of her *fumetti* magazine persona, Sofia was billed as Sofia Lazzaro for her role as "a girl in the boardinghouse."

The Return of Pancho Villa

Io sono il capataz (1951) ::
DIRECTED BY Giorgio Simonelli

Sofia plays a dictator's secretary in this western.

Milan Billionaire

Milano miliardaria (1951) ::
DIRECTED BY Marino Girolami, Marcello Marchesi, and Vittorio Metz

Again unbilled, Sofia has the role of a popular bakery shop clerk.

Quo Vadis

(1951) :: DIRECTED BY Mervyn LeRoy

Both Sofia and her mother, Romilda, landed roles as extras in *Quo Vadis*. Riccardo Scicolone's wife, whom they had the unpleasant experience of encountering at the casting, was not selected for a part. Their luck in getting jobs gave them the confidence to continue on their quest to make it big in the flourishing postwar Italian film industry.

Magician by Chance

Il mago per forza (1951) ::
DIRECTED BY Marino Girolami, Marcello
Marchesi, and Vittorio Metz

Sofia appears briefly as a young bride in this comedy.

===

It Was Him . . . Yes! Yes!

Era lui, sì, sì! (1951) ::
DIRECTED BY Marino Girolami, Marcello
Marchesi, and Vittorio Metz

Sofia actually had a dual role in this film, as a model and a mistress. The picture has gained some measure of fame for Sofia's topless appearance in the production, a move that the filmmakers insisted upon for the French market. It was far from ideal for the rising actress, but as she put it herself, she had not yet learned to say no. She made the best of every situation, absorbing and learning from each experience, curious to learn by association with top directors and stars, such as Walter Chiari, who led the cast of *It Was Him . . . Yes! Yes!*

===

The Industrialist

Il padrone del vapore (1951) ::
DIRECTED BY Mario Mattoli

Billed as Sofia Lazzaro, Sofia has the role of a ballerina.

Anna

(1951) :: DIRECTED BY Alberto Lattuada

In this picture starring the great Italian actress Silvana Mangano, Sofia was given some of her first spoken lines by director Alberto Lattuada, whom she met during the making of *Variety Lights*.

===

The Piano Tuner Has Arrived

È arrivato l'accordatore (1952) ::
DIRECTED BY Duilio Coletti

In this low-budget comedy, Sofia receives on-screen credit for the first time as the "friend of Giulietta."

===

The Dream of Zorro

Il sogno di Zorro (1952) ::
DIRECTED BY Mario Soldati

In this adventure film, Sofia's character, Conchita, gets an unwanted kiss from star Walter Chiari, playing Don Raimundo Esteban. Director Mario Soldati would later work with her on one of her early breakthrough films, *Woman of the River* (1954).

Girls Marked Danger

La tratta delle bianche (1952) :: DIRECTED BY Luigi Comencini

Sofia had only a small role in this film as a contestant who faints in a dance marathon, but that did not stop her likeness from being emblazoned on ads for its US theatrical release. Producers were beginning to notice that Sofia's face and figure could get people into theaters.

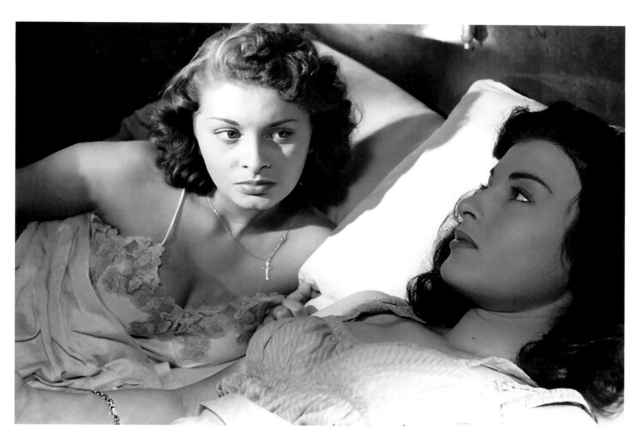

With Eleonora Rossi Drago in *Girls Marked Danger* (1952).

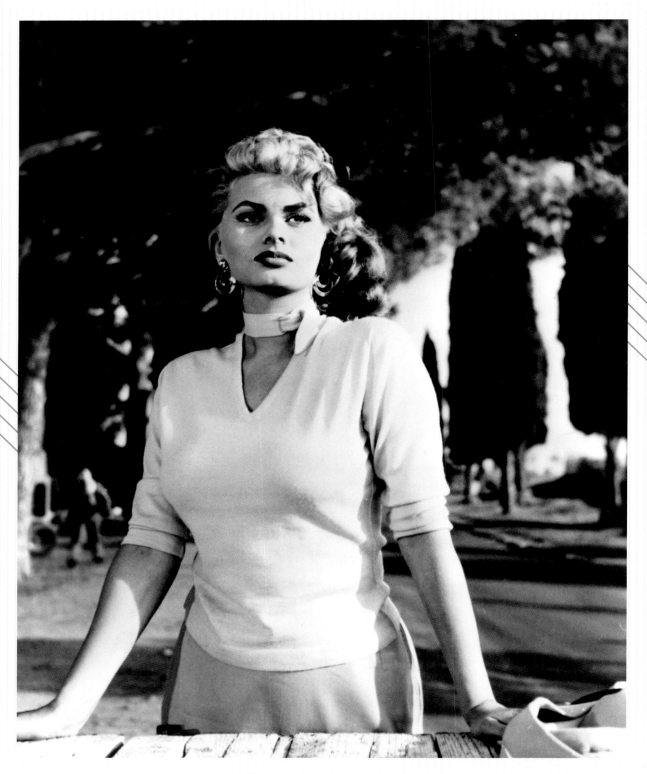

A publicity still for *Lucky to Be a Woman* (1956).

Sophia in the Golden Age of Italian Cinema

*I*talian cinema in the early 1950s was a boom town. Its epicenter was the legendary Cinecittà Studios in Rome, but directors of the postwar years like Vittorio De Sica famously took to the streets to achieve what would become the look of Italian neorealism. It was an exciting time to be in the industry, and Sofia quickly found her place. She was the spirit of the Neapolitan woman brought to life—beautiful, robust, full of laughter and strength belying the worst of hardships. Sofia was always at her best when portraying women of Naples, and in these roles, her career flourished. No longer the two-dimensional star of photo-romances and rechristened Sophia Loren, she became one of Italy's greatest stars. It was not long before Hollywood took notice.

The Favorite

La favorita (1953) :: DIRECTED BY Cesare Barlacchi

She was still billed as Sofia Lazzaro for her role as Leonora, the woman of the title to the king of Castile in *The Favorite*. A film adaptation of Donizetti's opera, her voice was dubbed by Palmira Vitali Marini, but Sofia displayed tremendous emotion in her expression of the lyrics, which proved to be invaluable practice for the performance she would soon give in *Aida*.

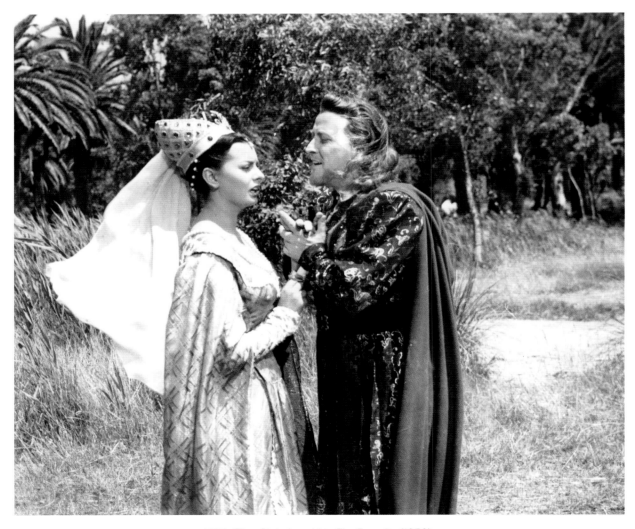

With Gino Sinimberghi in *The Favorite* (1953).

Aida

(1953) :: DIRECTED BY Clemente Fracassi

A film adaptation of Giuseppe Verdi's opera, *Aida* was not an ideal role for Sophia in that she was not a trained singer, nor was she black, but it gave her one of the best breaks of her early career. Dubbed by Renata Tebaldi, whose soprano voice she adored, Sophia mimed and emoted to perfection the words and meaning of Verdi's music. She would later write that "Providing Renata Tebaldi's voice with a body was a special emotion for me, and one that would be hard to repeat."

Each day Sophia would also spend four hours having makeup applied to turn her into an Ethiopian princess in the color film—an effort that was rewarded by stellar reviews for her performance. The *New York Times*'s Bosley Crowther said, "Sophia Loren, the handsome girl who plays the dark-skinned and regal Aida, might just as well be singing the glorious airs that actually come from the throat of Renata Tebaldi and have been synchronized to her lip movements in her scenes. The advantage is that a fine voice is set to a stunning form and face, which is most gratifying (and unusual) in the operatic realm."

Most important to Sophia, with the handsome paycheck received for *Aida*, she was able to buy her sister, Maria, the legitimacy that she craved by having the last name of their father. With money earned for this film, Sophia was able to convince Riccardo Scicolone to give Maria his name.

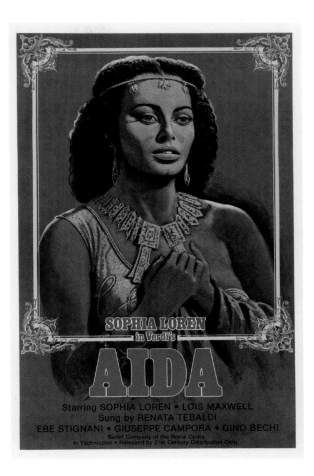

As Aida. Though her voice was dubbed, Sophia took pride in the emotion she was able to give Verdi's lyrics.

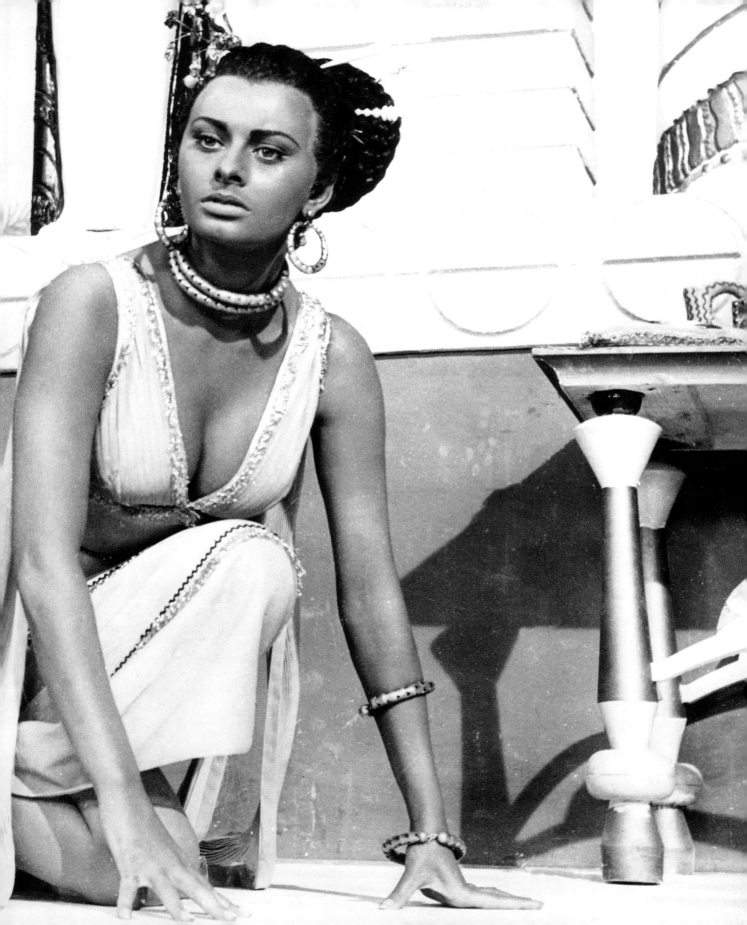

A Day in Court

Un giorno in pretura (1954) :: DIRECTED BY Steno

In this film, which follows a day in court for a judge (played by Peppino De Filippo), Sophia stars as Anna in "The Priest and the Prostitute" segment.

Sophia as Anna in *A Day in Court* (1954).

Poverty and Nobility

Miseria e nobiltà (1954) :: DIRECTED BY Mario Mattoli

Sophia had the chance to work with Totò again in this comedy, this time in a much larger capacity. Though nervous to be acting alongside him, Sophia's childhood idol put her at ease.

The Country of the Campanelli

Il paese dei campanelli (1954) :: DIRECTED BY Jean Boyer

In this fanciful film based on the operetta by Carlo Lombardo and Virgilio Ranzato, Sophia plays Bonbon, one of the beautiful inhabitants of an island village whose world is turned upside down by the unexpected arrival of officers in search of fun away from their wives. But will the enchanted town bells ring on cue, as promised, if an adultery is committed?

The film was not a success. In its review, the Italian paper *Il Giornale d'Italia* said "Not even Sophia Loren's curves and the exceptional number of comedians are enough to create a film that is any better than the mediocre film-variety shows typical of current Italian cinema comedy."

Pilgrim of Love

Pellegrini d'amore (1954) :: DIRECTED BY Andrea Forzano

Two former officers sharing a villa while at a conference fall in love with the portrait of a woman who comes to life in the form of a young dancer (Sophia) introduced to them by their crafty landlord. The girl's resemblance to the vision of beauty in the painting is uncanny, and the men fight, almost to the death, for her attention.

Two Nights with Cleopatra

Due notti con Cleopatra (1954) :: DIRECTED BY Mario Mattoli

Sophia played a dual role in the comedic spin on ancient Egypt. She played both the Queen of the Nile and her lookalike, a peasant girl by the name of Nisca. Filmed in color, the picture was to have starred Gina Lollobrigida, who ultimately stepped away from the production, leaving the door open for Sophia.

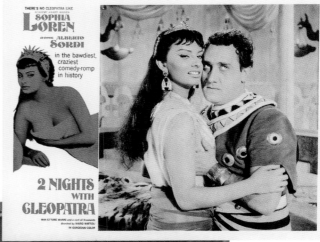

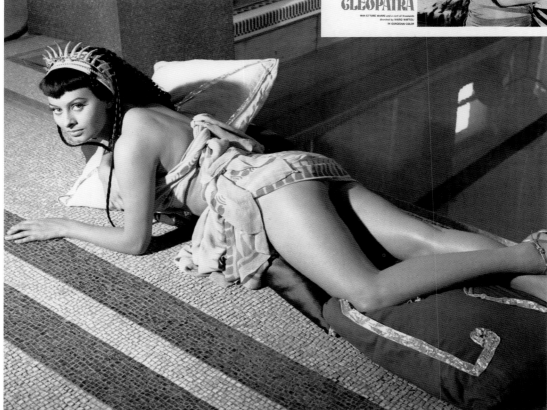

Above: As Cleopatra. **Opposite:** A publicity portrait for *Two Nights with Cleopatra* (1954).

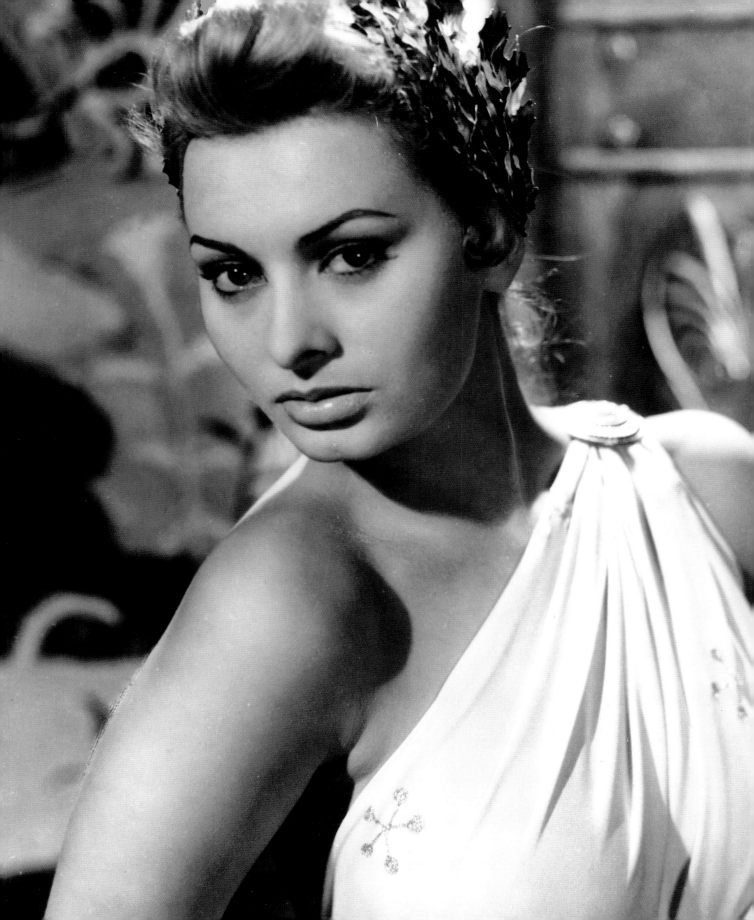

The Anatomy of Love

Tempi nostri (1954) :: DIRECTED BY Alessandro Blasetti and Paul Paviot

Sophia had a wonderful opportunity to act with Totò in this episodic film in the segment titled "The Camera," written by Alessandro Blasetti. The story line for them is slight: After Totò wins a camera, Sophia enthusiastically poses before his lens, only to have him fail in every attempt to take a good shot of his eminently photogenic subject. Where some of the other stories in the film are heavy, Sophia's segment is strictly played for laughs and gave her some shining moments to share on the screen with one of Italy's most beloved comedians. Both in their rapid-fire banter and a steady stream of sight gags, they are a riot, with a twist ending that surely sent audiences laughing all the way home.

Marcello Mastroianni and Vittorio De Sica each appear in separate segments in this well-received film about love and longing in its many different forms.

"There was an instinctive Neapolitan rapport between the two of them."

—Alessandro Blasetti, on Sophia and Totò

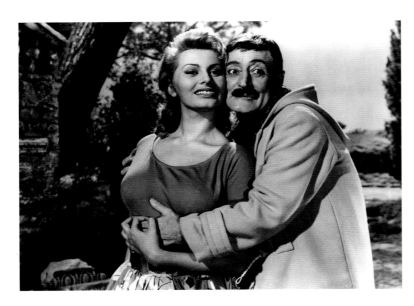

Smile for the camera! That is what Sophia and Totò (one of her real-life idols) do time and time again in their laugh-filled episode of *The Anatomy of Love* (1954).

Neapolitan Carousel

Carosello napoletano (1954) :: DIRECTED BY Ettore Giannini

Sophia makes a cameo appearance in this grand-scale musical, in which she performs (with a dubbed voice) one song.

Neapolitian Carousel was the most lavish song-and-dance film seen on Italian screens since the war, and it opened at the Cannes Film Festival in 1954.

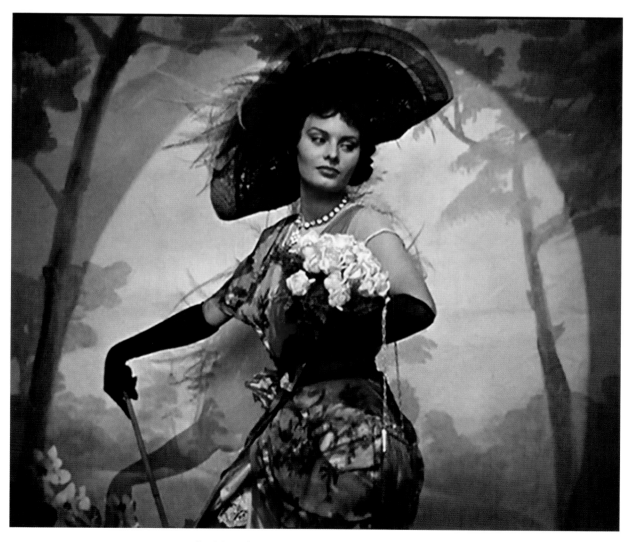

Sophia as Sisina in *Neapolitan Carousel* (1954).

The Gold of Naples

L'oro di Napoli (1954) :: DIRECTED BY Vittorio De Sica

The Gold of Naples was a breakthrough for Sophia in many different ways, first and foremost for being the film that connected her with Vittorio De Sica as director. De Sica and Sophia ran into each other at Cinecittà, and he thought that she would be perfect for the production he was mounting as a celebration of Neapolitan life. To her relief, she would not have to make a screen test, a process that she dreaded and that had never gone well for her up to then.

Based on a series of stories by Giuseppe Marotta, *The Gold of Naples* was another episodic film for Sophia. She starred in "Pizze a credito" ("Pizzas on Credit"), costarring Giacomo Furia. They played a husband and wife who manage a pizza shop, where the vivacious (and flirtatious) Sofia (Sophia) holds court as the most popular pizza maker in town. One day Sofia leaves her ring at the home of a lover. Upon getting it back, Sofia makes a triumphant walk down the street in the rain. With hips swaying and a look of exaltation on her beautiful face, the townspeople cannot take their eyes off of her.

Sophia came down with a case of bronchial pneumonia during production, which she attributed to that walk in the artificial rain, but she recovered quickly, and illness turned out to be a small price to pay for what came of that scene. It remains one of the most memorable moments in cinematic history and catapulted Sophia to international fame (as well as national infamy, when it was deemed too sexy in certain conservative quarters).

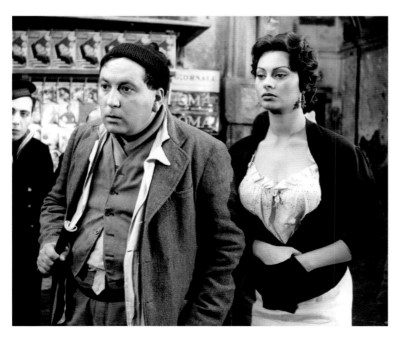

With Giacomo Furia. Sophia had a wonderful time making this celebration of Neapolitan life.

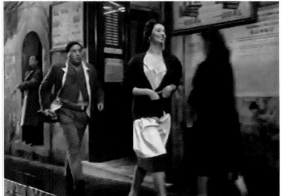

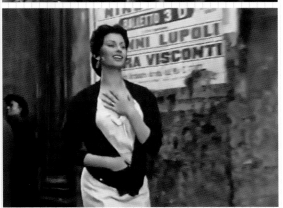

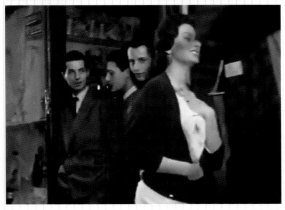

"**[Sophia's] self-congratulating look seemed to say, look at me, I'm all woman and it will be a long time before you see such a woman again. She took a long, unforgettable walk in the rain through the streets of the city, drinking the applause of venal eyes.**"

—*Time* magazine review of *The Gold of Naples* (1954)

Attila

(1954) :: DIRECTED BY Pietro Francisci

Sophia starred as Honoria in this epic historical drama with Anthony Quinn, a star she had admired as a young girl, having watched him and costars Tyrone Power and Rita Hayworth in *Blood and Sand* (1941). Quinn was in Italy also working on the Fellini classic *La Strada*. He and Sophia would reunite in Hollywood a few years later.

In her book, *Living and Loving*, Sophia called this film a "lump of a movie that did neither of us any good."

"**Sophia Loren as the covetous Honoria was a stroke of casting genius.**"

—*Ames Tribune*

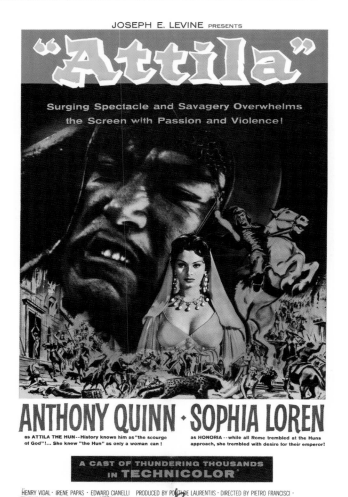

JOSEPH E. LEVINE PRESENTS

"Attila"

Surging Spectacle and Savagery Overwhelms the Screen with Passion and Violence!

ANTHONY QUINN · SOPHIA LOREN

as ATTILA THE HUN—History knows him as "the scourge of God"!... She knew "the Hun" as only a woman can!

as HONORIA—while all Rome trembled at the Huns approach, she trembled with desire for their emperor!

A CAST OF THUNDERING THOUSANDS IN TECHNICOLOR

HENRY VIDAL · IRENE PAPAS · EDWARD CIANELLI PRODUCED BY PONTI-DE LAURENTIIS · DIRECTED BY PIETRO FRANCISCI ·

Opposite: As Honoria in *Attila* (1954).

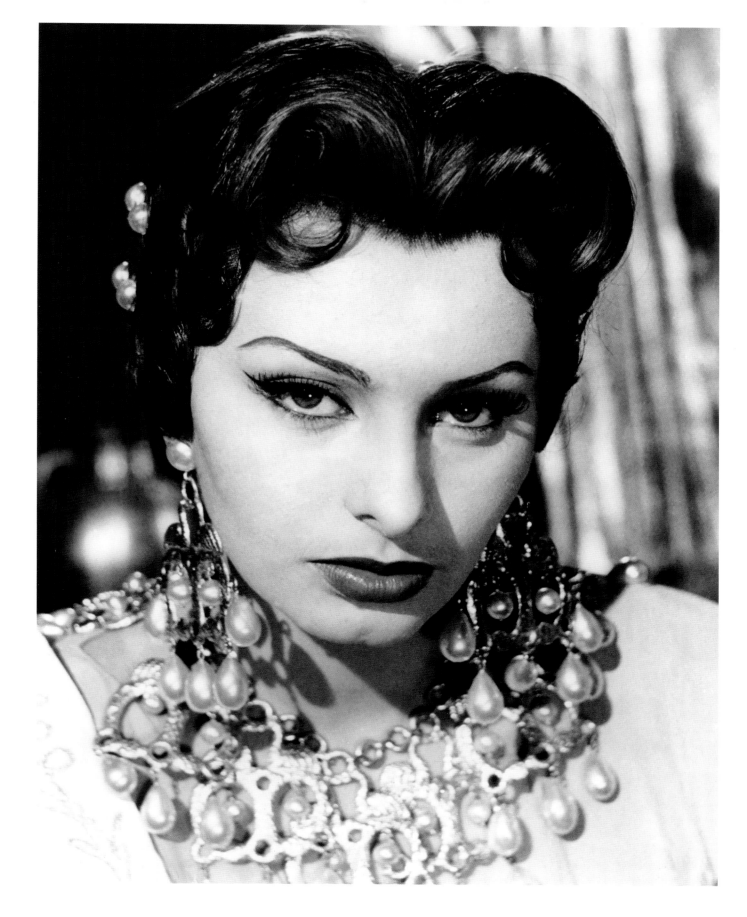

Woman of the River

La donna del fiume (1954) :: DIRECTED BY Mario Soldati

Carlo Ponti developed *Woman of the River* expressly for Sophia. She plays Nives, the beauty of a small village who toils away in an eel-picking factory while avoiding the come-ons of the slick Gino Lodi (Rik Battaglia). Gino is a smuggler keeping just one step ahead of the police, and he eventually wins Nives over. At the first hint of marriage, however, Gino leaves her and does worse yet when he finds out that she is pregnant with his child. The story line reminded Sophia of her mother's own failed romance with her father, which helped infuse her performance with gripping realism. This was a wonderful role for Sophia, which allowed her to express a full spectrum of emotions in the unusual story of an independent young mother who loses her son under a harrowing set of circumstances.

The dramatics of the story began to take a toll on Sophia, who suffered from anxiety and asthma symptoms at night that left her a nervous wreck in the mornings. Director Mario Soldati's intense style was not an ideal match for Sophia, but she found a kindred spirit in producer/screenwriter Basilio Franchina, who personally directed her on the set and became one of Sophia's dearest friends for decades to come. The bouts of anxiety and asthma disappeared as quickly as they had started at the end of the production. The film seemed to be worth the wear on her system. Nineteen-year-old Sophia had immersed herself fully into this dramatic film and the outcome is perhaps the most significant example of her exemplary early work in the Italian film industry.

Woman of the River also brought Sophia and Carlo Ponti closer. At the end of filming he gifted her a diamond ring. While bittersweet that they could not actually be wed at this time, it was a precious symbol of a deep affection and respect that had blossomed into the love of her life.

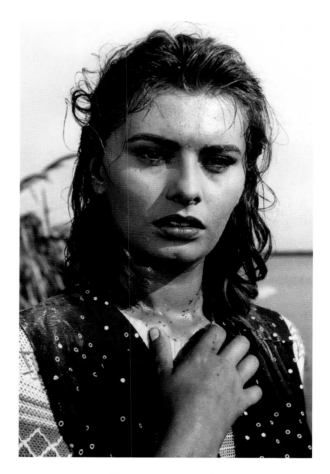

Above and opposite: Nineteen-year-old Sophia in *Woman of the River*, filmed in the summer of 1954.

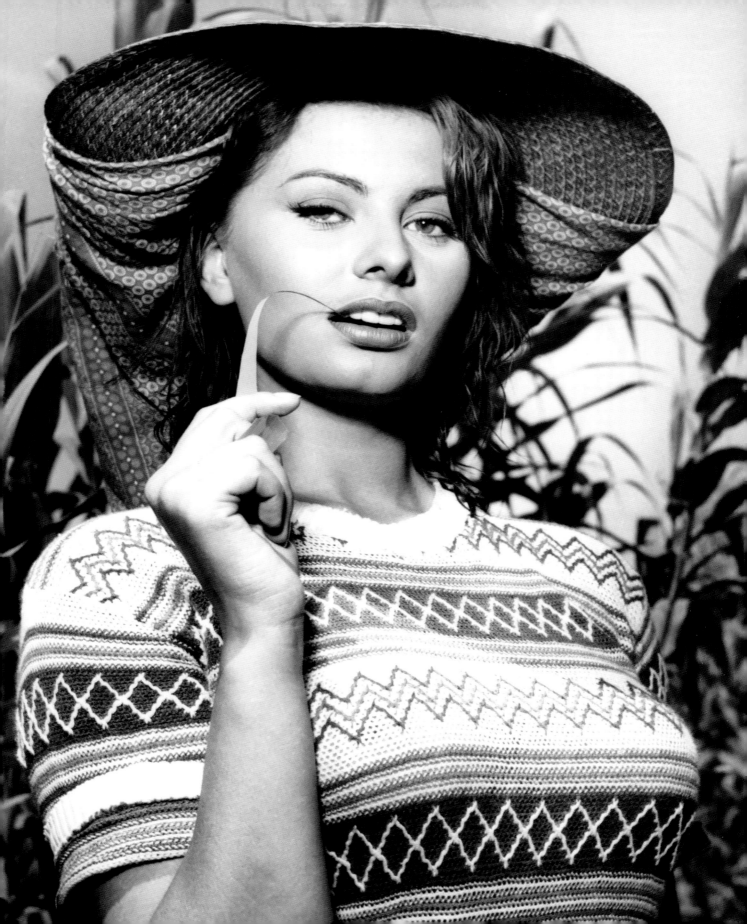

"Everyone who's ever seen a pin-up of Sophia Loren knows she's all female and then some. But what an actress, too!

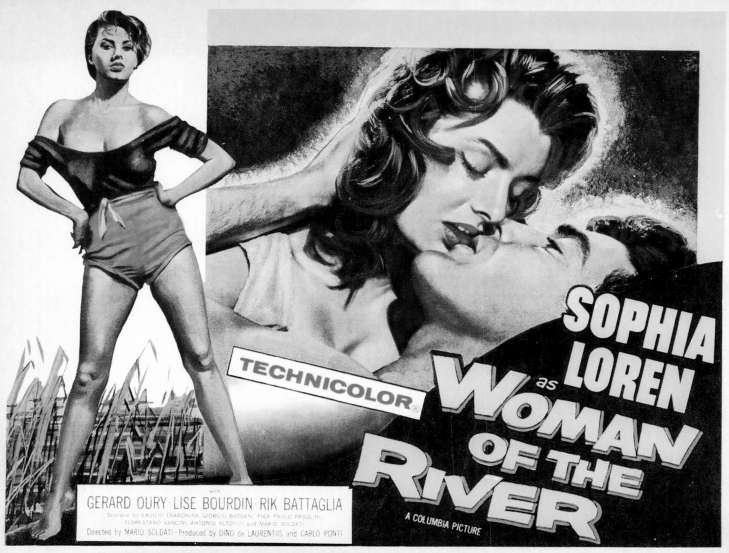

TECHNICOLOR®

SOPHIA LOREN as WOMAN OF THE RIVER

A COLUMBIA PICTURE

with
GERARD OURY · LISE BOURDIN · RIK BATTAGLIA
Scenario by BASILIO FRANCHINA, GIORGIO BASSANI, PIER PAOLO PASOLINI
FLORESTANO VANCINI, ANTONIO ALTOVITI and MARIO SOLDATI
Directed by MARIO SOLDATI · Produced by DINO de LAURENTIIS and CARLO PONTI

That's the surprising thing. And the combination of such an actress and such a woman is pretty terrific."

—*Picturegoer* review of *Woman of the River* (1954)

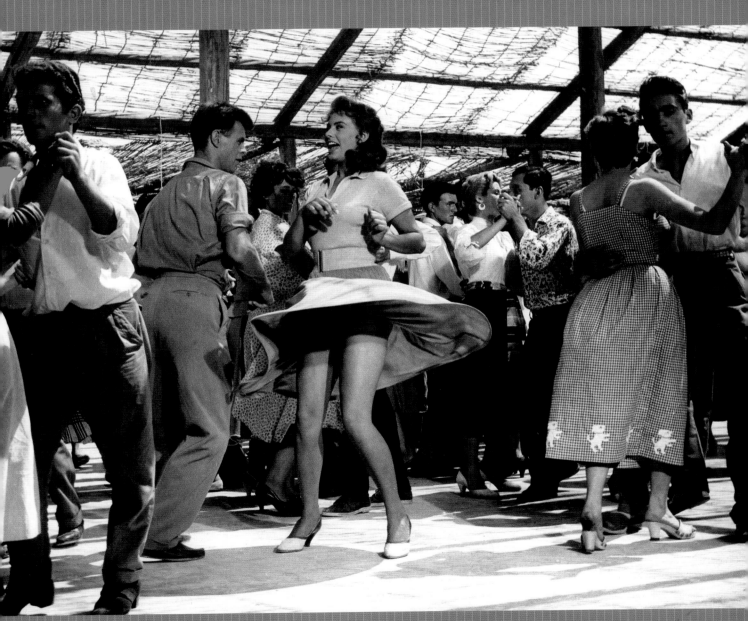

Sophia, as Nives, dances in one of the light moments of *Woman of the River*.

Too Bad She's Bad

Peccato che sia una canaglia (1955) :: DIRECTED BY Alessandro Blasetti

Gina Lollobrigida was originally intended as the female lead in this comic caper, but screenwriter Suso Cecchi D'Amico had other ideas. She had seen Sophia dance a vivacious mambo in *We'll Meet in the Gallery* and thought she would be perfect for *Too Bad She's Bad*. When they met by chance on a train, D'Amico was more convinced than ever about Sophia and recommended her for the role of a lovely but larcenous young lady.

The film is significant for bringing together the dream team of Sophia, Marcello Mastroianni, and Vittorio De Sica on the screen all at the same time. Led through the production by director Alessandro Blasetti, the three stars showed the kind of chemistry

that can only come from having a deep rapport off the screen as well. The three became fast friends. De Sica was a fellow Neapolitan, and though Mastroianni was from "somewhere nearby," the actor nevertheless hit it off with Sophia immediately.

Based on a short story by Alberto Moravia (author of the novel *Two Women*), *Too Bad She's Bad* stars Sophia as the daughter in a family of thieves. Marcello plays a beleaguered victim of their schemes in this enormously fun screwball comedy. Sophia was the standout. Bosley Crowther wrote in the *New York Times*, "forget the subtitles. Forget the story. They're unimportant. Just watch the dame."

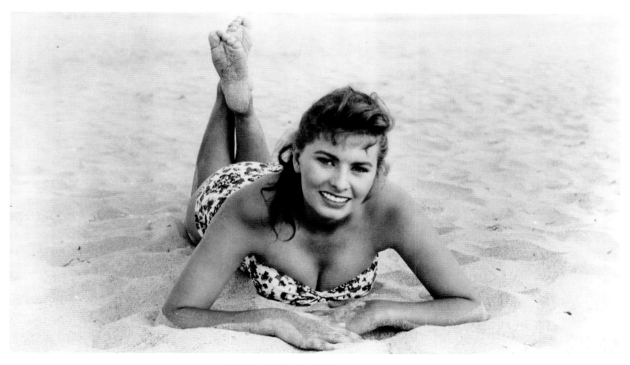

As Lina in *Too Bad She's Bad* (1955).

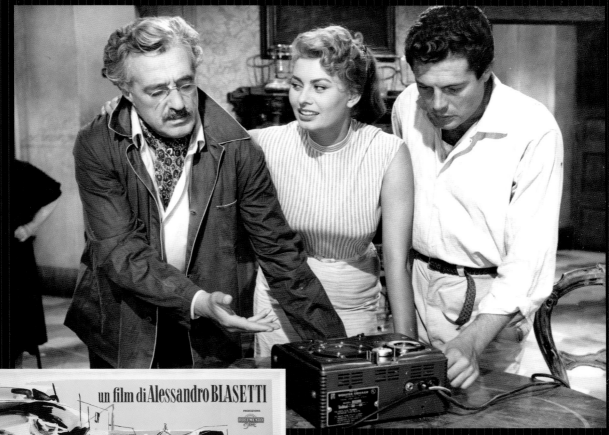

On set with Vittorio De Sica (who played her father) and Marcello Mastroianni.

un film di Alessandro BLASETTI

PRODUZIONE
DOCUMENTO Film

Vittorio DE SICA
Sophia LOREN
Marcello MASTROIANNI

DISTRIBUZIONE
CEI INCOM

Peccato che sia UNA CANAGLIA

The Sign of Venus

Il segno di Venere (1955) :: DIRECTED BY Dino Risi

Sophia plays a magnet for male attention by the name of Agnese, cousin to Cesira (played by Franca Valeri), whose relentless search for love is at turns comic, touching, and heartbreaking. Surrounded by top talent in director Dino Risi, Valeri (who also cowrote the story and became a dear friend), and Vittorio De Sica in the role of a penniless poet, Sophia thoroughly enjoyed the production, and it shows on-screen. She is as bewitching as can be in *The Sign of Venus*.

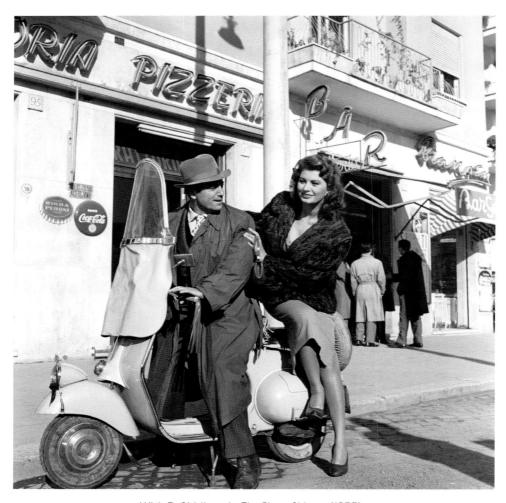

With Raf Vallone in *The Sign of Venus* (1955).

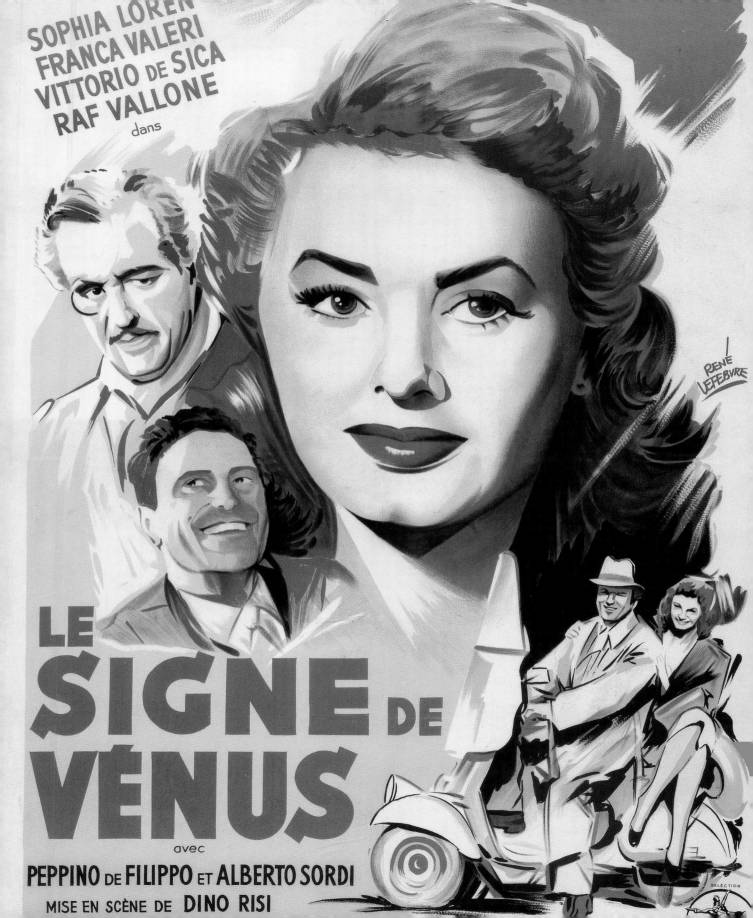

As Carmela in *The Miller's Beautiful Wife* (1955).

The Miller's Beautiful Wife

La bella mugnaia (1955) :: DIRECTED BY Mario Camerini

A period film set in seventeenth-century Naples, Sophia played Carmela, the titular character opposite Marcello Mastroianni as her foolish husband and Vittorio De Sica as a lecherous governor intent on seducing Carmela. The actors fared well, but the story itself (which director Mario Camerini had actually already turned into a film before in 1935) let them down. The *New York Times* surmised, "Mario Camerini's broad direction and all the money in the world cannot save this fatuous buffoonery. All it has is Miss Loren's ample charms." The movie was released in the United States in 1957 and promptly condemned by the Catholic Legion of Decency.

> "**Miss Loren is a monument to her sex, and the mere opportunity to observe her is a privilege not to be dismissed.**"
>
> —Bosley Crowther, *New York Times* review of *The Miller's Beautiful Wife* (1955)

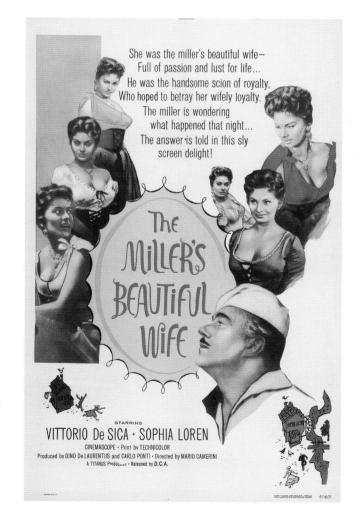

She was the miller's beautiful wife—
Full of passion and lust for life...
He was the handsome scion of royalty,
Who hoped to betray her wifely loyalty.
The miller is wondering
what happened that night...
The answer is told in this sly
screen delight!

The MiLLER'S BEAUTIFUL WiFE

STARRING
VITTORIO De SICA · SOPHIA LOREN
CINEMASCOPE · Print by TECHNICOLOR
Produced by DINO De LAURENTIIS and CARLO PONTI · Directed by MARIO CAMERINI
A TITANUS Production · Released by D.C.A.

Scandal in Sorrento

Pane, amore e . . . (1955) :: DIRECTED BY Dino Risi

Scandal in Sorrento was the third installment of a series of black comedies titled *Bread, Love and. . . .* The first two, *Bread, Love and Dreams* (1953) and *Bread, Love and Jealousy* (1954) had been huge hits in their day starring Vittorio De Sica and Gina Lollobrigida. When Lollobrigida bowed out and Sophia was announced to replace her, it added fuel to the fire of the trumped-up rivalry between the two most famous buxom beauties of Italian cinema. Sophia stayed above the fray and was thrilled to

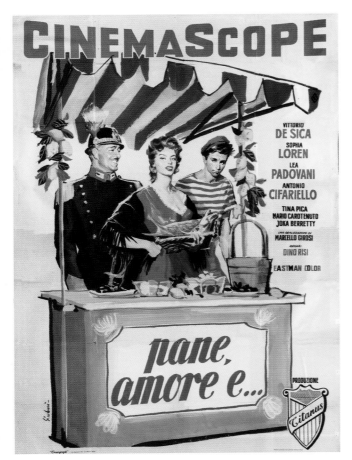

work on *Scandal in Sorrento* with Vittorio De Sica, under the leadership of *The Sign of Venus* director Dino Risi. She plays Sofia, a fishmonger known as *la Smargiassa*—the Show-off—a spitfire who has taken over the home of the roguish Marshal Antonio Carotenuto (Vittorio De Sica—in a role that earned him the David di Donatello Award for Best Actor).

Most delightful is an improvised scene in which Sophia dances an alluring mambo for De Sica. Sophia called the production "once again an explosion of happiness and vitality." In years to come De Sica would prove time after time that he brought out the best in Sophia as a director, but he seemed to do the same for her when appearing with her in front of the cameras.

In his autobiography, Dino Risi recalled, "I have had a special liking for Sophia. I remember we used to call her Miss Anticamera for the long hours she would spend, patiently, in front of the Ponti-De Laurentiis studios in Rome, hoping for a small role. Even at that time, she was natural and had a princess look." Through her own fortitude and support from people like Risi, De Sica, and Ponti, she had made it in Italy by 1955. The rest of the world lay ahead.

Opposite: Playing a fishmonger in *Scandal in Sorrento* (1955).

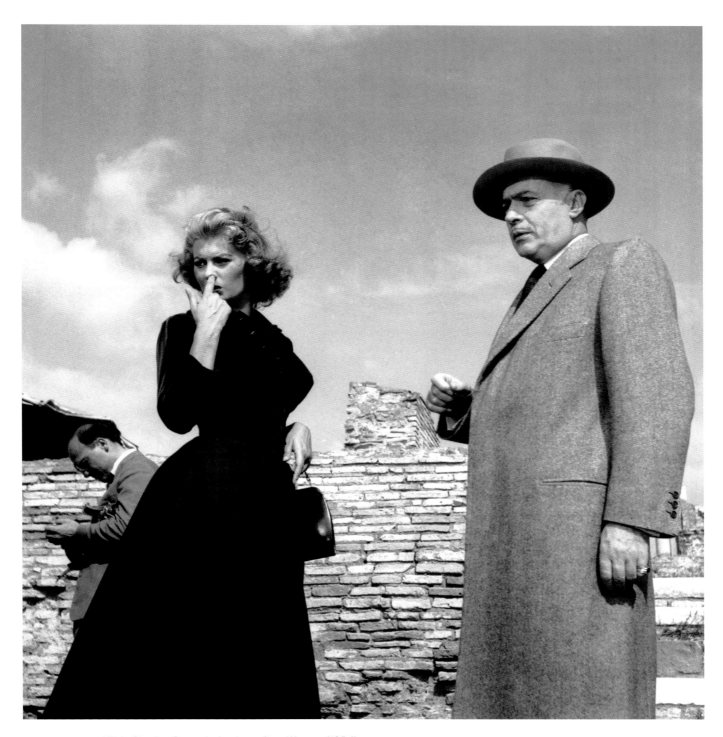

Above: With Charles Boyer in *Lucky to Be a Woman* (1956).

Opposite: With Marcello Mastroianni. Sophia had fun playing with her look in this period. She later recalled, "I dyed my hair nearly every other day. . . . Fortunately the film was in black and white, and I don't think anyone noticed!"

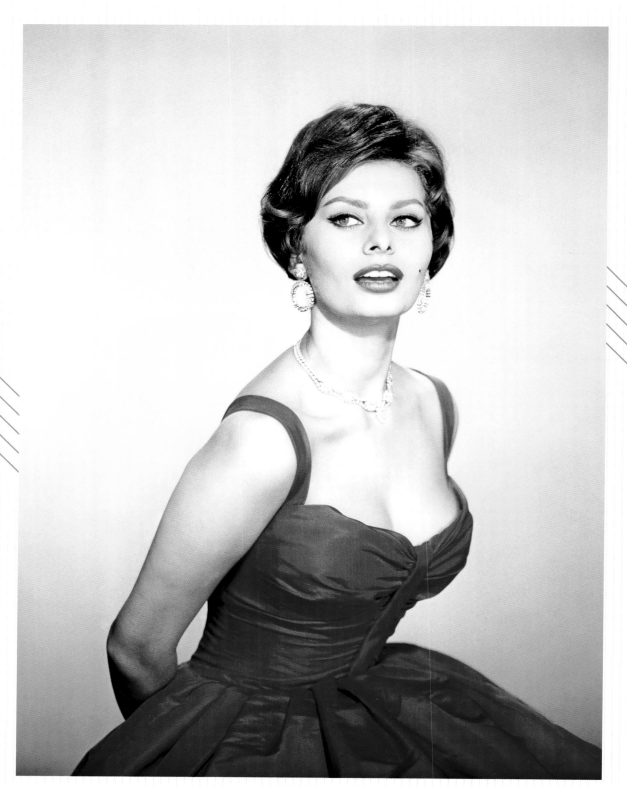

Sophia, 1957.

Hollywood Calling

With the impact Sophia was making in Italian films, it was not long before the movie capital of the world took notice. Sophia and Carlo Ponti entered into a deal in which he would produce a series of films released by Paramount Pictures and starring Sophia. She stood out among a sea of buxom blonde Marilyn Monroe clones in Hollywood, and she had the talent behind her stunning looks to validate all of the attention she received. Sophia was an instant sensation in Hollywood, even if the town made her feel like a fish out of water.

The Pride and the Passion

(1957) :: DIRECTED BY Stanley Kramer

As Sophia's stardom grew, Carlo Ponti kept his eye out for the ideal opportunity to break her out beyond Italian films and onto the world stage. When he got wind of the news that producer Stanley Kramer was looking for a female lead for his epic mounting of *The Pride and the Passion*, Ponti saw their chance. He had already hired an instructor who had been working tirelessly with Sophia on the actress's English, and Carlo knew she was ready to take on an important role in a Hollywood-backed production. After screening *Woman of the River* for Kramer, the director made Ponti an offer for Sophia's services on the spot. Ponti hesitated only momentarily before enthusiastically accepting.

Sophia plays the part of a young peasant girl in nineteenth-century Spain torn between her devotion to the leader of the people's cause and a growing love for a British officer. The two leading men in this love triangle during the Napoleonic wars were Frank Sinatra as the Spanish rebel and Cary Grant as the British soldier. Both actors feel woefully miscast, but Sophia looks authentic in the Spanish setting, and her flamenco routine in the middle of the film is a highlight—the most frequently referenced and arguably the most memorable scene from the film. No spoken lines—in the language she was still struggling to learn—were necessary as Sophia expressed her inner passion through dance.

Left: On the set in Spain.

Opposite: As Juana in *The Pride and the Passion* (1957).

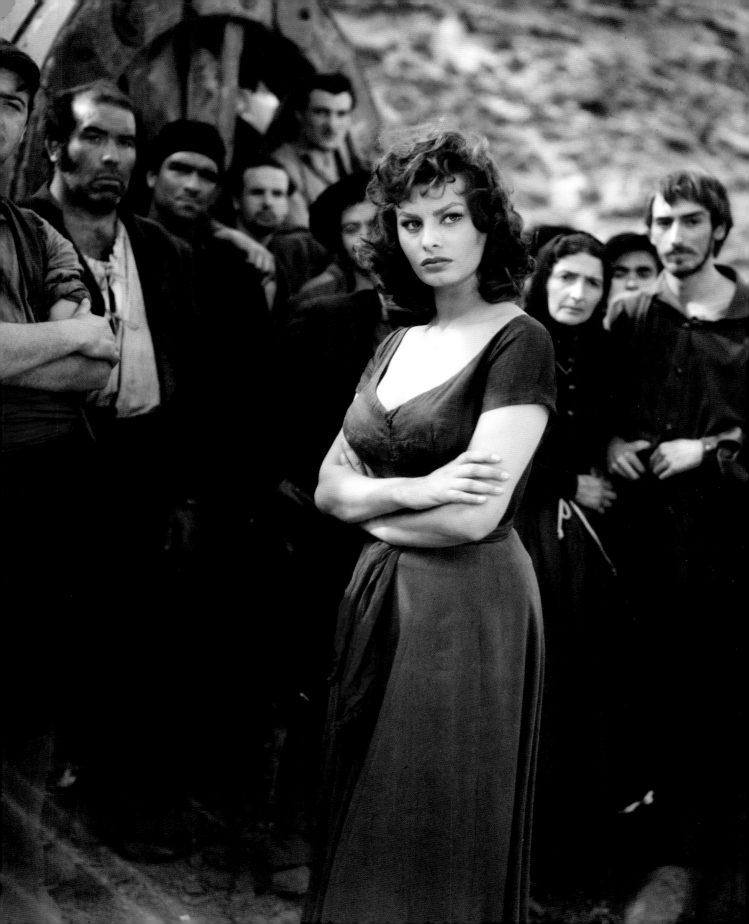

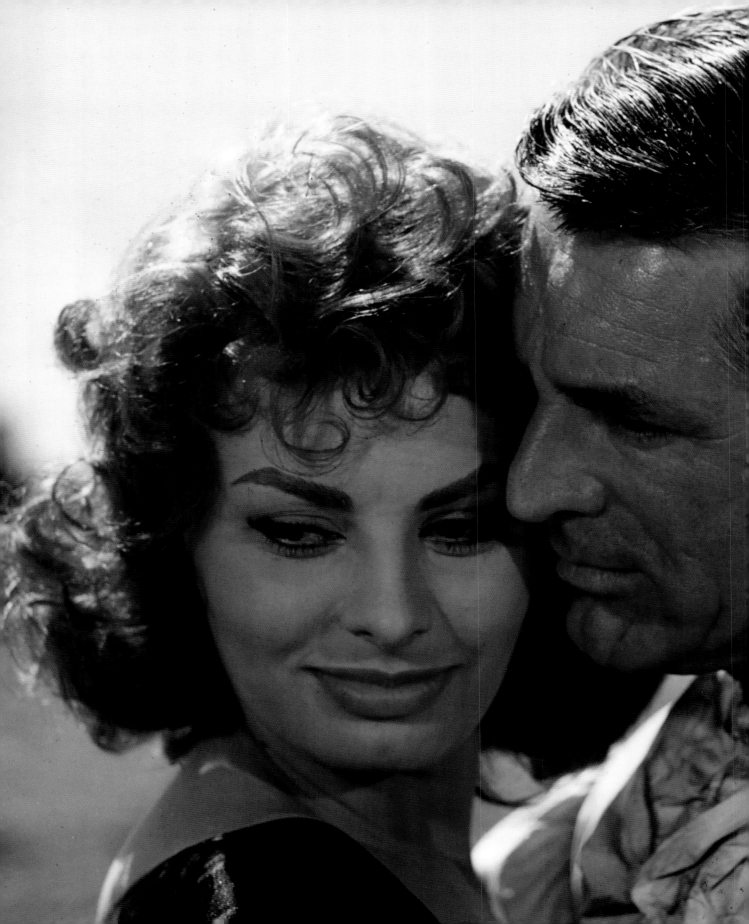

Cary Grant teased Sophia about her supposed feud with fellow Italian screen queen Gina Lollobrigida when they were first introduced. Sophia was at first irked by his joke, but then could not resist laughing. They remained devoted to each other from that moment on.

Sophia was nervous to be working with such illustrious leading men—in her shaky English—but the two veteran actors put her at ease. Sinatra joked with her, and Grant opened up to her as a friend. Their relationship quickly deepened to a romance, with Grant deeply in love by the end of the production, but Sophia's heart was truly with Carlo Ponti, and the interlude with Grant served to strengthen their resolve to find a way to legitimize their relationship through marriage. In spite of his heartbreak, Sophia and Grant remained dear friends for the rest of his life.

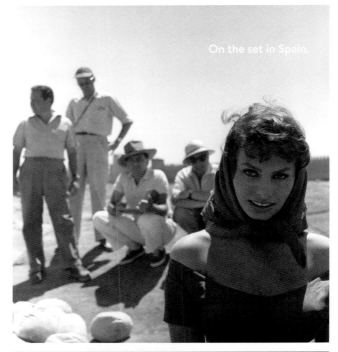

On the set in Spain.

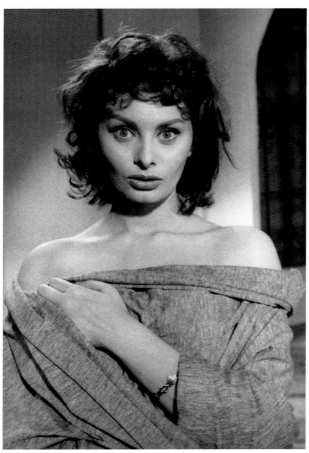

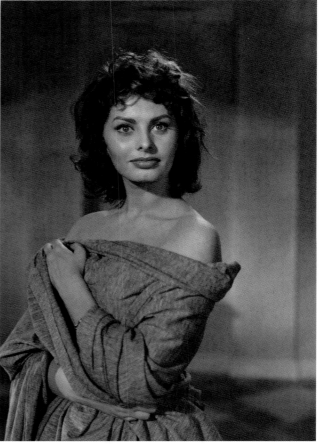

Test shots of Sophia as Juana.

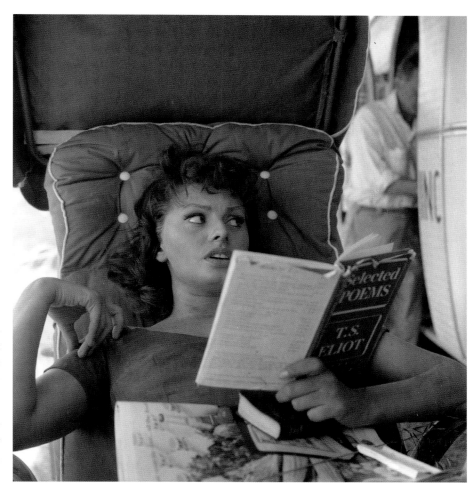

Right: Director Stanley Kramer's wife, Anne, gave Sophia a book of poems by T. S. Eliot. She found that reading the book aloud helped improve her English.

Below: Sophia danced a passionate flamenco in the film. She actually stomped on her own foot during filming and broke a toe.

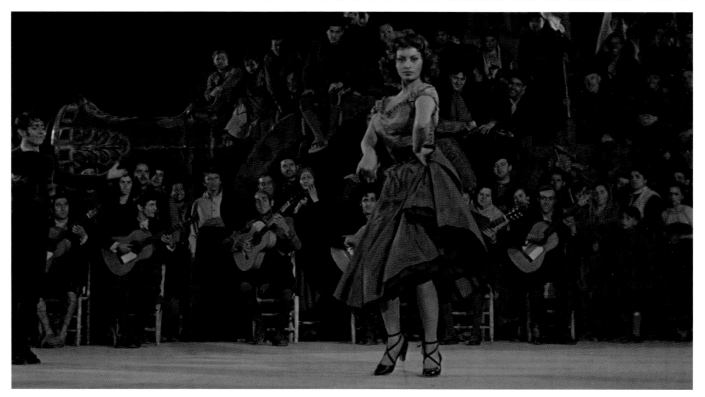

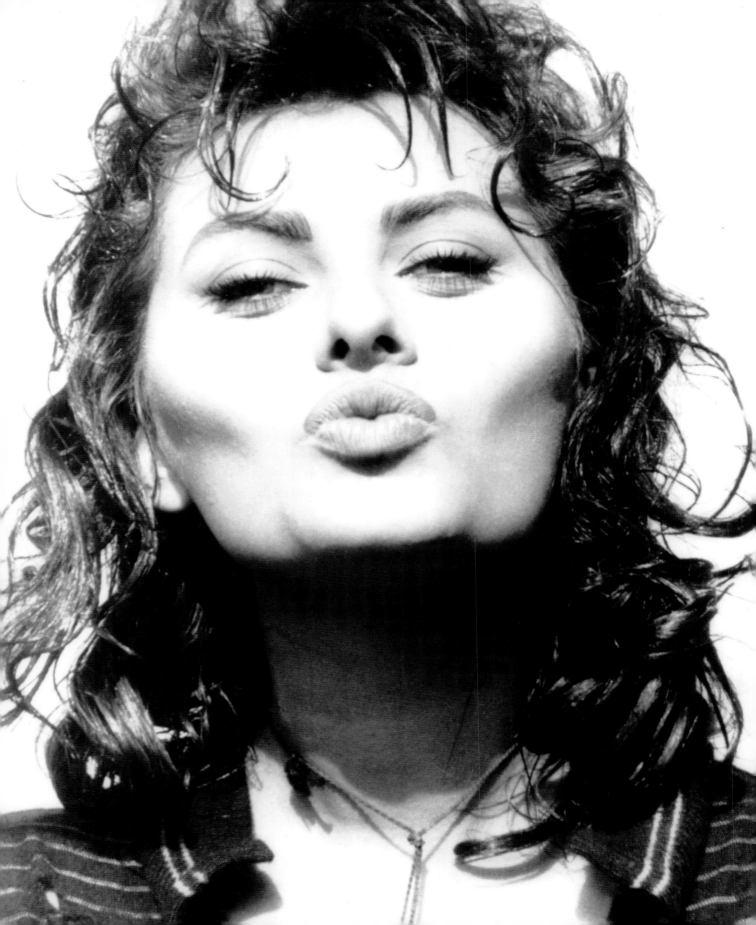

Boy on a Dolphin

(1957) :: DIRECTED BY Jean Negulesco

Hollywood studios were looking to far-off lands for film settings in the mid-1950s, granting American audiences who were glued to the very American-centric shows on their television sets a taste of some of the world's most luscious sights. Sophia, of course, fit this trend perfectly, and the vision of her coming up out of the water to climb aboard a boat, her shapely figure hugged by wet clothing, is the scene for which *Boy on a Dolphin* is best remembered. This movie made it to theaters before *The Pride and the Passion*, so this was technically Sophia's big introduction to American moviegoers.

But Sophia is not the only sight to behold in the film. The star's splendor plays out against a beautiful Grecian backdrop, filmed by director Jean Negulesco, who had recently brought the magic of Rome to the screen so adroitly in *Three Coins in the Fountain* (1954). His was the first American production team to shoot in Greece, and with its stunning Technicolor photography, the gamble paid off.

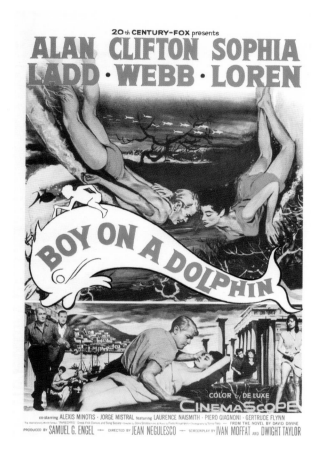

"It is not a boy who rides high, wide and handsome in *Boy on a Dolphin*, but a girl—Sophia Loren."

—Philip K. Scheuer, the *Los Angeles Times*

Opposite: Sophia in makeup as Phaedra. She enjoyed filming on location in Greece.

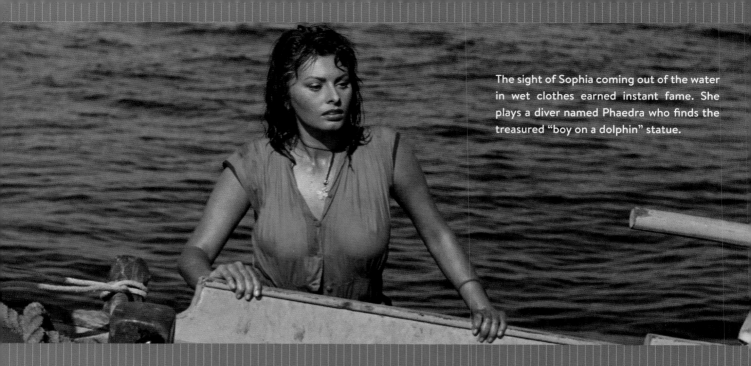

The sight of Sophia coming out of the water in wet clothes earned instant fame. She plays a diver named Phaedra who finds the treasured "boy on a dolphin" statue.

"[Sophia] has, without a doubt, the most extraordinary talent I have ever met."

—Jean Negulesco

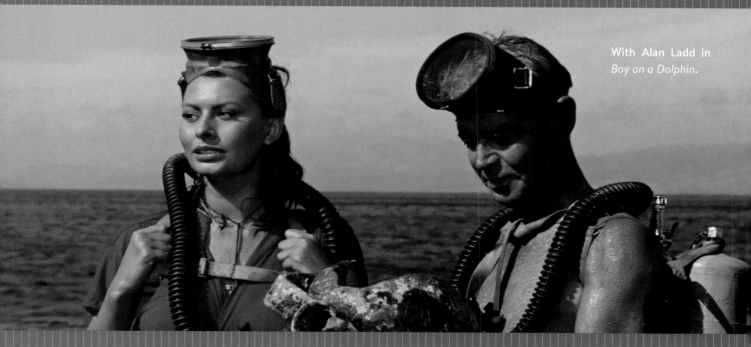

With Alan Ladd in *Boy on a Dolphin*.

Legend of the Lost

(1957) :: DIRECTED BY Henry Hathaway

Legend of the Lost took the now globe-trotting Sophia to the Libyan Sahara Desert for the tale of three wanderers in search of treasure in the "lost" city of Ophir. Her love interests were played by Rosanno Brazzi, with whom she becomes immediately enamored for seeing beyond her shady past, and John Wayne as a ne'er do well whose authenticity puts him head and shoulders above other men.

Sophia got along famously with Wayne, and this, her third Hollywood production, might have been her last if not for Brazzi, whom she credits with saving her life. Alone and asleep in her room one night during filming, the gas stove installed to keep her warm on cold desert nights slowly filled her small quarters with carbon monoxide. She awoke with a pounding headache and just made it to the door before collapsing. Brazzi appeared a short time later, returning to his own room, spotted Sophia, and promptly called for help. Other hardships of blazing hot days, scorpions, and sandstorms paled in comparison to the scare of that terrible night.

Filming in the Sahara Desert had both its drawbacks and benefits. The location was exquisitely filmed in color. Sophia looks beautiful as well, if misplaced. One can see why her character, Dita, has so much difficultly navigating the harsh terrain—she walks through most of the film in the same dress with supercinched waist.

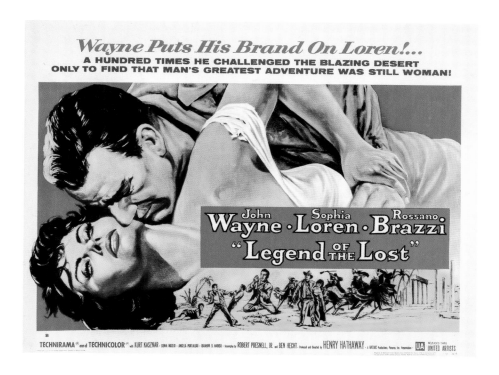

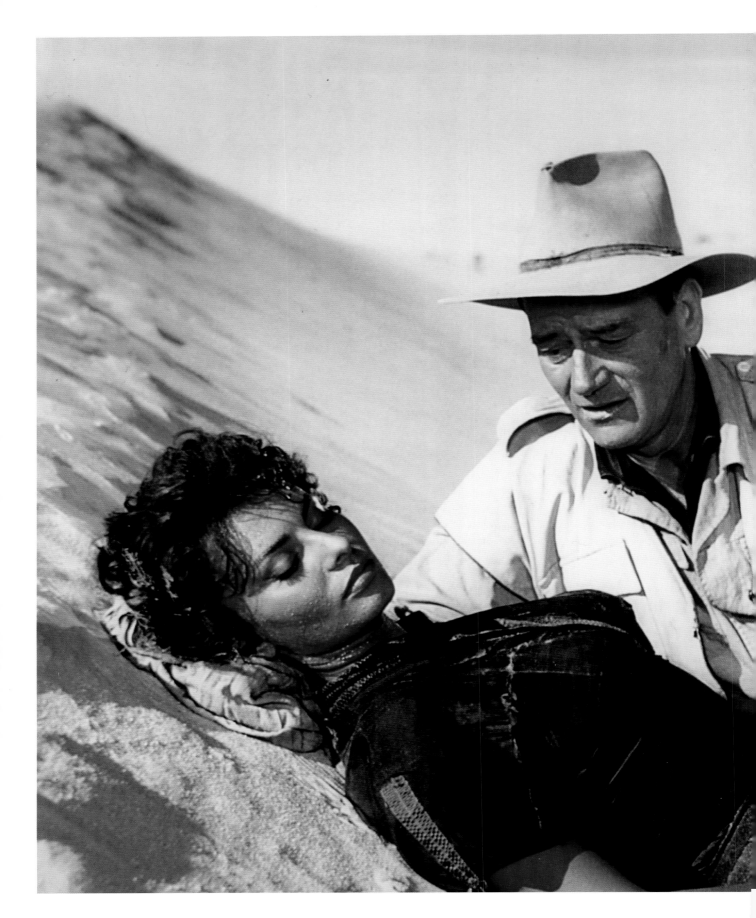

"She was a good actress—and she has the most expressive eyes I've ever seen."

—John Wayne

With John Wayne in *Legend of the Lost*, filmed in Libya.

Desire Under the Elms

(1958) :: DIRECTED BY Delbert Mann

This was Sophia's first film after taking up residence in Los Angeles and her first shot exclusively on a Hollywood soundstage. Based on a 1924 play by Eugene O'Neill, the film adaptation retained a certain stage-bound quality, but it was beautifully lit and photographed, earning cinematographer Daniel Fapp an Academy Award nomination.

The story is utterly melodramatic in true O'Neill fashion. Eben Cabot (Anthony Perkins) and his two half-brothers despise their father (Burl Ives), who makes them slave away on a New England farm with only menace and resentment as fuel and no assurance that they will inherit the land they've worked since birth. Suddenly, father Cabot turns up a beautiful, wily Italian bride (Sophia) intent on claiming the land for herself. Matters come to a head when Eben impregnates his father's bride and they attempt to hide the affair while simultaneously trying to prove their devotion to each other rather than to the claim over the Cabot land.

The material certainly gave Sophia a great deal to work with, and she played her role of the cunning seductress for all its worth opposite a disturbingly calm yet portentous, soon-to-be-*Psycho* Anthony Perkins.

In its review, *Variety* was kind to Sophia, saying she "manages the scenes of tenderness with special value," but otherwise was not impressed. "It is painfully slow in getting underway, the characters are never completely understandable or believable, and the ghastly plot climax (of infanticide) plays with disappointingly little force."

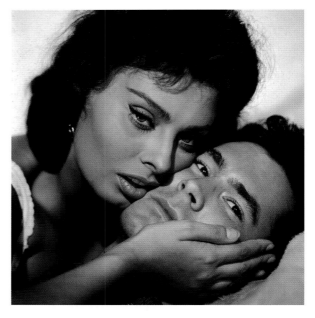

Above: With Anthony Perkins in *Desire Under the Elms* (1958).

Below: With Burl Ives, the much older husband who uses his young bride as a pawn to threaten his sons' ownership of the land on which they live and work.

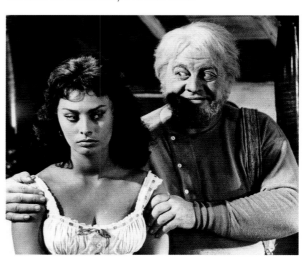

Houseboat

(1958) :: DIRECTED BY Melville Shavelson

Houseboat offers a glimpse of what might have been if Sophia had chosen Cary Grant over Carlo Ponti after they entered a short-lived but deep romance during the making of *The Pride and the Passion*. Grant was still in love with Sophia, but she was sure at that point that Ponti was the right man for her. On-screen in *Houseboat*, the story ends with a marriage between Sophia and Cary. The scene was filmed the day after her marriage to Ponti was announced: they had just been wed by proxy in a Mexican court.

While in retrospect that history gives the film a wistful quality, *Houseboat* is a delight from start to finish. Sophia plays Cinzia Zaccardi, a spirited Italian socialite looking for an escape from the confines of her cloistered world. She finds it by playing nanny to the three young children of widower Tom Winters (Grant), who lives in a rather rigid world himself while trying to figure out how to be a single parent. With Cinzia's lively company, both Tom and the kids rediscover their own *joie de vivre*.

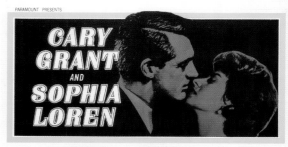

"A spirited Sophia Loren occasionally breaking into song and dance, seems more at home than in any of her previous American films."

—Peter John Dyer, *Monthly Film Bulletin* review of *Houseboat* (1958)

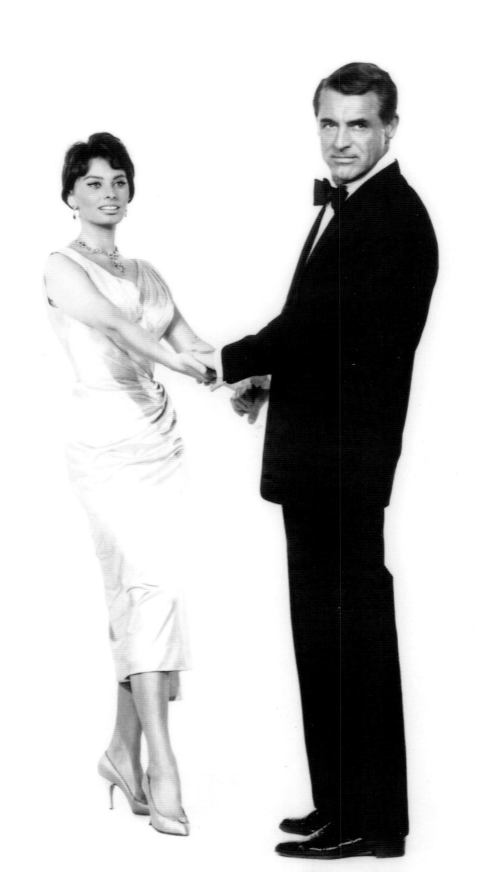

The Key

(1958) :: DIRECTED BY Carol Reed

Sophia plays Stella, the World War II–era tenant of a flat in London shared with a succession of soldiers who operate treacherous salvage missions off the nearby port. Each man is given a key to her apartment and takes care of war widow Stella. Captain David Ross (William Holden) is the latest and most dear to Stella's heart.

Stella was a nuanced and emotional role for Sophia that she looked forward to taking on under the direction of Carol Reed, but when she arrived in London for filming, she discovered Reed had really wanted Ingrid Bergman for the part. As production got underway, Sophia quickly proved herself, and while the movie opened to mixed reviews, Sophia was widely praised as rising above the script (which departed so heavily from the Jan de Hartog novel upon which it was based that it left a good deal of character development to be desired).

Two endings were shot for *The Key*—one in which she and Holden end up together and one in which they do not. The happy ending went out to American audiences, while the alternate was deemed acceptable for tastes around the rest of the world.

> **"With this key I thee wed."**
>
> —Tagline for
> *The Key* (1958)

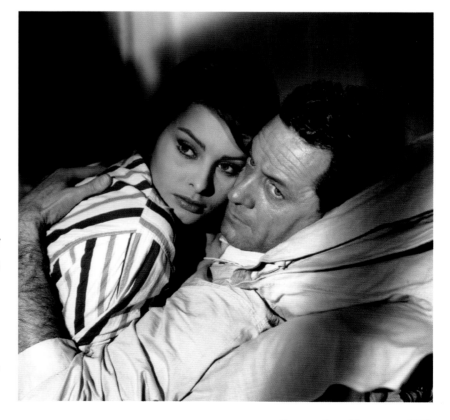

Opposite: As Stella in *The Key* (1958).

Right: With William Holden.

A Breath of Scandal

(1960) :: DIRECTED BY Michael Curtiz

This fable about Princess Olympia of Austria was loosely based on the Ferenc Molnár play *Olympia*. The play had been adapted for the screen once before, as *His Glorious Night*, starring John Gilbert and Catherine Dale Owen. Carlo Ponti and his business partner, Marcello Girosi, produced *A Breath of Scandal* for Paramount, and the studio spent lavishly on the production, which was shot on location in Austria. In Italy the film was known by the same title as the play from which it was derived, *Olympia*.

Sophia portrays a high-spirited princess. After feigning a riding accident to gain the attention of a handsome American named Charlie (John Gavin), she ends up spending the night with him in a hunting lodge. It's an innocent night in which Charlie attempts to nurse Olympia back to health (unaware that she is a princess). So begins the "scandal" of the film's title. From there on, Maurice Chevalier makes an appearance as a rakish count and Angela Lansbury appears as a countess and rival to Olympia who is happy to see the princess's name besmirched.

"You'll Find Yourself in a Whirlpool of Wine, Women and Wonderful Fun!"

—Tagline for *A Breath of Scandal*

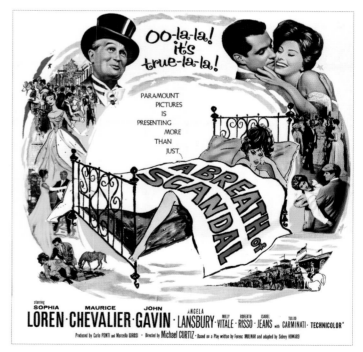

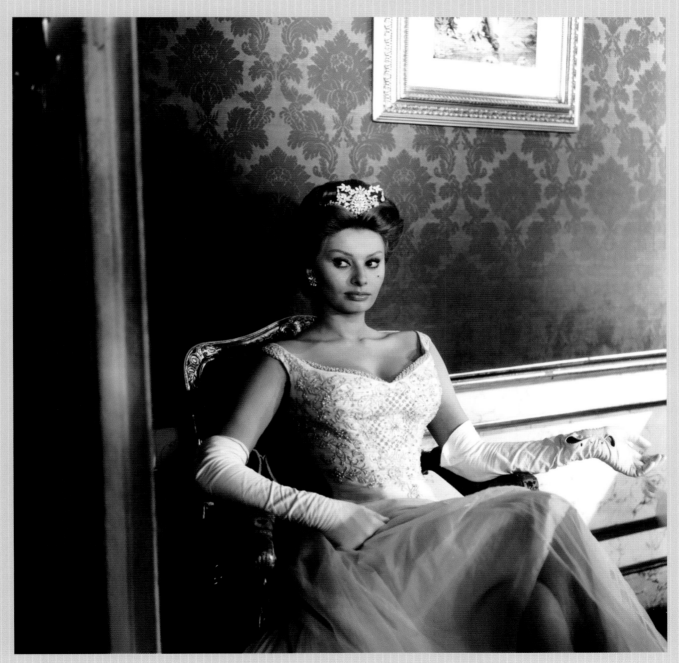

Sophia as Princess Olympia in *A Breath of Scandal* (1960).

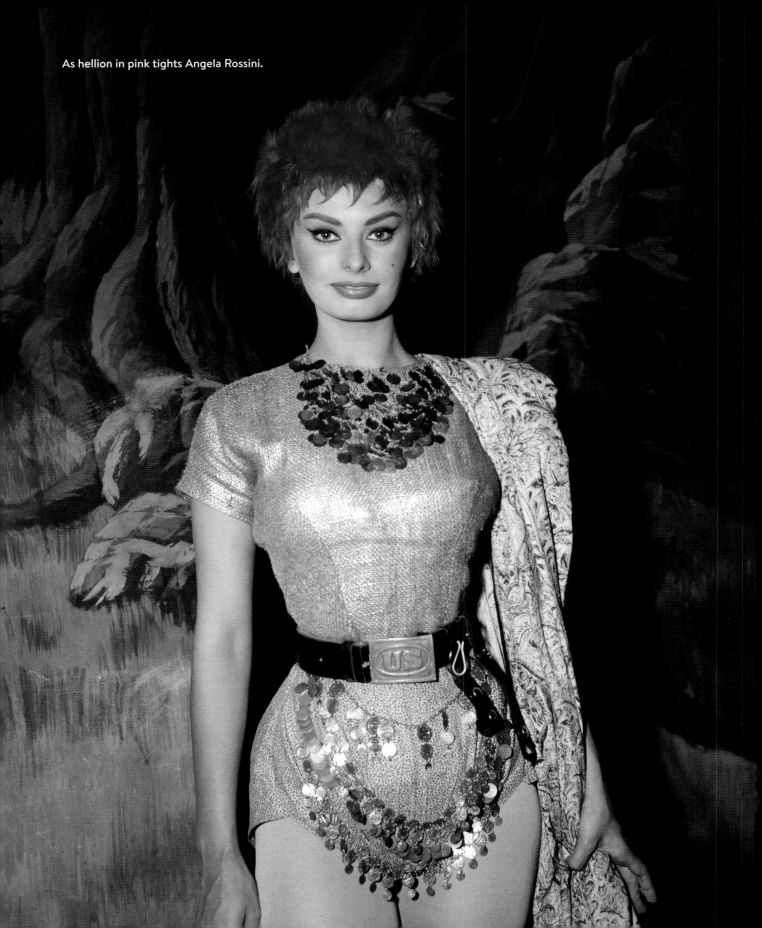

As hellion in pink tights Angela Rossini.

Heller in Pink Tights

(1960) :: DIRECTED BY George Cukor

Tom Healy (Anthony Quinn) leads a frontier theatrical troupe crossing the American plains of the Wild West in a covered wagon. His star (and frequent cause of their frequent dramas) is Angela Rossini (Sophia), who performs her showstopping routines in pink tights and keeps the troupe on their toes.

Screenwriters Dudley Nichols and Walter Bernstein's story of this hellion in pink tights was loosely inspired by frontier-era star Adah Isaacs Menken, famous for her apparently nude performance astride a horse in the play *Mazeppa*. Sophia

was superb in the lively role. The *New York Times* remarked, "Miss Loren is remarkably appealing, as warm and natural as she has been in anything since that little pizza item in *The Gold of Naples*."

This became one of Sophia's favorite films in spite of the fact that she did not at first take to George Cukor's directing style, in which he'd perform the scenes himself, then ask her to repeat what he had done rather than encouraging her to follow her own acting instincts. However, she would later say that once she saw the finished film she thought, "He was right. He did a good job with me."

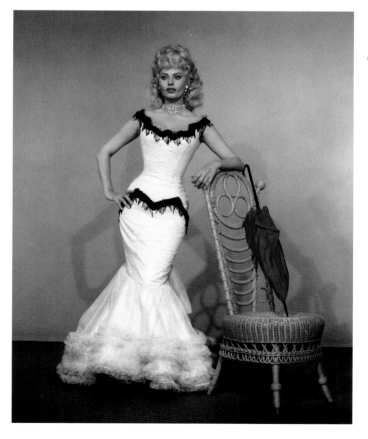

“I thought Sophia Loren very good, light and humorous. She's really adorable.”

—George Cukor

Sophia was at her thinnest in *Heller in Pink Tights* (1960), but still had the curves to fill out her period costumes. Corsets tied her waist down to eighteen inches.

The Millionairess

(1960) :: DIRECTED BY Anthony Asquith

In one of her best American films, Sophia stars as Epifania, the beautiful but spoiled daughter of a recently deceased Italian tycoon. Domestic bliss has eluded the heiress, but she is hopeful that a condition imposed by her late father will help her find the right man: he must be able to take £500 and quickly turn it into £15,000. Epifania finds herself quite unexpectedly drawn to Dr. Kabir (Peter Sellers), an Indian doctor who is poor but rich in the spirit of helping others. His late mother, too, has imposed a challenge for her son's future wife: she must be able to live on a meager stipend and just the clothes on her back and be happy. Are either Epifania or Dr. Kabir up to the challenge?

The resulting plot affords many opportunities for comic brilliance not just from the celebrated comedian Peter Sellers but from Sophia as well. She benefitted from a strong script by Wolf Mankowitz based on George Bernard Shaw's play of the same name, stellar support from Sellers (and Vittorio De Sica in a small but very funny role), and director Anthony Asquith. She later said "Tony is the essence of a refined man: articulate, well-educated and always gentle and considerate, he was a pleasure to work with."

Sophia also loved working with Sellers and later called him one of her favorite costars—certainly the funniest. They made an exceptional team and it is unfortunate that they were never paired again. However, their collaboration is commemorated not only by this hit film but also by a pop song: in a promotional effort for *The Millionairess*, they recorded the song "Goodness Gracious Me!" which became a hit worldwide.

Another highlight of *The Millionairess* is Sophia's wardrobe, all of it by Balmain. The succession of hats is particularly exquisite.

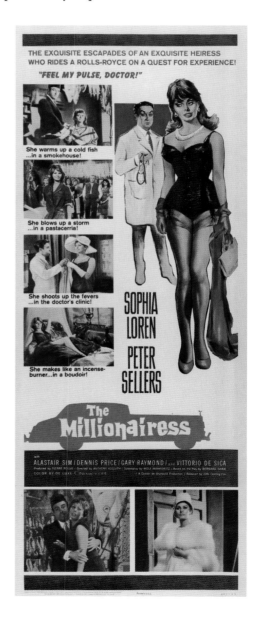

> "The racy revelations of the richest girl in the world . . . and her wild, wonderful ways!"
>
> —Tagline for *The Millionairess* (1960)

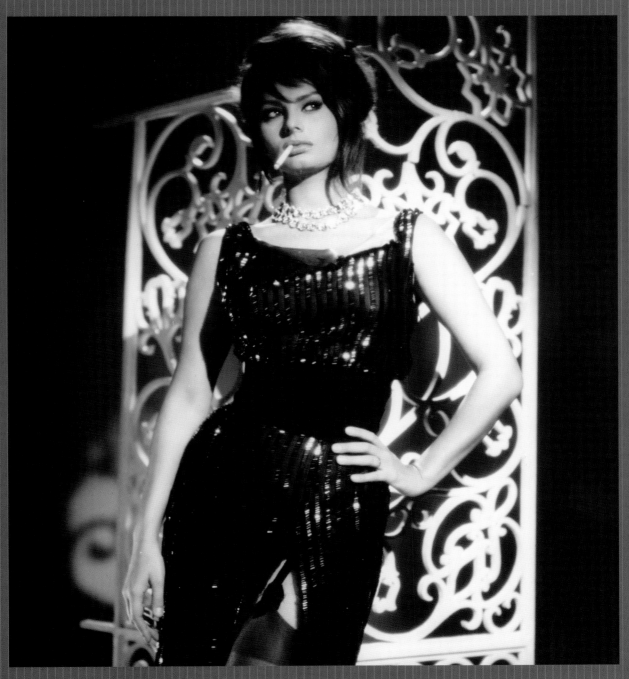

Sophia's Epifania is a true character. After being disappointed by the one man she cared for selflessly, she decides she would prefer to retire from a world shared with the male sex and open a haven where other women can do likewise.

It Started in Naples

(1960) :: DIRECTED BY Melville Shavelson

Clark Gable, the movie giant whom Sophia had long admired in classics like *Gone with the Wind* (1939), costarred in *It Started in Naples*, a film about a straight-laced Philadelphia lawyer who travels to Naples to settle his late brother's affairs, only to fall in love with the irresistible Neapolitan (Sophia) who is foster-mothering his nephew.

Sophia found Gable as charming as the Rhett Butler of her childhood dreams but thought he felt out of place in Italy, much like the staid character he portrays in the movie. The thirty-three-year difference in their ages is evident, and Sophia runs away with this picture with her engaging performance of a surrogate mother by day, nightclub entertainer by night. Besides a sizzling rendition of "Tu vuò fà l'Americano," some of Sophia's best scenes are played out between her and the boy who plays her street urchin nephew, an enchanting young Italian actor simply known as Marietto.

Sophia and Carlo Ponti wrapped their contract with Paramount Pictures with this film that took them home again. Though Sophia had been back to Italy briefly to accept an award for *The Black Orchid* at the International Film Festival in Venice, this was the first time the couple had been back together since being vilified by the press and accused by the courts about the legality of their Mexican marriage by proxy. Many of Sophia's best films lay ahead of her on her homeland. Sophia was about to embark on a new, hugely successful phase of her career.

"Gable and Loren are a surprisingly effective and compatible comedy pair. The latter, more voluptuous than ever, is naturally at home in her native surroundings and gives a vigorous and amusing performance."

—*Variety* review of *It Started in Naples* (1960)

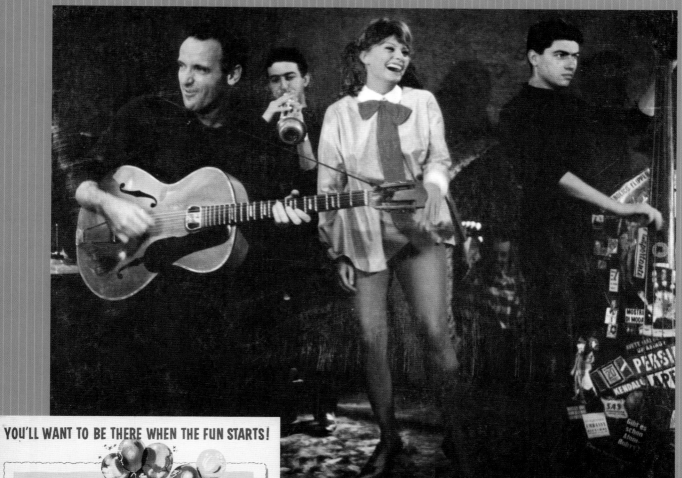

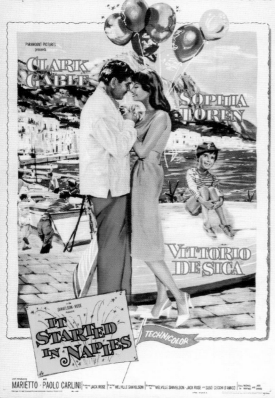

PARAMOUNT PICTURES presents

CLARK GABLE

SOPHIA LOREN

VITTORIO DE SICA

IT STARTED IN NAPLES

TECHNICOLOR

MARIETTO · PAOLO CARLINI · JACK ROSE · MELVILLE SHAVELSON · MELVILLE SHAVELSON · JACK ROSE · SUSO CECCHI D'AMICO · JACK ROSE

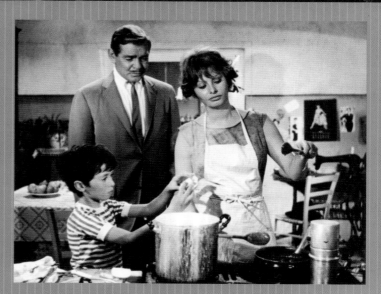

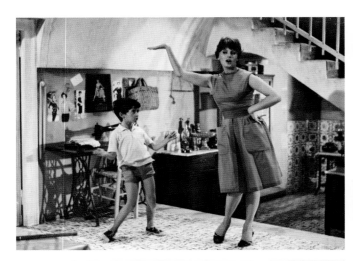

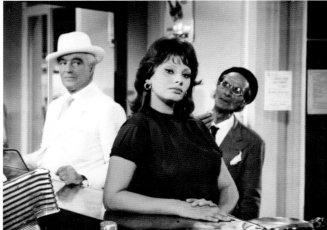

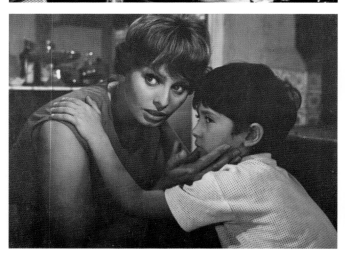

Moments from *It Started in Naples* (1960).

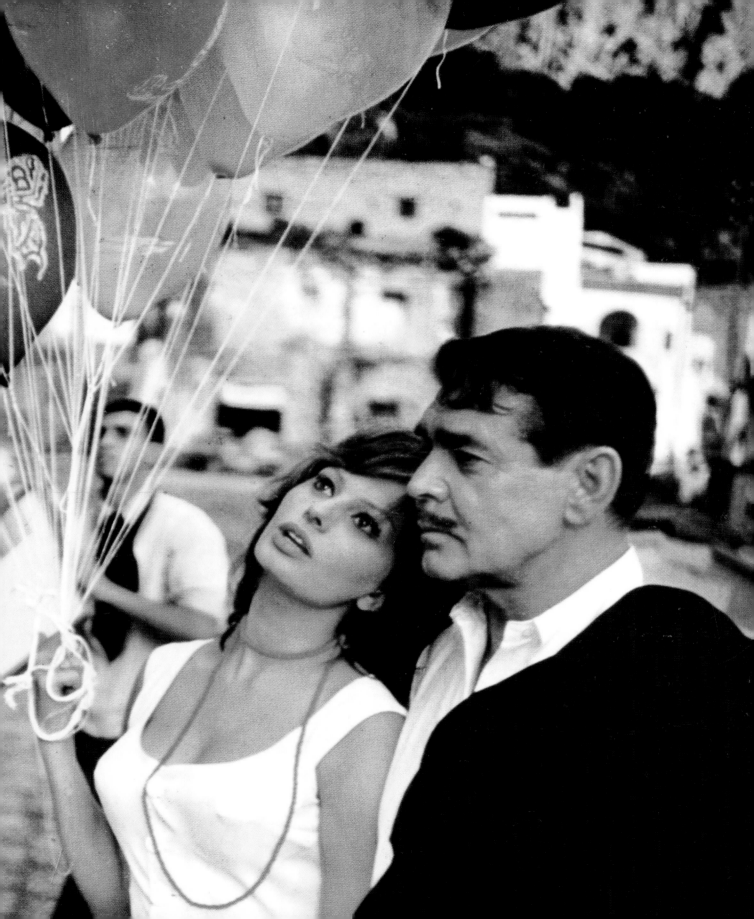

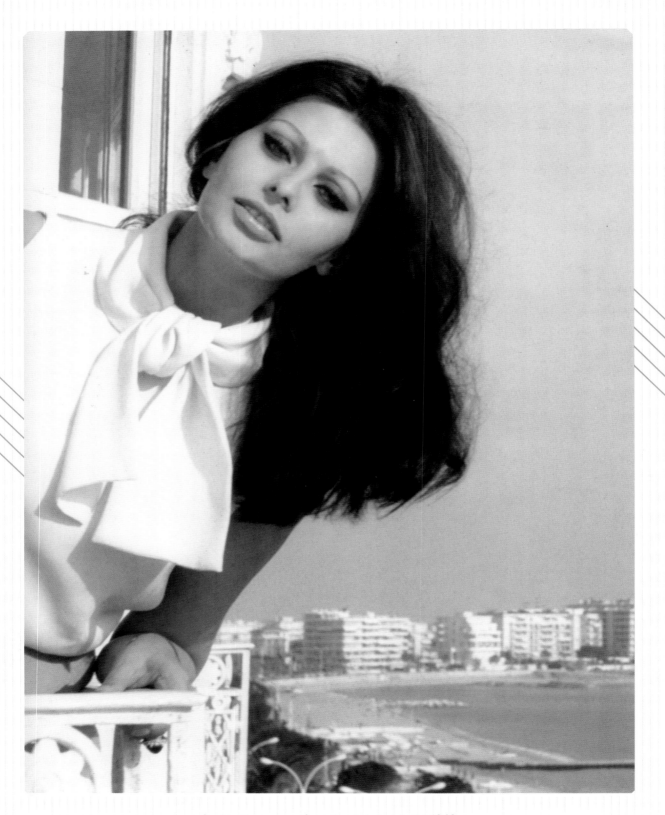

Sophia, the queen of continental stars in the 1960s.

International Icon

With more than fifty films under her belt and an incredibly active career across two continents, by the '60s Sophia was just hitting her stride. In a time when many of the biggest stars of the previous two decades struggled to find their footing in a rapidly changing cultural landscape, Sophia seemed only to be getting started. Her career flourished as she made films in Italy, America, and all over Europe. She became an international icon beloved not only for her unmatched beauty but also for her thrilling screen performances and warmth of character that she conveyed in her public persona. In the '60s she climbed a pedestal of worldwide adulation that few stars have reached, and it is a position she maintains more than half a century later. She has never stopped playing interesting roles, in later years happily turning to television for choice roles not available to her on the big screen.

Two Women

La Ciociara (1960) :: DIRECTED BY Vittorio De Sica

Sophia returned to Italian cinema post-Hollywood in *Two Women*, the film that won her Hollywood's most coveted prize, the Academy Award. Hers was the first Best Actress Academy Award to be given for a performance in a foreign film.

It all began with *La ciociara*, a novel by Alberto Moravia about a mother and daughter fighting for their lives during harrowing times in World War II Italy. With Sophia's enthusiastic endorsement, Carlo Ponti optioned the film rights, and plans got underway for Sophia to costar in the film. She would play the daughter, and Anna Magnani was cast as the mother. Magnani backed out, feeling their pairing was all wrong. She wanted an actress of smaller stature (which she allegedly meant literally, though many speculated she was also wary of Sophia's large personality), like Pier Angeli, to play her daughter. An off-handed suggestion of Magnani's inspired Vittorio De Sica to cast Sophia as the mother, bringing in a younger actress, Eleonora Brown, as her daughter.

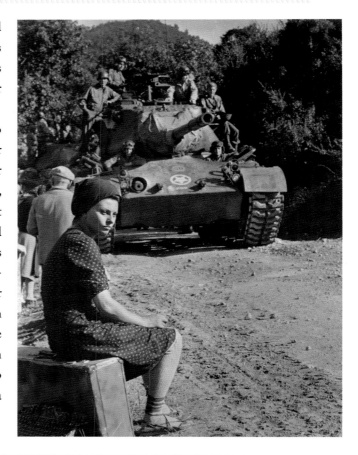

66 **The story was about our land, about Italy, it was about me and my mother, about the war we'd lived through and the one we'd feared, about wounds that will never heal.** 99

—Sophia on *Two Women*

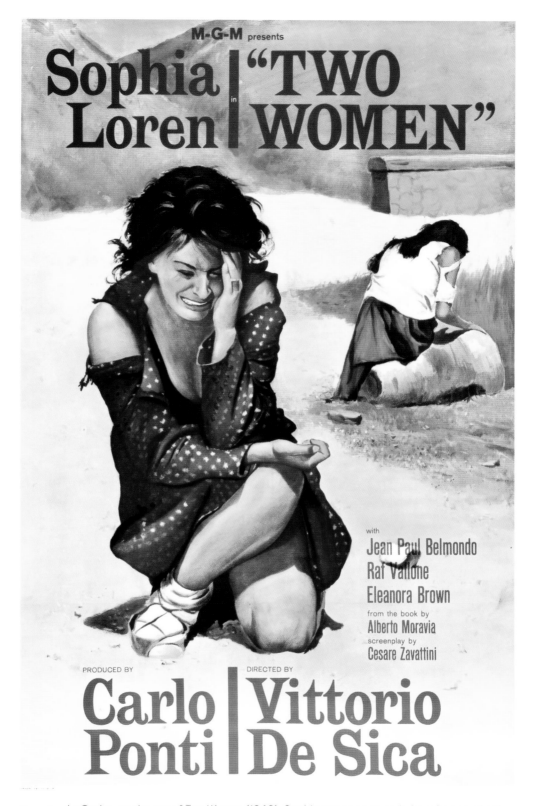

Opposite: As Cesira, on the set of *Two Women* (1960). Sophia was so spot-on in her characterization that they were able to shoot most of the scenes in one take.

In the story, Sophia is Cesira, a widow just making ends meet for her and her thirteen-year-old daughter, Rosetta, in Rome. As the war intensifies, Cesira takes them back to her home village of Ciociaria, hoping for refuge from daily bombardments. There they make a friend in Michele (Jean-Paul Belmondo), who helps them get by through the closing days of war. But as the Germans retreat and the Allies push on, the worst is yet to come for Cesira and Rosetta. On their way back to Rome they seek shelter in a bombed-out church, where they are attacked by a brutal band of Allied soldiers. The aftermath of their violation plays out in the most heart-wrenching way.

This was a story that deeply hit home with Sophia. It brought back haunting memories of the war years—witnessing harrowing atrocities; the long, woeful walk home from Naples to Pozzuoli at war's end; and even the Moroccan soldiers reminiscent of those who had camped out near the entrance of the Villani family home so many years earlier. Channeling her own mother, Sophia threw herself into her role. She always maintained that "the accessories of a part—the costume, makeup, and hairdo—can help to create the essence of a character." For *Two Women* she opted for no makeup at all to aid in her unforgettably raw performance.

Her reviews were stellar. Bosley Crowther of the *New York Times* said, "the beauty of Miss Loren's performance is in her illumination of a passionate mother role. She is happy, expansive, lusty in the early phases of the film, in tune with the gusto of the peasants, gentle with her child. But when disaster strikes, she is grave and profound. When she weeps for the innocence of her daughter, one quietly weeps with her."

The crowning achievement was the Academy Award. Sophia also received Best Actress honors from the British Academy, the Cannes Film Festival, and the David di Donatello, among numerous other accolades.

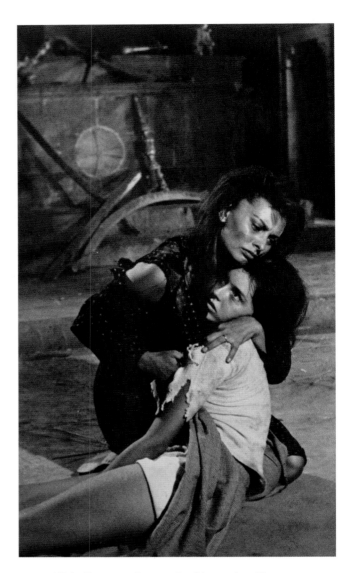

Above: With Eleonora Brown. Sophia made efforts to form a connection with Brown immediately, knowing that it was crucial for the intense roles they would be bringing to life. She comforted Brown when De Sica would go too far in trying to get a performance out of her, for one scene even telling the girl that her parents had been injured in an accident. The two actresses remained friends for life.

Opposite: Sophia was at home in Italy the night of the Academy Awards ceremony but stayed awake almost until morning to hear the results. Cary Grant delivered the good news to her.

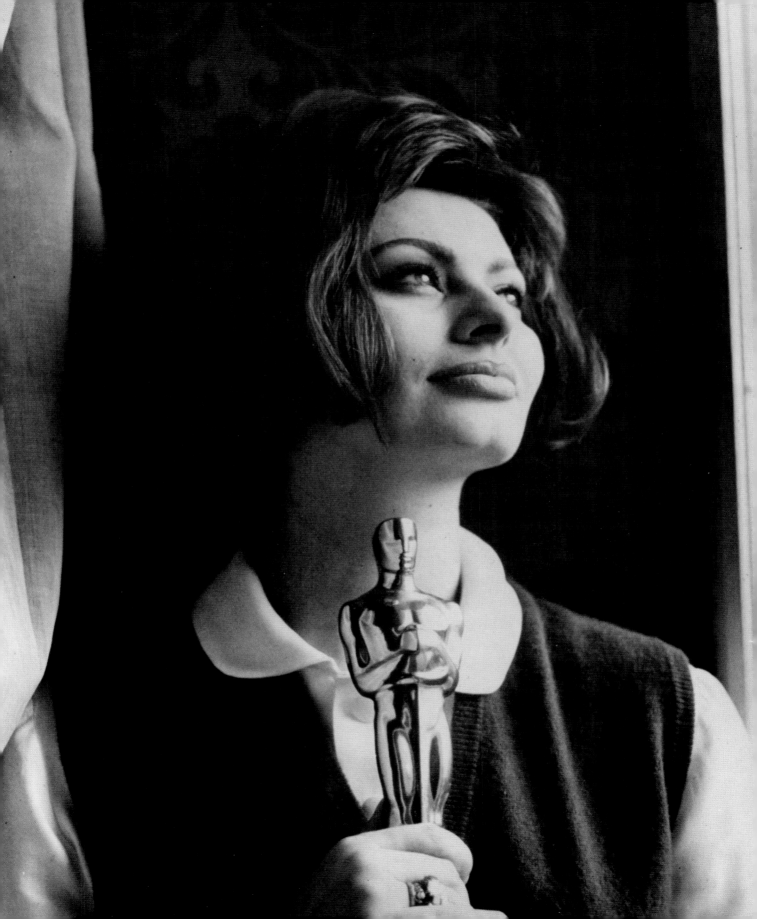

El Cid

(1961) :: DIRECTED BY Anthony Mann

El Cid, the adventurous story of medieval Spanish soldier Rodrigo Díaz (played by Charlton Heston) was a blockbuster production on the grandest scale. *Time* magazine reported, "The picture is colossal—it runs three hours and 15 minutes (including intermission), cost $6,200,000, employs an extra-wide widescreen, a special color process, 7,000 extras, 10,000 costumes, 35 ships, 50 outsize engines of medieval war, and four of the noblest old castles in Spain." The film's visuals are outstanding and Sophia is decorative, feisty, and loyal to the end as the hero's wife. It was an uncomfortable shoot for her due to cold weather on location in Spain, but the real pain Sophia felt came on the last day of shooting, when she fell down a flight of stairs and broke her arm.

The film's considerable expenses paid off: *El Cid* was a winner at the box office, taking in more than $12 million. It earned three Academy Award nominations (though no wins) for art direction by John Moore and Veniero Colasanti, musical score by Miklós Rózsa, and Rózsa's theme song.

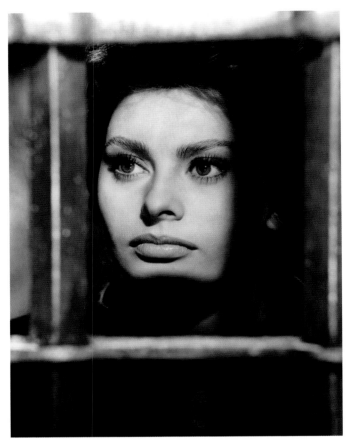

As Jimena in *El Cid*.

Scenes from *El Cid*.

"She's one of the most remarkable actresses I've ever worked with, and quite an extraordinary woman."

—Charlton Heston

With Charlton Heston in *El Cid* (1961).

Madame

(1961) :: DIRECTED BY Christian-Jaque

Sophia stars as Catherine Hübscher, a Parisian washerwoman who wins the title of Duchess from Emperor Napoleon but never forgets her salty past. She brings a lusty spirit to the noble court, earning her a different kind of title: Madame Sans-Gêne (Madame Without Embarrassment).

Previously brought to the screen by Gloria Swanson in 1924, it was a none-too-demanding, fun role for Sophia, and she enjoyed getting into character, later saying, "My washerwoman hair was wild and disheveled; this made it easier for me to act with the passion and gusto that the role demanded."

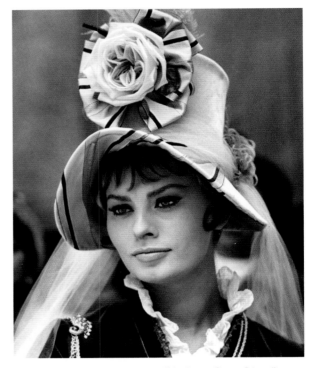

As Catherine Hübscher, "Madame Sans-Gêne."

"**Miss Loren breezes through [her role], sassy, vulgar, and gay . . . It is a straight vehicle for her appearance, and she rides it luxuriously**"

—The *New York Times*

Boccaccio '70

(1962) :: DIRECTED BY Vittorio De Sica, Federico Fellini, and Luchino Visconti

Three of Italy's top directors offered up short stories of modern love and lust in *Boccaccio '70*. Under De Sica's direction, Sophia starred in "The Raffle" as a carnival worker who, in an effort to make money to pay back taxes, raffles off a night with herself. *Variety* called "The Raffle" "the most completely enjoyable [episode] of the lot."

A fourth segment, directed by Mario Monicelli, was cut before the film's release. Carlo Ponti considered adapting that story into a full-length feature, but it did not come to fruition. Most home video copies available today feature all four episodes.

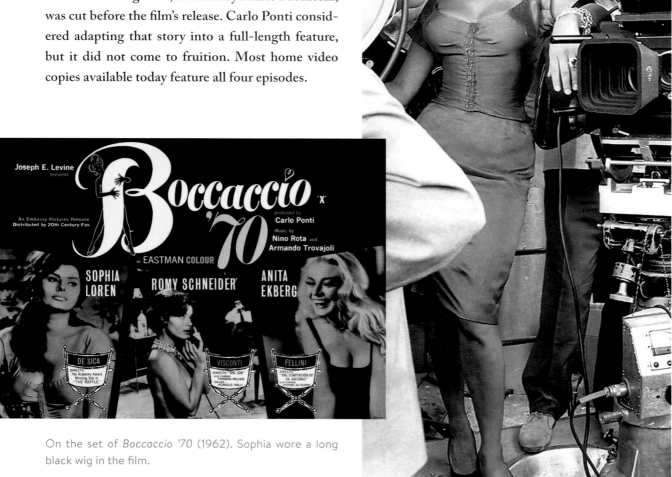

On the set of *Boccaccio '70* (1962). Sophia wore a long black wig in the film.

International Icon ~ 161

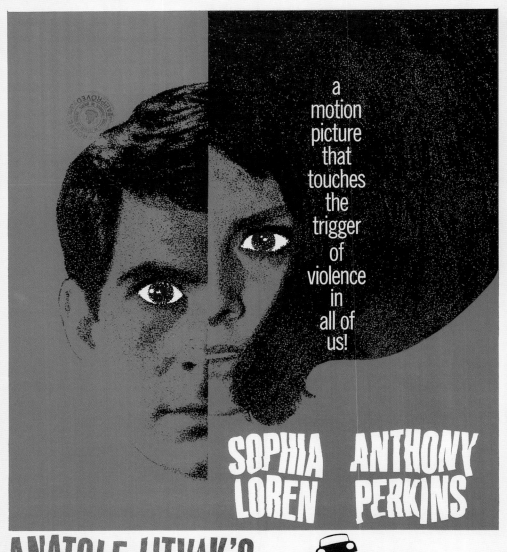

a motion picture that touches the trigger of violence in all of us!

SOPHIA LOREN ANTHONY PERKINS

ANATOLE LITVAK'S FIVE MILES TO MIDNIGHT

CO-STARRING GIG YOUNG AND JEAN-PIERRE AUMONT

SCREENPLAY BY PETER VIERTEL AND HUGH WHEELER

ADAPTED BY PETER VIERTEL FROM AN ORIGINAL IDEA BY ANDRE VERSINI MUSIC BY MIKIS THEODORAKIS PRODUCED AND DIRECTED BY ANATOLE LITVAK UNITED ARTISTS RELEASE

Five Miles to Midnight

(1962) :: DIRECTED BY Anatole Litvak

Sophia was reteamed with her *Desire Under the Elms* costar Anthony Perkins for this tense drama. Perkins is her devious husband, Robert, who was supposedly killed in a plane crash. He turns up alive in Lisa's (Sophia) apartment and convinces her to commit fraud on his behalf by collecting on his life insurance policy. The complications of the scheme lead to a torturous existence for all involved.

Both Sophia and Perkins felt they were a mismatched pair. Perkins told an interviewer, "I've got to do something drastic about my inability to age. Sophia just seems more grown up." She, meanwhile, said, "When I play opposite Tony, he makes me look like his mother, even though I'm younger than he is."

Right: Moments from *Five Miles to Midnight* (1962).

Below: With Anthony Perkins.

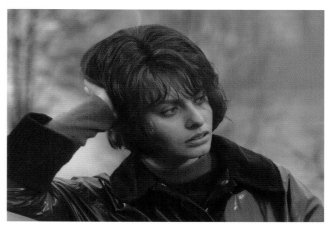

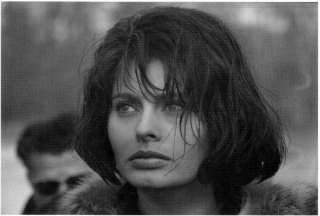

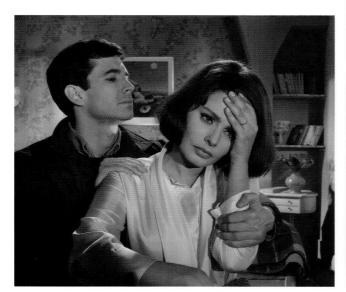

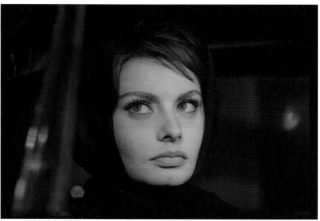

The Condemned of Altona

I sequestrati di Altona (1962) :: DIRECTED BY Vittorio De Sica

Based on a play by Jean-Paul Sartre, in *The Condemned of Altona* Sophia is a young wife taken to live at the home of her father-in-law (Fredric March) near Hamburg, Germany. There she discovers a dark family secret: a second son (Maximilian Schell), driven mad by war crimes committed in the name of Nazism twenty years earlier, hidden away in a vaulted room of the attic. The compassionate Johanna (Sophia) tries to help him.

The Condemned of Altona was widely panned by critics in the United States; however, in Italy, De Sica would take home the year's award for Best Director.

"[Loren] creates a shudderingly magnificent portrait of a beautiful, intelligent woman."

—*Variety* review of *The Condemned of Altona* (1962)

Opposite: With Maximilian Schell in *The Condemned of Altona* (1962).

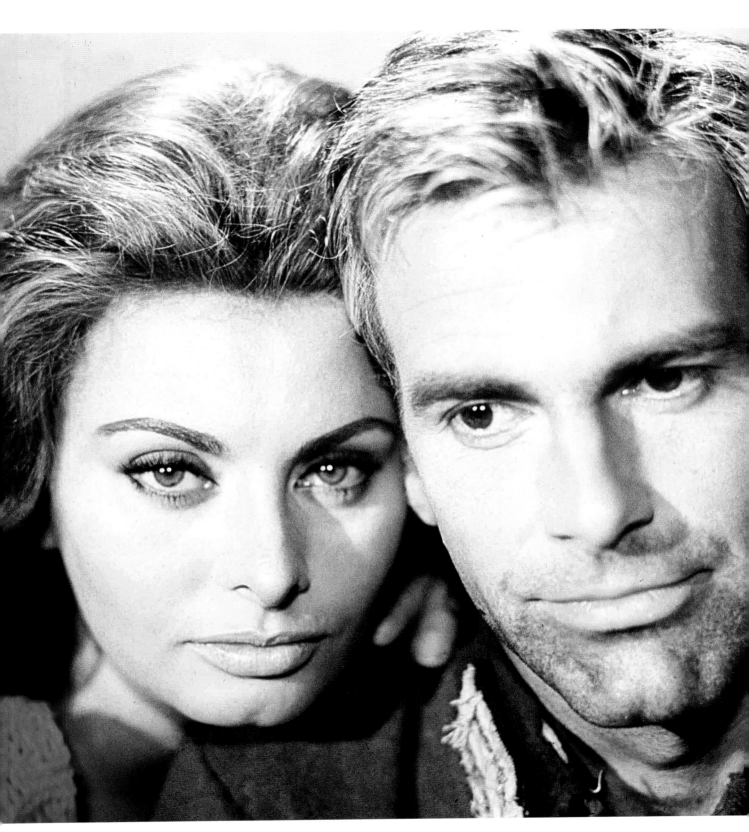

Yesterday, Today and Tomorrow

Ieri oggi domani (1963) :: DIRECTED BY Vittorio De Sica

If *The Condemned of Altona* had been a disappointment, *Yesterday, Today and Tomorrow* made up for it handsomely. Though they had each worked together often, this was the first teaming of Sophia and Marcello Mastroianni as stars directed by Vittorio De Sica. Sophia and Marcello were a match made in cinematic heaven, but Sophia called De Sica the "key" to their magic.

Yesterday, Today and Tomorrow gives its audience three short comic vignettes set in three different locales. Episode one unfolds in the Neapolitan town of Forcella. Adelina (Sophia) is in hot water with debt collectors and faces jail time, which she is conveniently able to avoid because "she's expecting!" with her husband, Carmine (Marcello). All they have to do is continue having babies year after year to continue avoiding jail. But how long will Carmine's stamina hold out?

In Milan, a wealthy (and totally self-absorbed) woman named Anna (Sophia) plots an affair with an old flame, Renzo (Marcello), while trying to keep her beloved Rolls-Royce unharmed with Renzo behind the wheel.

The third segment, "Mara," is the treat saved for last. In Rome, Augusto (Marcello) is in love with a beautiful prostitute named Mara (Sophia), but he can't keep her attention as she is preoccupied with drama unfolding from the balcony across the way, where an aspiring priest (Gianni Ridolfi) has become infatuated with Mara. Against his will, Marcello joins Mara's effort to prevent the young man from leaving the seminary.

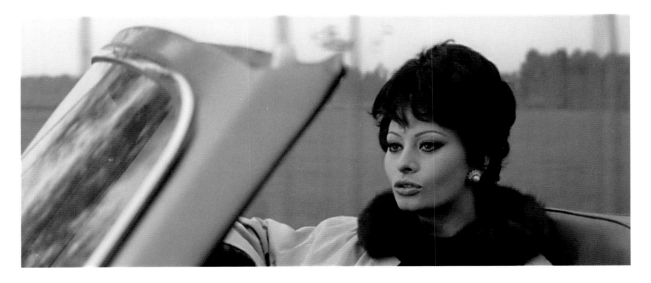

The most famous moment is the striptease that Mara performs for Augusto. Sophia was unsure how to even approach the scene, but coaching from Jacques Ruet, choreographer of the famous Crazy Horse cabaret in Paris, helped her craft a sequence that has gone down in the annals of film history.

Yesterday, Today and Tomorrow was worldwide hit, winning the Academy Award for Best Foreign Language Film and David di Donatello Awards for Sophia, Marcello, and Carlo Ponti (as producer).

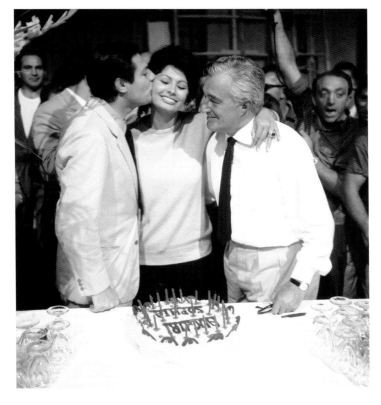

Right: Celebrating her birthday on the set with Marcello and Vittorio De Sica. She cherished their friendship, and she truly needed it while filming *Yesterday, Today and Tomorrow*, as she suffered her first miscarriage midway through the production.

Opposite: She is cold as ice in "Anna."

Below: In "Adelina," Sophia is a perpetually pregnant wife to Marcello.

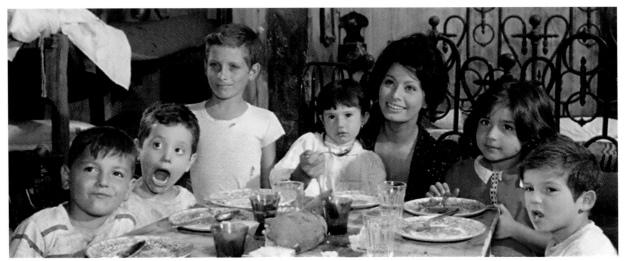

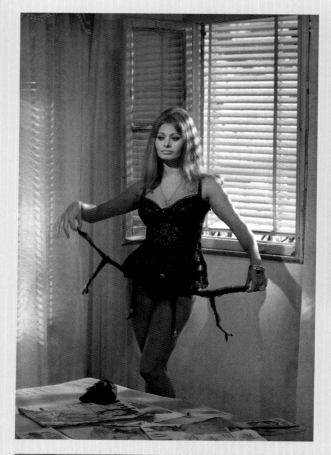

"**But Vittorio, I've never seen a striptease.**"

—Sophia

The Fall of the Roman Empire

(1964) :: DIRECTED BY Anthony Mann

The history of second-century A.D. Rome is told over more than three hours of screen time in this sprawling Samuel Bronston superproduction. And, as the narration informs viewers at the end, that was only the *beginning* of the end. The focus is on Emperor Marcus Aurelius (Alec Guinness), his rival Livius (Stephen Boyd), and son and successor to Rome, Commodus (Christopher Plummer).

Sophia's role as Commodus's sister is primarily decorative, though she was given top billing.

Filmed in the Sierra Guadarrama region of Spain on an epic budget of $19 million, it was a failure at the box office but has since regained appreciation as one of the more thoughtful historical epics of the era. Sophia earned $1 million for her work.

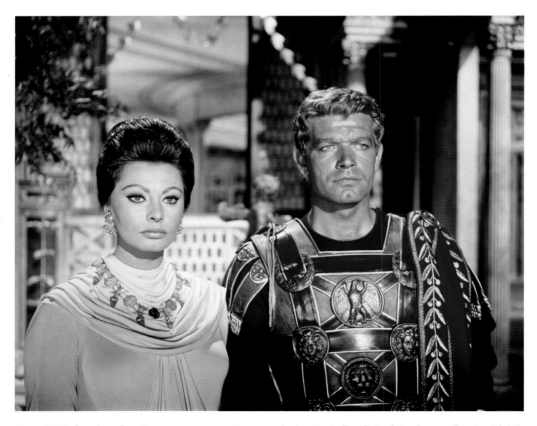

Above: With Stephen Boyd. **Opposite:** As Lucilla in *The Fall of the Roman Empire* (1964).

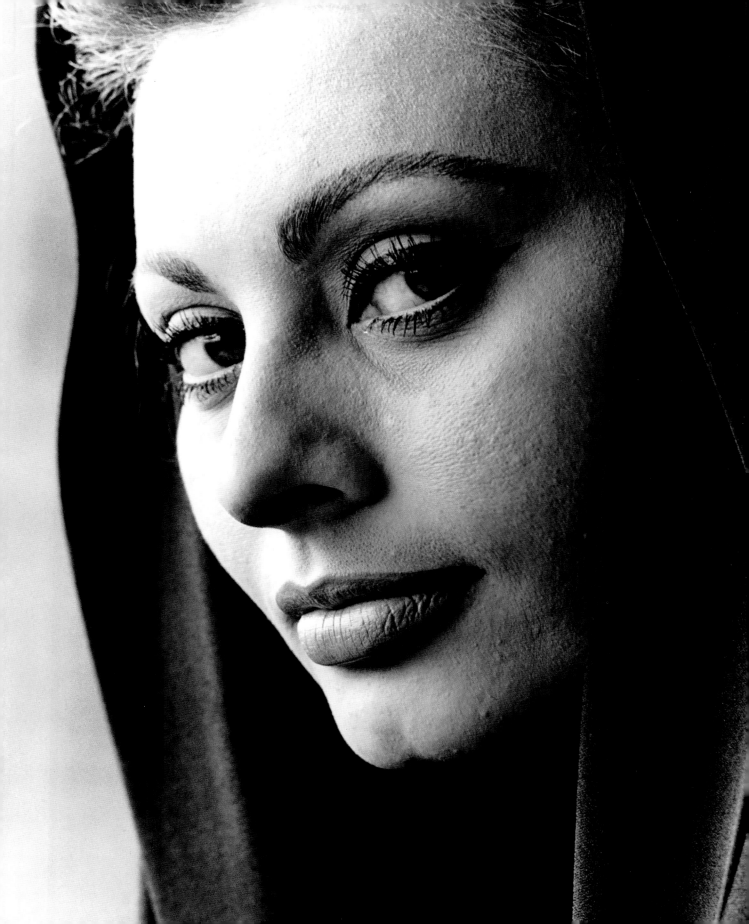

Marriage Italian Style

Matrimonio all'italiana (1964) :: DIRECTED BY Vittorio De Sica

Author Eduardo De Filippo originally wrote his 1946 play *Filumena Marturano* for his sister, actress Titina De Filippo. It was a beloved production in Italy and became the actress's signature role. The play was first adapted for the screen as a musical in Argentina in 1951. Carlo Ponti's production, in the expert hands of Vittorio De Sica, was a drama with comic tones. It was titled *Marriage Italian Style*, in a nod to Pietro Germi's *Divorce Italian Style* (1961, also starring Marcello Mastroianni).

Filumena Marturano (Sophia) is hopelessly in love with Don Dummì (Marcello), a handsome, wealthy, irrepressible cad. Filumena becomes increasingly frustrated with her alternating roles as Dummì's mistress, servant to his mother, and overseer of his business in Naples. After tricking Dummì into marriage, she reveals that she has three sons that she has given up after bringing them into the world, but she knows the whereabouts of each. Hoping Dummì will give the boys his family name and provide for each equally, she tells him that only one of them is his. Which one becomes the crux of the story's dénouement.

Sophia was in her element, costarring again with Marcello, under the guidance of her favorite director, and in a story of Neapolitan life. In bringing the role of Filumena to life, Sophia said she studied both her mother and aunt Dora, even inviting them to the set for inspiration. The idea of needing a family name to secure your future was one close to her heart. Her single mother, Romilda, had fought to give Sophia her father's last name of Sciocolone, and

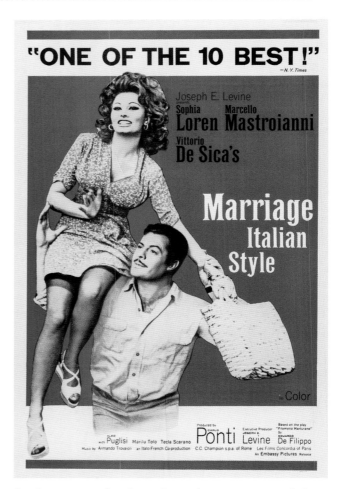

Sophia in turn fought to have that name extended to her younger sister, Maria, even using money earned from one of her first important roles to pay Sciocolone for the privilege.

Marriage Italian Style was very well received. It was nominated for an Academy Award for Best Foreign Film, and Sophia was nominated for Best Actress. In Italy, it won David di Donatello Awards for Sophia, Marcello, De Sica, and Ponti.

"It's hard to imagine a role closer to my heartstrings . . ."

—Sophia on *Marriage Italian Style*

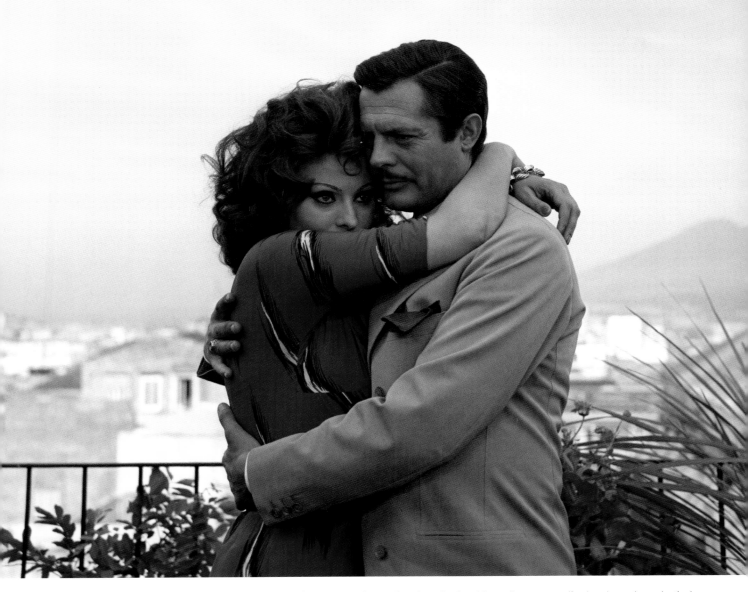

With Marcello Mastroianni. This was a bit of a change of pace for them in that Marcello was usually the abused one in their films. Here Sophia gets the worst of his character.

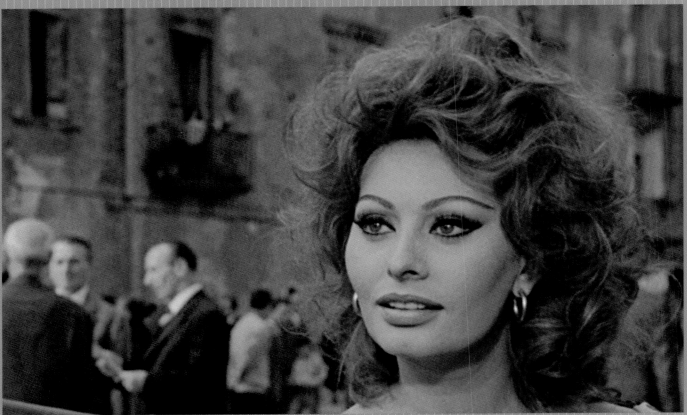

As Filumena Marturano in *Marriage Italian Style* (1964).

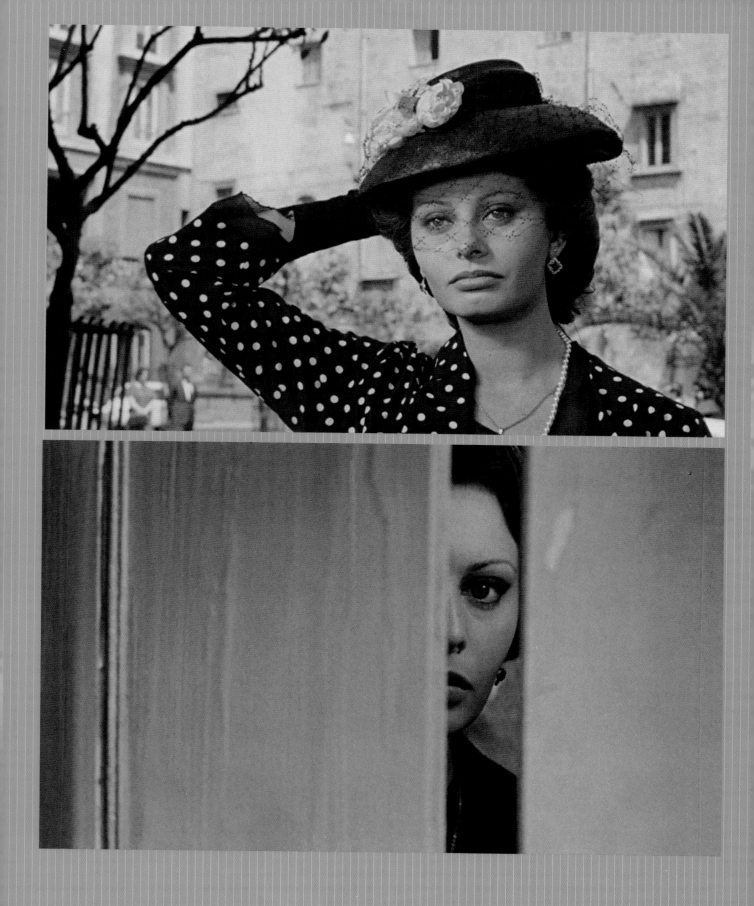

Operation Crossbow

(1965) :: DIRECTED BY Michael Anderson

Loosely based on the actual events of Operation Crossbow during World War II, a team of Allied spies, including American John Curtis (George Peppard), execute plans to take out the rocket bases where the Nazis are developing their deadliest bombs. Sophia played the widow of a German scientist whose identity Curtis assumes.

Operation Crossbow was a popular hit. The *New York Times* called it, "a beauty that no action-mystery-spy movie fan should miss. It is a grandly engrossing and exciting melodrama of wartime espionage, done with stunning documentary touches in a tight, tense, heroic story line."

Around this time, Sophia also appeared in a television documentary, *Sophia Loren in Rome*, which aired on NBC in November 1964.

"He makes me feel like I am relaxing at home with friends rather than working at a studio."

—Sophia on Peter Ustinov

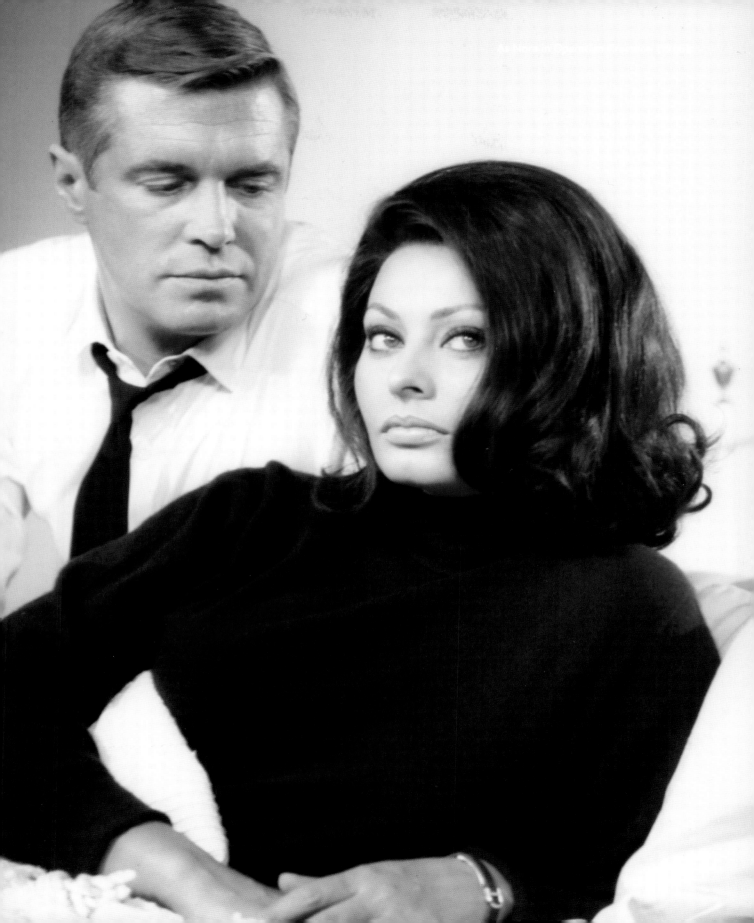

Lady L

(1965) :: DIRECTED BY Peter Ustinov

Peter Ustinov both wrote and directed this urbane and original romantic comedy, which was based on a novel by Romain Gary. In the film, an eighty-year-old Lady Lendale (Sophia) looks back on her adventurous life. Her memories begin as a laundress at a Parisian brothel, where she first meets Armand (Paul Newman), a bomb-wielding revolutionary and possibly the love of her life. A wise and witty British lord (David Niven) takes her on a different path, offering her a life among English aristocracy. But Armand remains in the picture.

Sophia filled her role as a young Frenchwoman who becomes a proper English noblewoman with all her Italian gusto. The biggest challenge was turning the thirty-two-year-old Sophia into a woman of eighty. The makeup process took three hours each day, but she ultimately did not mind, later recalling "The experience of becoming an old woman was perhaps more valuable to me personally than any other film experience. . . . when you have tried on your old age, you find that it is not so terrible."

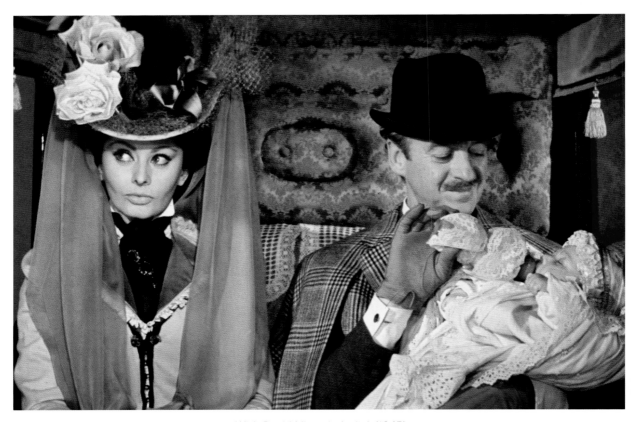

With David Niven in *Lady L* (1965).

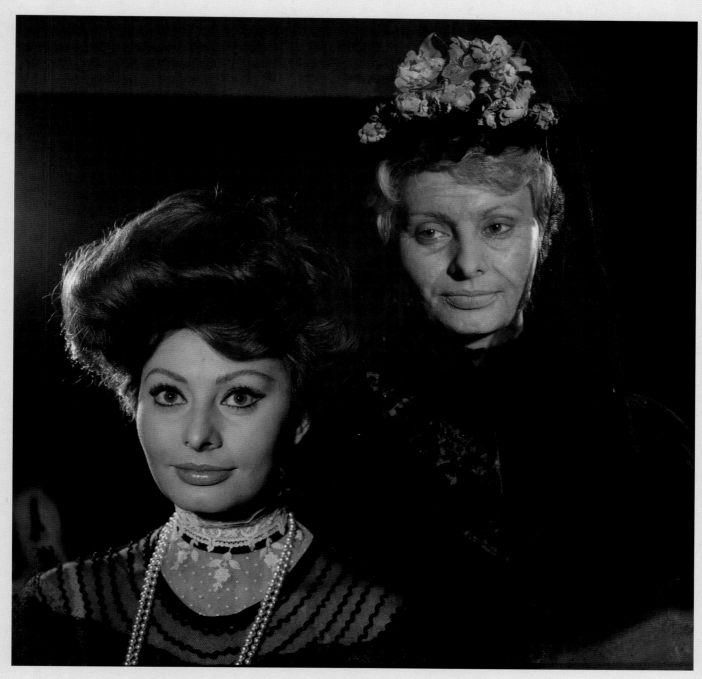

Three hours of aging makeup each day transformed thirty-two-year-old Sophia into an eighty-year-old woman.

With Peter Finch, who played a Jewish underground movement leader in *Judith* (1966).

Judith

(1966) :: DIRECTED BY Daniel Mann

Sophia was back in a World War II–era setting in this drama from director Daniel Mann. In postwar Palestine, as an independent state of Israel is set to rise with the end of the British mandate, enemies in neighboring Arab countries threaten to attack. One such force is being led by a former Nazi general (Hans Verner), and the Jewish underground plots to stop them with the help of the general's Jewish former wife, Judith (Sophia). Judith is not keen on fighting anyone else's causes—she has her own score to settle with her former husband: he let her be taken to a concentration camp and took away their son. Judith will do anything for revenge, but can she ever see the greater good of the cause for her people? The plot weaves through many twists and turns before reaching its hopeful conclusion.

The film was not a big success but gave fans the sight of Sophia strutting around a *kibbutz* in the shortest of shorts and a tight, jet-black coiffure. The response in select Arab countries to *Judith* was to ban Sophia Loren films.

 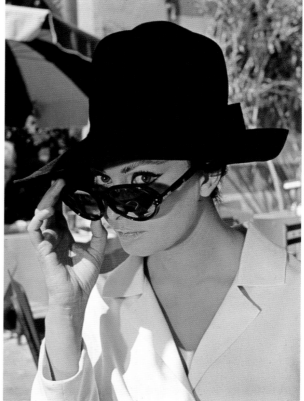

Sophia sporting a new look as Judith .

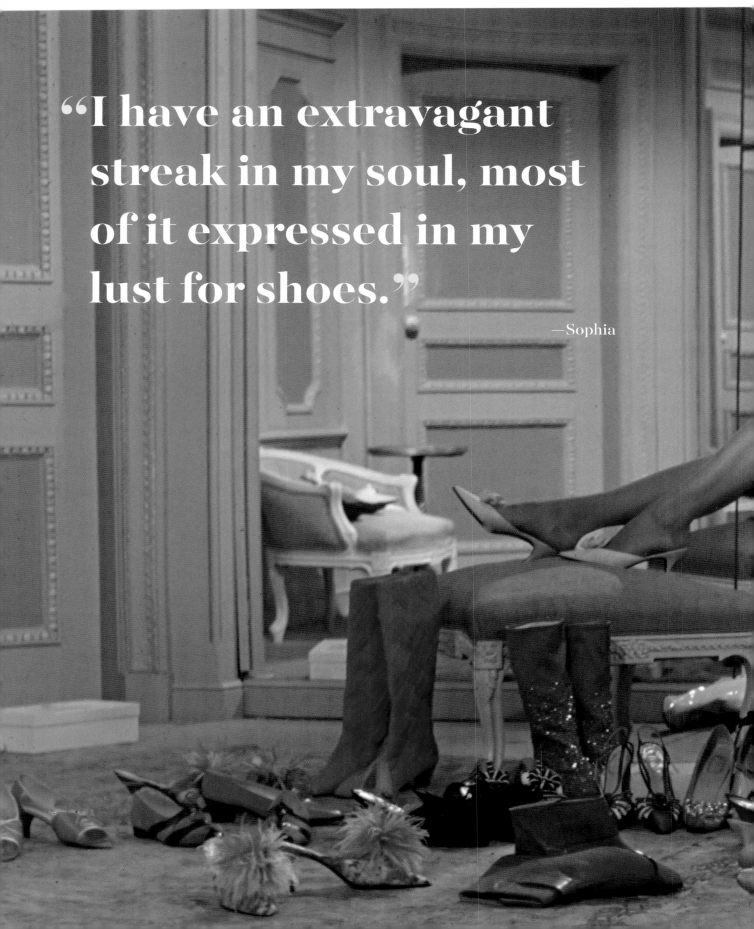

"I have an extravagant streak in my soul, most of it expressed in my lust for shoes."

—Sophia

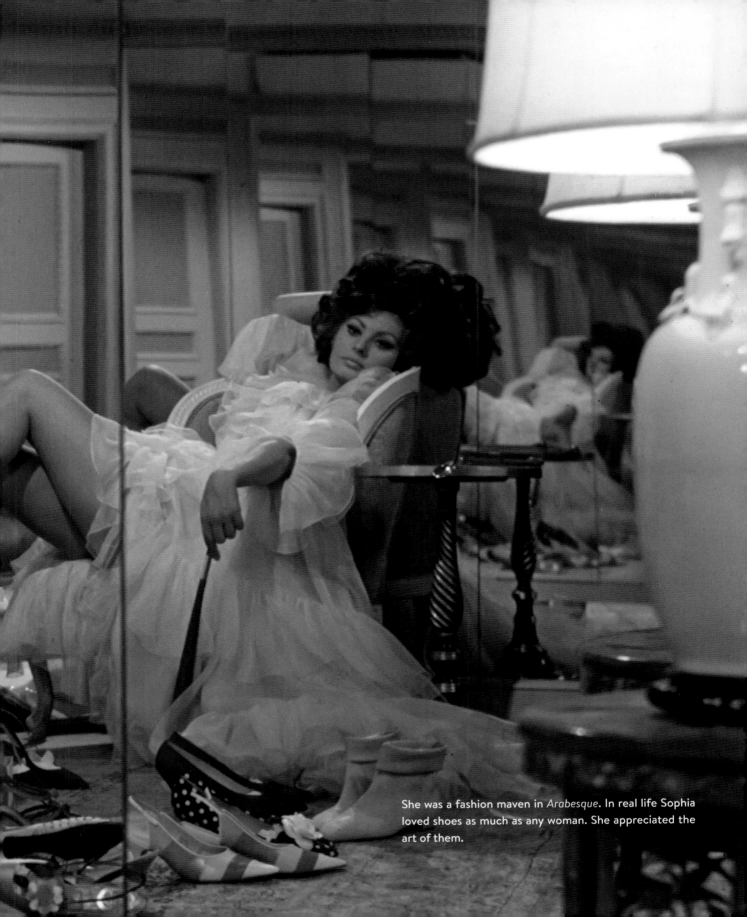

She was a fashion maven in *Arabesque*. In real life Sophia loved shoes as much as any woman. She appreciated the art of them.

More Than a Miracle

C'era una volta (1967) :: DIRECTED BY Francesco Rosi

Cinderella Italian Style, as the film was known outside of the United States, is an exceedingly appropriate title for *More Than a Miracle*, a beautiful romantic fairy tale filmed in the countryside of Naples. In seventeenth-century Italy, strong-willed peasant girl Isabella (Sophia) vies for the heart of a handsome but pompous Prince Rodrigo (Omar Sharif), who fancies her, too, but his attention is distracted by the seven princesses who are in competition to become his bride. Could witchcraft be the only way for a lovely peasant girl to win her prince? Or perhaps a nutty dishwashing contest can settle matters? Isabella finds out before the final fade-out.

Omar Sharif was fresh off of his triumph in *Doctor Zhivago* (1965) when he made *More Than a Miracle* with Sophia. The two got along well and even entered into an eggplant cook-off involving their mothers before production wrapped. They were two of the biggest stars in the world at the time, but apart from also featuring Dolores del Rio of '30s screen-siren fame, the cast was largely made up of little-known Italian actors, giving the movie touches of Italian neorealism in the midst of its fantasy plot.

Sophia performed much of the film in her bare feet, as envisioned by director Francesco Rosi, who remembered, "She was very patient: she moved forward fearlessly, as if she had walked barefoot all her life. Sometimes her feet would bleed, but she didn't complain." That, unfortunately, was not the worst hardship Sophia endured during the making of *More Than a Miracle*. She also suffered her second miscarriage. Work helped keep her mind off of the pain. It would not be long before Sophia became pregnant again, though. Under the close watch of a doctor in Switzerland, she carried the baby to term, and the Pontis had their first child in December 1968.

Left: A riotous dishwashing contest was a centerpiece of the film.

Opposite: With Omar Sharif, who became a good friend during filming.

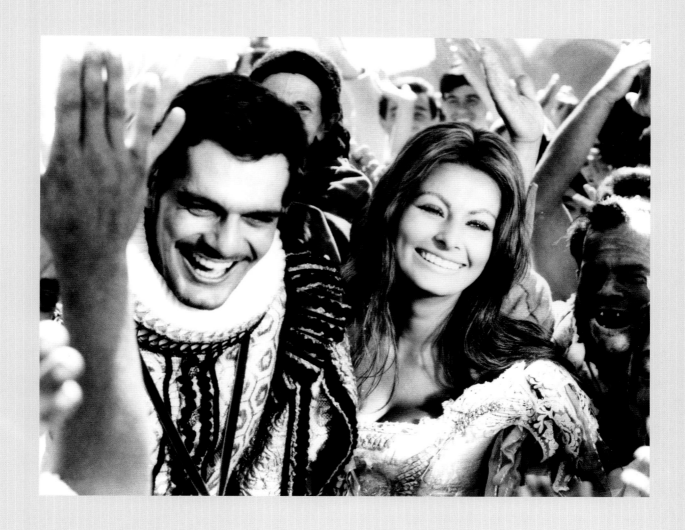

"[Sophia is] the most completely feminine woman you will ever meet."

—Omar Sharif

A Countess from Hong Kong

(1967) :: DIRECTED BY Charles Chaplin

When Charlie Chaplin got in touch with Sophia while she was in England making *Arabesque* and told her that he was interested in working with her on the next film he was directing, she said yes even before he had the chance to tell her about the project. Such was her reverence for the comedic legend whose work—both in front of and behind the camera—had been enjoyed and celebrated worldwide for the past several decades. Chaplin had originally written the story—inspired by the life of a Russian entertainer that he had known in France—for his ex-wife, actress and muse Paulette Goddard. After seeing *Yesterday, Today and Tomorrow*, Chaplin wanted to make his tale of *A Countess from Hong Kong* with Sophia.

It was a story about Natascha (Sophia), a beautiful Russian "countess" making her way as an escort in Hong Kong. When called to entertain a US ambassador, Ogden Mears (Marlon Brando), aboard a ship bound for America, Natascha takes the opportunity to stow away in his stateroom, hoping to improve her fortunes in America. As a refugee without papers and not wanting to cause a scandal, she must stay locked away in his cabin for the trip. Her presence drives Mears to distraction until he inevitably falls head over heels for her. Then the only problem left is his wife back home (Tippi Hedren).

As much as she relished the experience of working with Chaplin on this film, Sophia found

> "I loved Sophia Loren in the part and I loved my picture. . . . It had beauty and good human qualities. What do people want these days?"
>
> —Charlie Chaplin

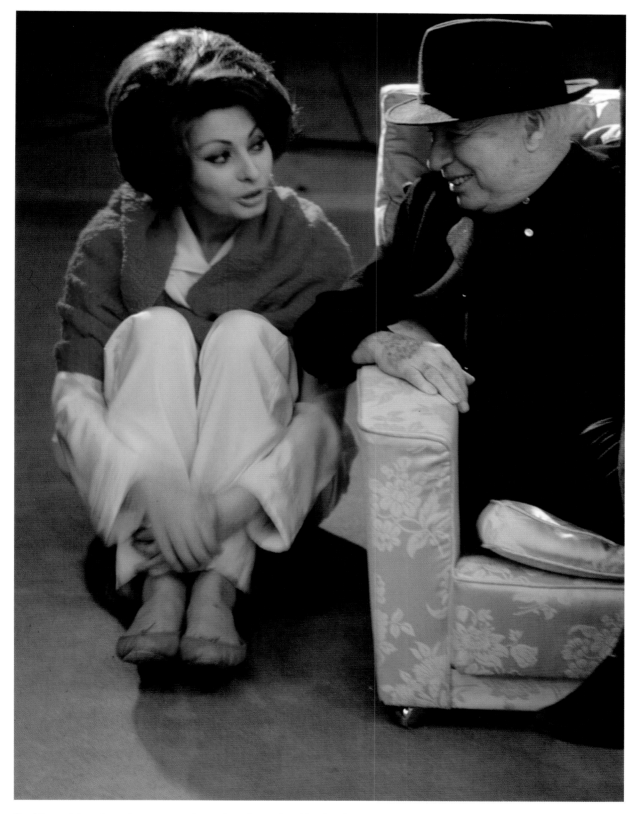

Sophia could not have been more pleased working with Chaplin. She was nervous to meet him but he instantly put her at ease by giving her flowers and breaking the ice.

"**Sophia Loren, aside from being extremely beautiful physically, is one of the most exciting, witty women on this planet.**"

—Tippi Hedren, costar in *A Countess from Hong Kong*

it challenging to work with costar Marlon Brando. She found him "ill at ease in the world" and they did not warm to each other. Still, Sophia is adorable in her role, donning men's pajamas for much of the story and trying out a new accent. She enjoyed doing accents and, in fact, reverted to a British sound at times in early American interviews.

A Countess from Hong Kong ended Chaplin's career on a bit of a sour note, as the film was not well received by critics or audiences, many finding the bedroom farce old-fashioned. It may have been more warmly greeted when Chaplin originally intended to make the film, in the 1930s. The picture earned an estimated $2 million at the box office after $3.5 million had been spent on the production. The disappointing box office notwithstanding, Sophia cherished the memory of this film for giving her the opportunity to work with one of her idols.

Above: Sophia spends much of the story wearing men's pajamas in *A Countess from Hong Kong* (1967).

Opposite: Between scenes of *A Countess from Hong Kong*.

Ghosts, Italian Style

Questi Fantasmi (1967) :: DIRECTED BY Renato Castellani

Based on the Eduardo De Filippo play *Questi Fantasmi*, in this comic fantasy a penniless couple, Maria (Sophia) and Pasquale (Vittorio Gassman), move into a seventeenth-century palace that is offered to them rent-free. The only drawback is that it may be haunted, and the living company surrounding the home, including a caretaker, lodger, and neighboring nuns, give them nary a moment's peace.

The film was first released in Italy in 1967 before making its way to the United States in January 1969, where the dialogue was dubbed into English by Sophia and Gassman. *Ghosts, Italian Style* was a minor production and not a success, but Sophia was not distressed; rather, she was having the time of her life, overjoyed about becoming pregnant. The birth of her son, Carlo Ponti Jr., in 1968 marked the start of the first real break in Sophia's extremely fast-paced filming schedule since her career began in 1950.

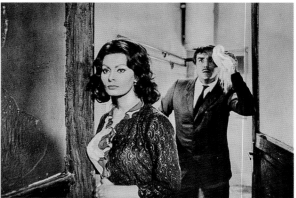

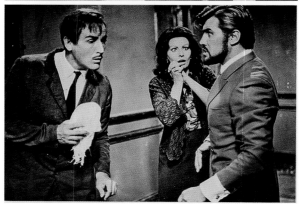

Above and opposite: Lobby cards for *Ghosts, Italian Style* (1967).

Sunflower

I girasoli (1970) :: DIRECTED BY Vittorio De Sica

For her first film back after the birth of her son, Sophia teamed once again with her favorite leading man, Marcello Mastroianni, and favorite director, Vittorio De Sica, for *Sunflower*. Cesare Zavattini and Antonio Guerra penned the screenplay about young lovers Giovanna (Sophia) and Antonio (Marcello), who meet at the outset of World War II and marry. Their wedded bliss is cut short as Antonio is ordered to join his comrades in battle on the Russian front. Giovanna receives word some time later that Antonio went missing in action and, by war's end, still has not returned to Italy. He had been left for dead on a frozen battlefield and was rescued by a young Russian nurse (Lyudmila Saveleva) who restored him to health. His memories of the past were gone, and he married the nurse. Unaware of what became of Antonio but convinced that he is still alive, Giovanna travels to Russia to find him, only to discover him with his new wife as well as their young daughter. The sight of Giovanna brings back his memory of her. Giovanna returns to Italy, determined to go on without Antonio, but forgetting each other is no small feat.

Sophia gives a moving performance as Giovanna, particularly heartbreaking in the scene where she follows Antonio's new wife to the train station to catch a glimpse of her lost love. De Sica later talked about the need for a delicate touch with this scene, which he was worried would come across as too melodramatic. He directed both Sophia and Saveleva not to cry—he wanted "just a mist in the eyes over the guy they both loved."

Sunflower was filmed in part in the Ukraine and is credited as the first film from a Western studio to be shot in the Soviet Union. It was Sophia's first film after becoming a mother, and she could not leave her baby far behind. The son who appears toward the film's end is, in fact, Carlo Jr. Sophia came back to work with a hit, earning her a fourth David di Donatello Award for Best Actress.

> "Sophia Loren reaches a new high of mature, dramatic expression."
>
> —*Variety* review of *Sunflower* (1970)

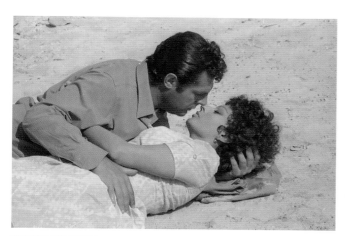

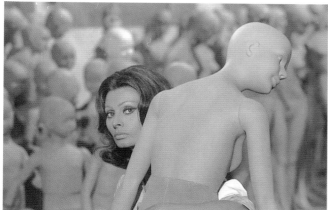

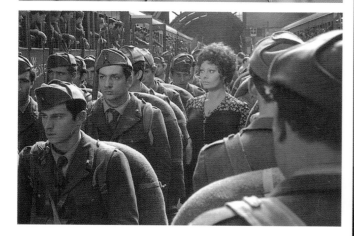

Moments from *Sunflower* (1970).

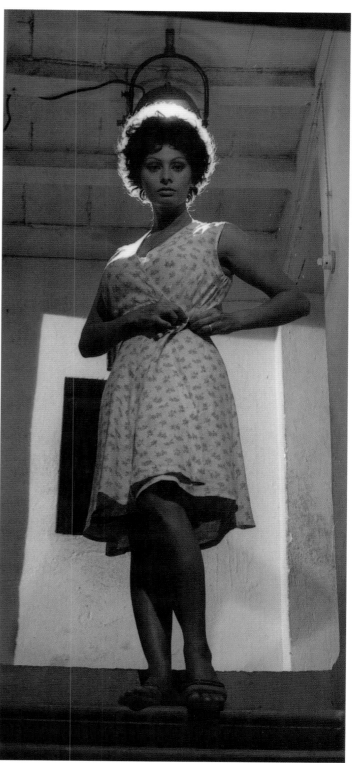

Joseph E. Levine presents An Avco Embassy Film · A Carlo Ponti Production starring

Sophia Loren

Marcello Mastroianni

in Vittorio De Sica's
Sunflower

Filmed in Russia
from the Kremlin
to the Ukraine.

A woman born for love.
A man born to love her.
A timeless moment in a
world gone mad.

"We shared a certain *joie de vivre* and the complete awareness of just how lucky we were . . . "

—Sophia on Marcello Mastroianni

Sophia and Marcello, shot by Tazio Secchiraoli for *Sunflower.*

The Priest's Wife

La moglie del prete (1970) :: DIRECTED BY Dino Risi

Sophia and Marcello were reteamed for this comedy from director Dino Risi, who had previously worked with Sophia on *The Sign of Venus* and *Scandal in Sorrento* many years earlier. Sophia is Valeria Billi, a singer who is in despair after learning that her lover has a wife. Contemplating suicide, she calls a charity help hotline and is talked out of taking any desperate measures by a man named Mario Carlesi (Marcello). Valeria is touched by his compassion and forms a crush on the man she knows only by voice, who unbeknownst to her is a priest. She tracks him down, and even finding out that he is a man of the cloth who has taken a vow of celibacy does not stop Valeria from pursuing her heart's desire. How long can a man, even a priest, resist her charm? They fall in love and decide to marry, but at the most crucial moment, it becomes unclear whether Mario's heart truly belongs to the Church or to Valeria.

The Priest's Wife was a commercial success with audiences, but the Catholic church was less charmed. The film was renounced by religious groups, with priests even visiting the set demanding to check the script. Sophia and Marcello are delightful in the Italian production (which they later voiced in English). This was their eighth of twelve films together, and their rapport was as strong as ever.

Sophia recorded the song "Anyone" for the film in her own voice, and it became a pop hit.

A girl in love has enough problems...

Warner Bros. presents a Carlo Ponti production

Sophia Loren Marcello Mastroianni

The Priest's Wife

Screenplay by Ruggero Maccari · Produced by Carlo Ponti · Directed by Dino Risi TECHNICOLOR® FROM Warner bros. a Kinney company GP

The Sin

Bianco, rosso e . . . (1972) :: DIRECTED BY Alberto Lattuada

The Sin was also known as *White Sister* in English-speaking countries. Turning the tables on *The Priest's Wife*, in this story by Tonino Guerra and Ruggero Maccari, Sophia is a nun who falls in love with an outspoken Communist man she is hoping to heal, played by Adriano Celentano.

Director Alberto Lattuada had previously worked with Sophia on *Anna* twenty years earlier, when he took a chance and gave her some of her first lines of dialogue at the time. Sophia remained eternally grateful.

As Sister Germana in *The Sin* (1972).

Man of La Mancha

(1972) :: DIRECTED BY Arthur Hiller

Man of La Mancha, a musical stage production inspired by Miguel de Cervantes's classic *Don Quixote*, opened in November 1965 and became a hit on Broadway. In years past, Hollywood would have been clamoring to mount a film adaptation, but big-budget musicals had fallen out of favor, so it was a risk for United Artists to launch this production. In fact, the vision of the original director, Peter Glenville, was to scrap the musical numbers, so UA instead turned to producer/director Arthur Hiller to take the reins.

The story-within-the-story follows Alonso Quijana/Don Quixote (Peter O'Toole), a daft nobleman whose eccentricities lead him to seek adventure as a fearless knight-errant, backed by his manservant Sancho Panza (James Coco) and faithfully in service to the prostitute that he believes to be a gentle highborn lady, Dulcinea (Sophia).

Sophia, not known to be a singer but having successfully recorded songs a few times in the past, performed all of her own musical numbers in the film. O'Toole was dubbed, but his tour de force performance as Don Quixote is not to be missed. Sophia referred to him as one of her favorite costars, a "dear, eccentric friend."

Though panned by critics in *Newsweek*, *Time*, and other high-profile publications that criticized the film's use of "non-singers" in lead roles, the National Board of Review selected *Man of La Mancha* for its list of Ten Best Films of 1972.

Sophia took some time off from the screen again, as following production she discovered she was pregnant. The Pontis' second son, Edoardo, was born on January 6, 1973.

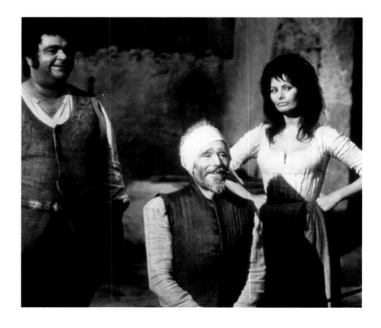

Brief Encounter

(TV, 1974) :: DIRECTED BY Alan Bridges

Sophia was back to work with Richard Burton in this film adaptation of the Noël Coward play *Still Life* about strangers, each married, who fall in love after meeting in a railway station. The material had previously been filmed by David Lean with his classic 1945 production, *Brief Encounter*. This latter-day made-for-TV remake was widely regarded as ill-advised.

> "I'd be perfectly content to act with Sophia for the next million years."
>
> —Richard Burton

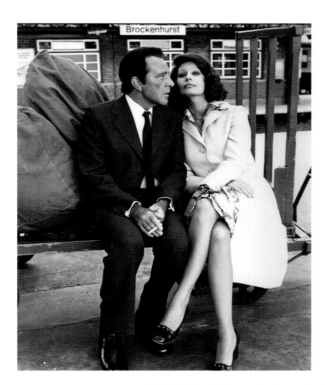 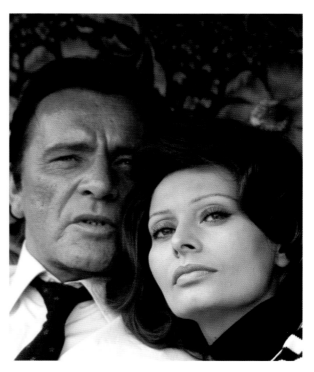

With Richard Burton in the made-for-TV film *Brief Encounter* (1974).

Jury of One

Verdict (1974) :: DIRECTED BY André Cayatte

In this French film, Sophia worked with two of France's most celebrated artists, director André Cayatte and actor Jean Gabin, in what would be one of Gabin's last films. *Jury of One* (also known as *The Verdict* in English) harkened back to Cayatte's earlier notable films that challenged and brought to light flaws in the French judicial system, including *Justice est faite* (1950) and *Nous sommes tous des assassins* (1952).

This film centers around the trial of André Leoni (Michel Albertini) for the murder of his girl-friend, presided over by Judge Leguen (Jean Gabin). The accused man's mother, Teresa (Sophia), pleads with Lequen to acquit her son. When he refuses to be swayed, Teresa arranges for the judge's wife to be kidnapped. Concern for his diabetic wife's health while in the hands of kidnappers causes a deep moral dilemma that's played out in the courtroom.

"[Sophia] is a remarkable professional and working with her is a real pleasure. She's always on time and knows her lines, which is not my case since I never learn."

—Jean Gabin

A Special Day

Una giornata particolare (1977) :: DIRECTED BY Ettore Scola

The "special day" of the title is May 6, 1938, the day that Mussolini rolled out the red carpet for Hitler with a parade in the streets of Rome. But as most of the city flocked to join the festivities, what makes it special to overworked, disenchanted housewife Antonietta (Sophia) is time spent with her neighbor Gabriele (Marcello), an ex-radio broadcaster fired for his "deviant" sexual preferences whose views are out of favor for his antifascist leanings. The two lonely souls connect both emotionally and physically. But Gabriele is, in fact, a homosexual, and his true romantic inclinations prevent him from reciprocating the love that Antonietta develops for him. And in the current political climate, their entire lives will soon be upended.

Sophia and Marcello Mastroianni were both so brilliant in *A Special Day* that it feels like watching them pay tribute to the late Vittorio De Sica. Though this time they were led by the thoughtful and talented writer-director Ettore Scola, Sophia's work with De Sica had prepared her for this film. In her own words, "I could never had played Antonietta if I hadn't first played Cesira, Adelina, and Filumena." As in the best of her films, her character was

Sophia and Marcello, battling demons in *A Special Day* (1977).

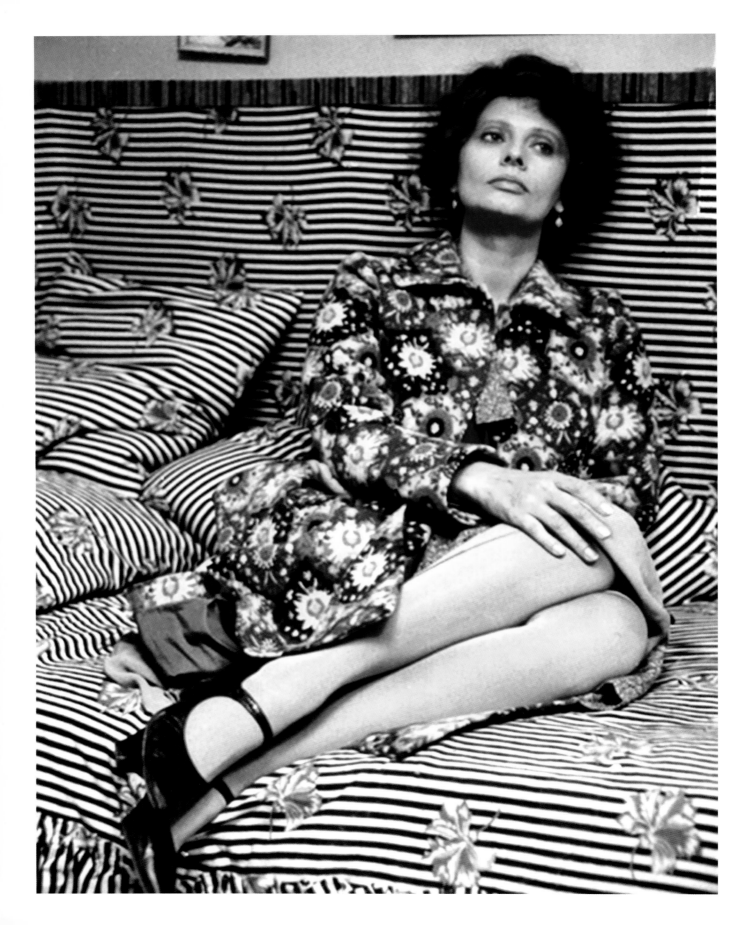

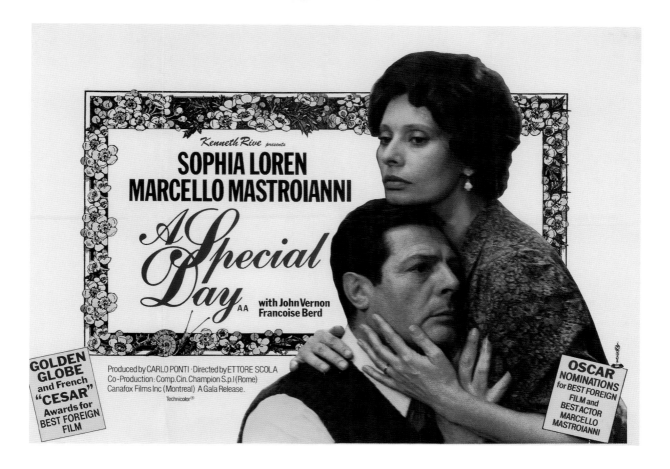

Kenneth Rive presents

SOPHIA LOREN
MARCELLO MASTROIANNI

A Special Day AA

with John Vernon
Francoise Berd

GOLDEN
GLOBE
and French
"CESAR"
Awards for
BEST FOREIGN
FILM

Produced by CARLO PONTI · Directed by ETTORE SCOLA
Co-Production: Comp.Cin. Champion S.p.I (Rome)
Canafox Films Inc (Montreal) A Gala Release.
Technicolor®

OSCAR
NOMINATIONS
for BEST FOREIGN
FILM and
BEST ACTOR
MARCELLO
MASTROIANNI

emotional, complex, and inspired by experiences particular to the women of Italy. In this film she said she channeled memories of her grandmother during the war in bringing Antonietta to life.

A Special Day earned Academy Award nominations for Best Foreign Film and for Marcello as Best Actor. It won many international awards, including David di Donatello Awards for Sophia as Best Actress and Best Director for Ettore Scola.

Above: With Marcello Mastroianni in *A Special Day* (1977). She once called this her "most beautiful film."

Opposite: Sophia's world-weary portrayal of Antonietta was inspired by her grandmother.

"**Miss Loren is magnificent in the best role she's had since *Two Women*.**"

—Vincent Canby, the *New York Times*

Angela

(1977) :: DIRECTED BY Boris Sagal

Angela, written by Charles E. Israel and directed by Boris Sagal (best known for his television credits), was a modern spin on classical Greek tragedy. Angela (Sophia) gives birth to a son while her husband, Ben (John Vernon), is away at war. When Ben returns from Korea, he (incorrectly) doubts the child is his and arranges for the baby to be kidnapped. Angela shares Ben's shady doings to the police and has him arrested and eventually jailed. She moves on in life, without her lost son. Many years later, she meets a young man by the name of Jean (Steve Railsback) who regularly visits the restaurant she runs, and they form a friendship that turns into love. Angela has no clue that the man is actually her son, and Jean, who had been adopted as a child, does not imagine that she is actually his birth mother. When Ben is released from prison and hunts them down, their lives take the most tragic of turns.

Filmed in Canada in late 1976 in frigid temperatures and away from her own two young boys, Sophia later looked back on *Angela* as one of her least favorite working experiences. The movie was not released in the United States until 1984 and received little attention.

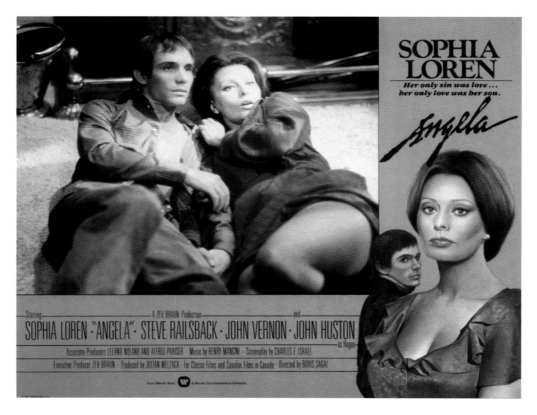

Brass Target

(1978) :: DIRECTED BY John Hough

Based on the Frederick Nolan novel *The Algonquin Project*, *Brass Target* presents the historic demise of General George S. Patton following an automobile accident as an assassination perpetrated by US military officers attempting to conceal their theft of gold from the vanquished Third Reich. Patton (played by George Kennedy) has ordered an investigation into the theft, with Major Joe De Lucca (John Cassavetes), who is also suspected as the perpetrator, leading the charge. De Lucca is aided by his beautiful friend Mara (Sophia). Together they search for the culprits and uncover the plot against Patton's life, but a ruthless assassin (Max von Sydow) carries out his deadly mission before they can reach the general.

$250 MILLION IN GOLD
The Germans hid it. The Russians want it. The Americans stole it.
General George S. Patton may die for it.

BRASS TARGET

...suspense that reaches the highest rank.

...rts A BERLE ADAMS · ARTHUR LEWIS PRODUCTION
...REN · JOHN CASSAVETES · GEORGE KENNEDY
...CE DAVISON · EDWARD HERRMANN and MAX VON SYDOW
...by LAURENCE ROSENTHAL · Screenplay by ALVIN BORETZ
...CK NOLAN · Produced by ARTHUR LEWIS · Directed by JOHN HOUGH
United Artists

With John Cassavetes in *Brass Target* (1978).

Blood Feud

Fatto di sangue fra due uomini per causa di una vedova (si sospettano moventi politici) (1978) :: DIRECTED BY Lina Wertmüller

In mafia-run 1920s Sicily, Titina Paterno (Sophia) has two loves: Rosario Spallone (Marcello Mastroianni), an attorney who protects her from the mob, and Nick (Giancarlo Giannini), a relative from America. One of them is the father of the baby she is carrying. The men rival each other, even as Titina harbors a feud against Vito Acicatena (Turi Ferro), the man who murdered her husband and who will initiate a plot against both Spallone and Nick.

Reunited again, Sophia and Marcello placed themselves in the hands of the acclaimed Lina Wertmüller, the first woman to be nominated for an Academy Award as Best Director, for *Seven Beauties* (1975). The first order of business for Wertmüller was

to dramatically change Sophia's look, attempting to remove all vestiges of the Movie Star. She wanted her to look like the women of rough-and-tumble Sicily in the 1920s. She asked Marcello to wear a long beard that the actor abhorred, but they trusted their director. Their efforts paid off for die-hard fans in Italy, where this film was well received by audiences, but it got very little attention internationally.

Another distinctly Wertmüller touch was the film's extended original title. It even made the *Guinness Book of World Records*, where it was listed with an even lengthier title. Roughly translated, the full title means "Blood feud between men over a widow (suspected to be politically motivated)."

Left: With Marcello Mastroianni and Giancarlo Giannini in *Blood Feud* (1978).

Opposite: As Titina Paterno.

Courage

(TV, 1986) :: DIRECTED BY Jeremy Kagan

Great movie roles for an aging actress have always been notoriously difficult to come by, leading many to turn to television, which Sophia did for the next several years. Nearing age fifty-two and still luminously beautiful wearing very little makeup, she found her best role in years in *Courage*, a film based on the daring real-life story of Martha Torres, an immigrant mother living in Queens who risked her life to save her son and in doing so broke up a billion-dollar cocaine ring. Sophia identified with the mother's deep love for her children that motivated her to action and relished the opportunity to bring the story to life. Her only regret was not being able to meet Torres herself, who was being protected for security reasons.

Marianna Miraldo (Sophia) is despondent over her son Joey's (Michael Galardi) drug addiction and to see how the drug trade has overtaken the city. She decides to take action, and at the risk of her own life offers her services to the FBI in a crusade against the narcotics ring.

> " **Sophia Loren, svelte, more mature, loaded with awesome directness and poise, proves that the star system still works.** "
>
> —*Variety* review of *Courage* (1986)

With Hector Elizondo, who portrayed her husband in the CBS TV movie *Courage* (1986).

The Fortunate Pilgrim

Mamma Lucia (TV, 1988) :: DIRECTED BY Stuart Cooper

The Fortunate Pilgrim was a moving TV adaptation of the novel of the same name by Mario Puzo (who also wrote *The Godfather*). Sophia plays a force of nature named Lucia, a twice-widowed mother of five children. The family has immigrated to New York from Italy in the early twentieth century and struggles through tragedies, including the suicide of one son and uncontrollable world events like the Depression and war. Through it all, Mamma Lucia is the indomitable backbone of the family.

This would be among the roles dearest to Sophia's heart. She had often portrayed powerful mothers, but appreciated these roles even more so after becoming a mother herself.

The *Los Angeles Times*, although dismissing the film as "a big snooze," conceded that "One thing *Pilgrim* never lacks is good acting: Loren is consistently fine as Lucia Angeluzzi, Olmos—currently getting raves for *Stand and Deliver*—is mesmerizing as the laconic yet complex Frank Corbo, and the other players give believable, sometimes intense performances."

Set in New York's Little Italy, *The Fortunate Pilgrim* was actually filmed in Yugoslavia.

> " **Mamma Lucia is my grandmother. She's my mother. She's all the people who lived around me in my little hometown.** "

—Sophia

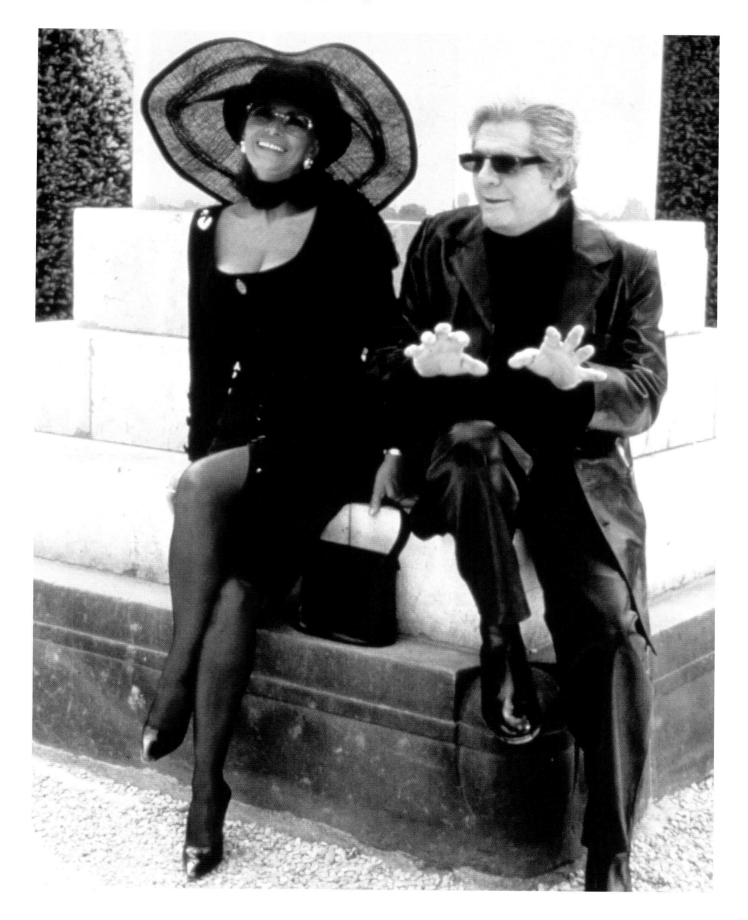

Grumpier Old Men

(1995) :: DIRECTED BY Howard Deutch

Sparring partners Jack Lemmon and Walter Matthau scored a massive hit with *Grumpy Old Men* in 1993. They were back at it and never better in this sequel. The first ends with the marriage of John Gustafson (Lemmon) to dream girl artist Ariel (Ann-Margret), while Max Goldman (Matthau) remains cantankerous and single. Their little world in Wabasha, Minnesota, is turned upside down by the arrival of Maria Ragetti (Sophia), who takes ownership of their beloved bait shop and transforms it into an Italian-style *ristorante*. The two men join forces to combat this travesty, but the old pros at sabotage have more than met their match in the crafty Maria and her equally hot-blooded mother (Anne Morgan Guilbert). And her charm proves impossible for Max to resist.

The cast is uproariously funny in *Grumpier Old Men*. Deserving of special mention is Burgess Meredith as Grandpa Gustafson, who though suffering from Alzheimer's disease, is hilarious—the gag reel shown at the end of the film highlights some of his funniest moments that did not make the final cut.

The movie was Sophia's biggest commercial success in many years, grossing more than $70 million at the box office in North America alone.

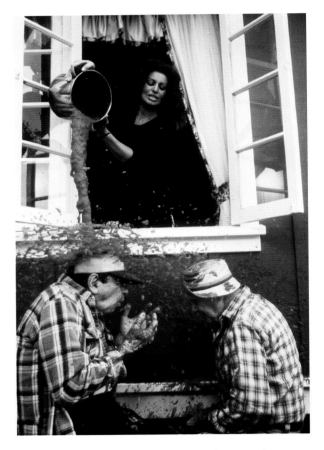

With Jack Lemmon and Walter Matthau, as the saucy Maria in *Grumpier Old Men* (1995).

Sofía Loren
Giancarlo Giannini

"Con indudable maestría, Sofía Loren compone con sinceridad y emoción su papel."
Adolfo Martínez. La Nación.

Una mujer valiente y pasional, un amor secreto en la glamorosa Italia del 1900

Francesca

Un Film de LINA WERTMULLER

Distribuye: **ifa** CINEMA

Between Strangers

(2002) :: DIRECTED BY Edoardo Ponti

Edoardo Ponti made his feature film debut as a director with *Between Strangers*. Sophia was at first apprehensive about working with her son but was quickly impressed by his professionalism, which helped make it feel like any other film set.

The film unfolds as three separate stories of women in Toronto at spiritual and emotional cross-roads. Sophia is Olivia, a talented woman whose artistic aspirations have been stifled as she cares for her wheelchair-bound husband, John (Pete Postlethwaite). Max (Gérard Depardieu), an eccentric Frenchman, helps relieve her demons. Other stories in *Between Strangers* feature Mira Sorvino as a photojournalist haunted by the subject of her most famous image and Deborah Kara Unger as a famed musician who has a score to settle with her father.

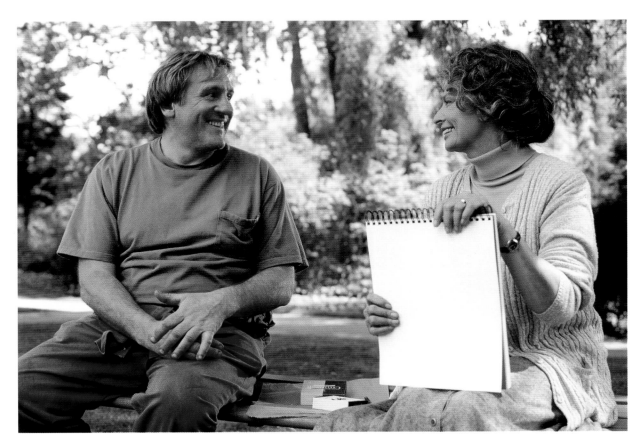

"Working with my mother is a beautiful experience. She puts love first, before anything. She's enhancing our movie with her warmth, love and good humor."

—Edoardo Ponti

Right: As Olivia, an artist, in *Between Strangers* (2002), directed by Sophia's son Edoardo Ponti.

Opposite: Sophia and Gérard Depardieu, who plays her friend in the film. She thought he was a brilliant actor.

Lives of the Saints

(TV, 2004) :: DIRECTED BY Jerry Ciccoritti

Lives of the Saints is a TV miniseries adapted from a literary trilogy by Nino Ricci about a family from a small Italian village and the coming of age of Vittorio Innocente (Fab Filippo). Sophia portrayed his emotionally detached aunt Teresa. Producer Gabriella Martinelli said that Teresa was inspired by Sophia's own screen portrayals of the past. She said, "I wondered about her character in *Two Women*; how she would be fifty years later, what would be her story? We created the character of Teresa based on that concept."

As Teresa Innocente in *Lives of the Saints* (2004).

“**A gripping family saga of passion, betrayal and forgiveness.**”

—Tagline for *Lives of the Saints* (2004)

Too Much Romance ... It's Time for Stuffed Peppers

Peperoni ripieni e pesci in faccia (2004) :: DIRECTED BY Lina Wertmüller

Sophia and F. Murray Abraham star as Maria and Jeffrey, an aging couple experiencing marital strife, a major bone of contention being Jeffrey's abandonment of his writing career to become a fisherman near Maria's beautiful hometown on the Amalfi coast. Maria, who has focused on Jeffrey, and then their children, her whole life, has regrets of unfulfilled dreams of her own. She prompts a family reunion with a party for her eccentric mother, Assunta (Angela Pagano). The three grown children are each grappling with personal battles of their own, which all come to light and find resolution at the family's seaside home and show Maria how loved she still remains.

Variety called the film, "a pleasant if overstuffed dysfunctional family comedy whose clutter can't ultimately prevent a pretty good time."

"I've worked with some of the biggest stars in the world and if every one of them was as easy to get along with as Sophia, it would be a much nicer business."

—F. Murray Abraham

Nine

(2009) :: DIRECTED BY Rob Marshall

Nine, a musical take on the Fellini classic *8½* (1963), brought Sophia back to a golden era of Italian cinema in a way. On the Broadway stage in 1982, *Nine* had been a smashing success, winning the Tony Award as Best Musical. Rob Marshall's ambitious big-screen adaptation told the familiar story of *8½*, with Daniel Day-Lewis in the Guido role as a director suffering both professional and personal crises as he flounders managing drama with his wife (Marion Cotillard), his mistress (Penélope Cruz), his assistant (Judi Dench), his muse (Nicole Kidman), and his mother (Sophia).

Javier Bardem had been Rob Marshall's original choice to play the iconic character of Guido, which Marcello Mastroianni had immortalized on the screen, but Sophia thought Daniel Day-Lewis was perfect. She was so in awe of his talent that she said "when I was near him I lost my head completely." She did not have a very large role in *Nine*, but participating in a tribute to Fellini—a great Italian director that she admired but never worked with except when she was an extra in *Variety Lights*—was a satisfying experience for her. And the influence of Sophia herself is visible in the look and performance of the ravishing Penélope Cruz, who has named Sophia as one of her key influences. Cruz earned an Academy Award nomination as Best Supporting Actress for her work in *Nine*.

As Mamma in *Nine* (2009).

My House is Full of Mirrors

La mia casa è piena di specchi (TV, 2010) :: DIRECTED BY Vittorio Sindoni

Sophia again took on the ultimate mother role—that of her own, Romilda Villani—in this Italian television miniseries that was based on the memoirs of Sophia's sister, Maria. As it was based on their lives, it followed a similar path as Sophia's own 1980 biopic but included some of Maria's story as well, including her first marriage to the son of Mussolini. Margareth Madè played Sophia.

With Margareth Madè.

Cars 2

(2011) :: DIRECTED BY John Lasseter and Brad Lewis

Sophia supplied the voice of an animated character for the first time for Mama Topolino in the Italian-language voice track for *Cars 2* (voiced by Vanessa Redgrave in English) using her "thick Neapolitan accent." Her grandchildren loved it.

Human Voice

Voce umana (2014) :: DIRECTED BY Edoardo Ponti

Sophia was again led by her director son Edoardo in this twenty-five-minute film based on the one-woman play written in 1930 by Jean Cocteau. The story—that of an aging woman talking to the man she loves over the phone and saying good-bye one last time before he leaves her—was one many great actresses relished playing over the years, including Anna Magnani, Simone Signoret, and Ingrid Bergman.

Sophia delivered a stirring performance, enacted in Italian with, at Edoardo's suggestion, her native Neapolitan dialect. It was a very emotional experience for mother and son, both saying they cried at the end of filming certain scenes. They clearly worked exceptionally well together, as Sophia was awarded a special David di Donatello Award for her work in the short film, and it was nominated for various other international awards.

"One of the most beautiful portraits of a woman ever written."

—Sophia on Jean Cocteau's *The Human Voice*

In *Human Voice* (2014), Angela speaks with her former lover, who is about to marry another woman.

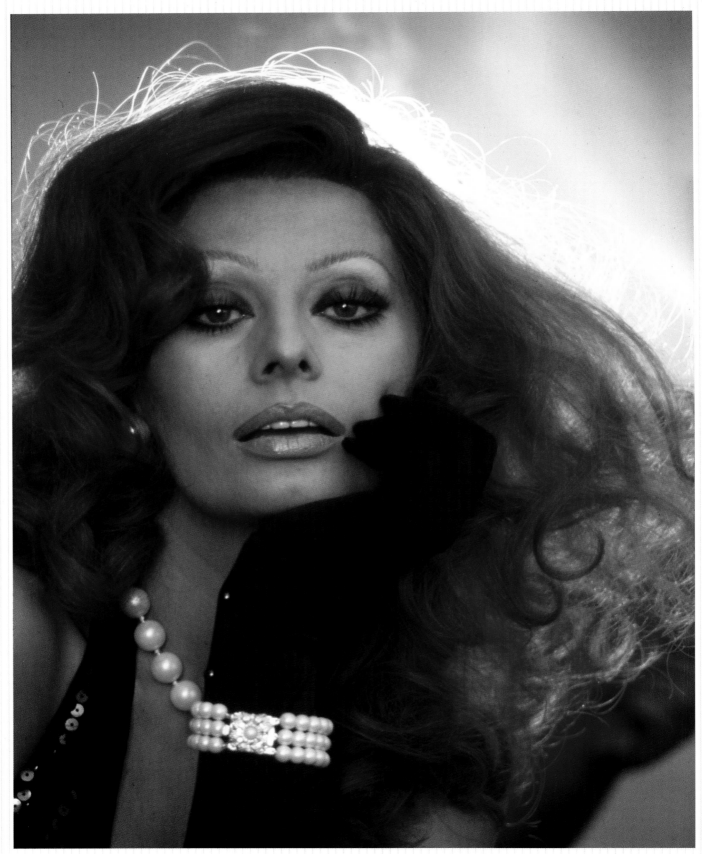

As Pupa in *Sex Pot* (1975).

An Ageless Beauty, An Enduring Star

"There is a fountain of youth: it is your mind, your talents, the creativity you bring to your life and the lives of people you love. When you learn to tap this source, you will truly have defeated age."

—Sophia

Opposite: Sophia, 1984.

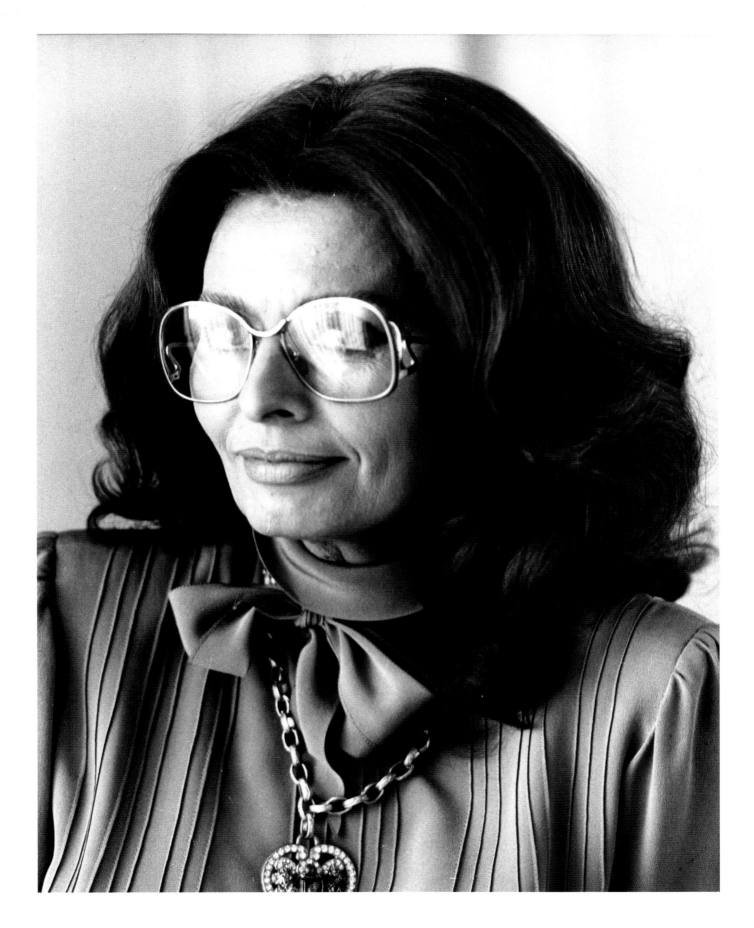

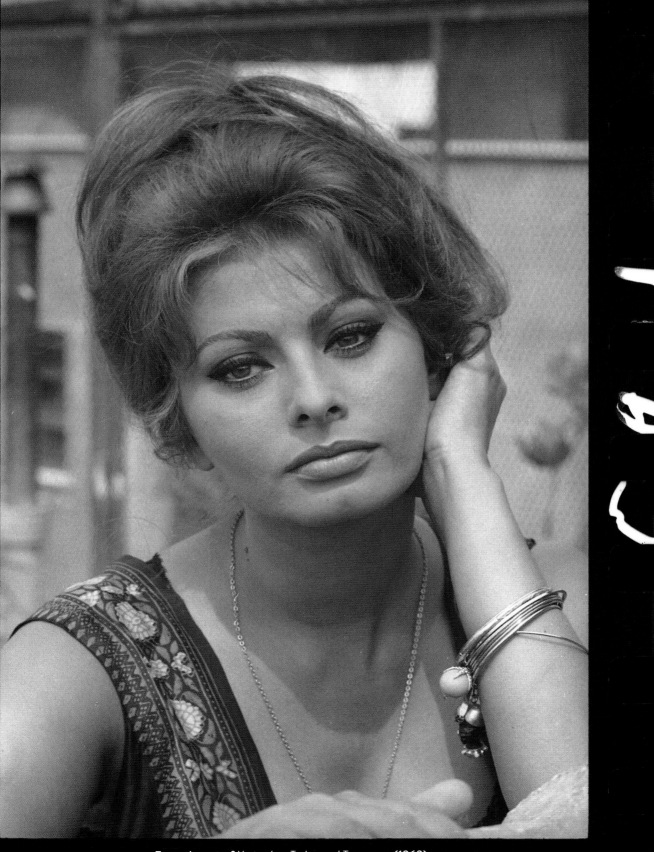

From the set of *Yesterday, Today and Tomorrow* (1963).

Over the decades that Sophia Loren has been in the public eye, the world has marveled at her breathtaking looks. A beautiful movie star is of course not unusual, but among the great beauties of film history Sophia stands out as uniquely age-defying. Some former screen goddesses stepped away and hid from cameras as they aged, the careers of others faded into obscurity, and still others passed before their time and the public never got to see them age. Sophia Loren has followed none of these paths. She has remained professionally active and astoundingly gorgeous well into her eighties. Beginning in the 1980s, when Sophia turned fifty, and up to the present, in reaction to newly released work or the vision of Sophia at public events, commentators never fail to remark on how luminously beautiful and vital she remains. Or that, like Dorian Gray, she must have a portrait in her attic that is showing the ravages of time on her behalf.

It is difficult to imagine that when she began working in films, Sophia's number-one fear was being asked to make a screen test, because early on she was invariably deemed unphotogenic. Her facial features were all said to be too large and a nose job was suggested to her on more than one occasion. Even in her earlier beauty pageant days, she was often named runner-up instead of the winner because her looks were not considered classically beautiful. The young Sophia, still in her late teens when her career began, firmly refused to have any work done. She liked her unique features—they were *hers* and she had no desire to change them for anyone. That mindset about beauty, a comfort in her own skin, may be the secret to her age-defying good looks and the vitality she conveys.

Frequently asked over the years how she took care of herself, Sophia often gave credit to pasta for her figure ("Everything you see I owe to spaghetti," being one of her famous quotes). She wrote an entire book, *Women & Beauty*, on beauty and aging. It was published in 1984, as she turned fifty. From her writing it is clear she put effort into every aspect of her outward appearance, from head (maintaining her hair color) to toe (with at-home pedicures). She talked of the benefits of apple cider vinegar, body-brushing, and eastern medicine before they were fads. She felt a healthy dose of self-care was good for a woman's well-being, and her philosophy encouraged self-love, acceptance, and maintaining an active mind as you age.

Although there have been gaps in her film-making career since the 1980s, it has never been for more than a few years. Sophia continues to seek out interesting roles, and between them she has worn many different hats—as an author, chef, beauty entrepreneur, designer, philanthropist, humanitarian, and, most important to her, mother and grandmother. Maintaining a passion in life for each of these roles, among others, seems to preserve Sophia both inwardly and outwardly. She has a rich lifetime legacy that will inspire future generations who discover the international treasure that is Sophia Loren.

"Having pride in your experience will keep you satisfied with your age, whatever it is."

—Sophia

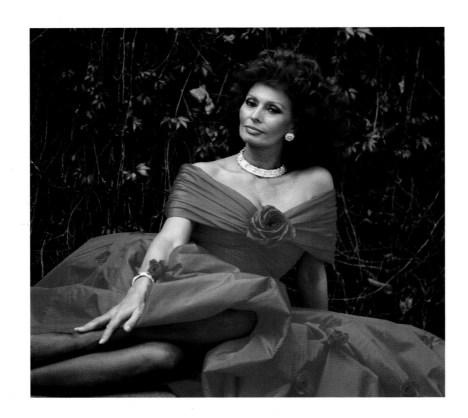

Opposite: Arriving at the Academy Awards, 1991.

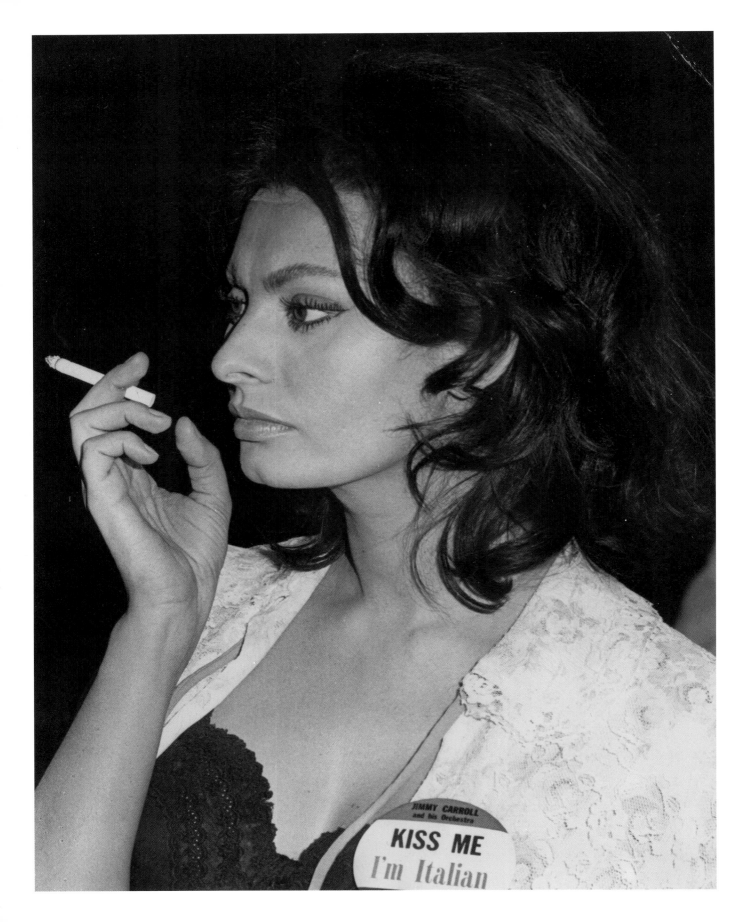

Photo Credits

AF archive/Alamy Stock Photo: front cover, Page 226

Author's Collection: Pages 17–20, 22, 24, 25, 27, 31, 34, 41, 49, 87, 101, 103, 107, 118–120, 127 (bottom), 128, 130, 132, 136, 139, 143, 149 (top, bottom right), 150, 151, 152, 158 (top), 160, 161 (right), 166, 167 (bottom), 170, 171, 174, 175, 177, 178, 180 (right), 182, 183, 192, 239, 241

David Wills Collection: Pages 92, 93, 96 (right), 98 (right), 104, 108, 111 (bottom), 113, 115, 116, 129, 131, 135, 140 (top), 141, 142, 146, 149 (bottom left), 155, 158 (bottom), 161 (left), 162, 172, 176, 180 (left), 196, 198, 200 (right), 202 (left), 204 (top), 206, 207, 210 (top), 213, 215 (top), 219, 233

Everett: Pages 48, 57, 84, 90, 96 (left), 100, 105, 112, 114, 117, 137, 167 (top), 173, 186, 187, 193, 199, 202 (right), 204 (bottom), 205 (left), 210 (bottom), 211, 212, 214, 215 (bottom), 216, 220, 221, 222 (bottom), 223, 225, 231, 234

Getty: Pages 30, 40, 52, 60, 63, 179

Independent Visions/MPTV: back cover, pages 8, 12, 36, 43, 50, 53, 56 (left, right), 58, 59, 62, 65, 75, 82, 110, 122, 126 (top, bottom, 127 (top), 144, 145, 147, 154, 156, 157, 163 (all), 168 (all), 169, 181 (left, right), 182 (left, center), 184, 189–191, 195, 197, 203, 242, 246, 250

MPTV: Page 205 (right)

Photofest: Pages 14, 88, 102, 111 (top), 124, 138, 200 (left), 201, 208, 209, 222 (top), 228, 230, 235, 236, 238

Rex/Kobal: Pages 1, 2, 5, 32, 37, 38, 44, 46, 55, 67–74, 76–81, 91, 94, 99, 106, 109, 123, 134 (top, bottom), 140 (bottom), 159, 165, 217, 218, 227, 229, 245, 248, 249

Sam Shaw © Sam Shaw Inc. licensed by Shaw Family Archives, Ltd.: Pages 45, 264

Quotation Sources

"Looking back on": *Women & Beauty*, Sophia Loren. William Morrow and Company, Inc., New York, 1984.

"cold, distant": *Yesterday, Today, Tomorrow: My Life*. Sophia Loren. Atria Books, New York, 2014.

"The two big advantages": *Sophia: Living and Loving: Her Own Story*. Sophia Loren and A. E. Hotchner. William Morrow and Company, Inc., New York, 1979.

"Sofia Scicolone is": *Yesterday, Today, Tomorrow: My Life*. Sophia Loren. Atria Books, New York, 2014.

"Everything was in": *Biography*: "Sophia Loren: Actress Italian Style." A&E Television Networks, Twentieth Century Fox Film Corporation, 1997.

"Without De Sica I": *Yesterday, Today, Tomorrow: My Life*. Sophia Loren. Atria Books, New York, 2014.

"That walk delivered": *Yesterday, Today, Tomorrow: My Life*. Sophia Loren. Atria Books, New York, 2014.

"Like all real": *Yesterday, Today, Tomorrow: My Life*. Sophia Loren. Atria Books, New York, 2014.

"The camera loves": *Sophia Loren: In the Camera Eye*. Sam Shaw. Exeter Books, New York, 1979.

"I'd never been": *Yesterday, Today, Tomorrow: My Life*. Sophia Loren. Atria Books, New York, 2014.

"I think that": *Biography*: "Sophia Loren: Actress Italian Style." A&E Television Networks, Twentieth Century Fox Film Corporation, 1997.

"Ordinary people just": *Yesterday, Today, Tomorrow: My Life*. Sophia Loren. Atria Books, New York, 2014.

"The courage to": *Yesterday, Today, Tomorrow: My Life*. Sophia Loren. Atria Books, New York, 2014.

"This girl will": *The Pride and the Passion* clipping file, the Academy of Motion Picture Arts and Sciences.

"What I wanted": *Vanity Fair*, Sam Kashner, February 14, 2012.

"If Vittorio thinks": *Yesterday, Today, Tomorrow: My Life*. Sophia Loren. Atria Books, New York, 2014.

"Though I taught": *Two Women* clipping file, the Academy of Motion Picture Arts and Sciences.

"She's vain, she's": Vittorio De Sica clipping file, the Academy of Motion Picture Arts and Sciences.

"When I perform": *Sophia: Living and Loving: Her Own Story*. Sophia Loren and A. E. Hotchner. William Morrow and Company, Inc., New York, 1979.

"It's hard to": *Yesterday, Today, Tomorrow: My Life*. Sophia Loren. Atria Books, New York, 2014.

"she was a": *Yesterday, Today, Tomorrow: My Life*. Sophia Loren. Atria Books, New York, 2014.

"The birth of": *Women & Beauty*, Sophia Loren. William Morrow and Company, Inc., New York, 1984.

"under his guidance": *Yesterday, Today, Tomorrow: My Life*. Sophia Loren. Atria Books, New York, 2014.

"He was a": *Yesterday, Today, Tomorrow: My Life*. Sophia Loren. Atria Books, New York, 2014.

"She is the": Sophia Loren clipping file, the Academy of Motion Picture Arts and Sciences.

"Sophia is the": *Biography:* "Sophia Loren: Actress Italian Style." A&E Television Networks, Twentieth Century Fox Film Corporation, 1997.

"I was more": *Yesterday, Today, Tomorrow: My Life.* Sophia Loren. Atria Books, New York, 2014.

"Hearing children laugh": *Women & Beauty*, Sophia Loren. William Morrow and Company, Inc., New York, 1984.

"She is an": *Ready to Wear* clipping file, the Academy of Motion Picture Arts and Sciences.

"Looking back on": 2020 Barbara Walters Special Edition, 1990.

"recipes are memories": *Sophia Loren's Recipes & Memories*, Sophia Loren. GT Publishing, New York, 1998.

"Living means setting": Live from the Turner Classic Movies Film Festival, interview with Sophia Loren, 2015.

"was the first": *Yesterday, Today, Tomorrow: My Life.* Sophia Loren. Atria Books, New York, 2014.

"I went to": *Talking with Mauro Bolognini.* Jean A. Gili. Istituto Poligrafico dello Stato, Italy. 1977.

"Providing Renata Tebaldi's": *Yesterday, Today, Tomorrow: My Life.* Sophia Loren. Atria Books, New York, 2014.

"Sophia Loren, the": The *New York Times.* Bosley Crowther, November 12, 1954.

"Not even Sophia": *Il Giornale d'Italia*, September 1, 1954.

"There was an": Sophia Loren clipping file, the Academy of Motion Picture Arts and Sciences.

"[Sophia's] self-congratulating": Sophia Loren clipping file, the Academy of Motion Picture Arts and Sciences. *Time* magazine, 1954.

"lump of a": *Sophia: Living and Loving: Her Own Story.* Sophia Loren and A. E. Hotchner. William Morrow and Company, Inc., New York, 1979.

"Sophia Loren as": *Ames Daily Tribune*, October 4, 1958.

"Everyone who's ever": *Picturegoer*, 1954.

"Forget the subtitles": The *New York Times.* Bosley Crowther, December 26, 1955.

"Mario Camerini's broad": The *New York Times.* Bosley Crowther, June 12, 1957.

"Miss Loren is": The *New York Times.* Bosley Crowther, June 12, 1957.

"once again an": *Sophia: Living and Loving: Her Own Story.* Sophia Loren and A. E. Hotchner.

"I have had": *I miei mostri.* Dino Risi, Mondadori, Italy, 2008.

"I dyed my": *Yesterday, Today, Tomorrow: My Life.* Sophia Loren. Atria Books, New York, 2014.

"Miss Lolloren, I": *Yesterday, Today, Tomorrow: My Life.* Sophia Loren. Atria Books, New York, 2014.

"It is not": The *Los Angeles Times.* Philip K. Scheuer, April 22, 1957.

"Sophia has, without": *Boy on a Dolphin* clipping file, the Academy of Motion Picture Arts and Sciences.

"She was a": *John Wayne: My Life With the Duke.* Pilar Wayne. McGraw-Hill, New York, 1987.

"manages the scenes": *Variety*, 1957.

"A spirited Sophia": *Monthly Film Bulletin*. Peter John Dyer, 1957.

"Most everybody who": *That Kind of Woman* clipping file, the Academy of Motion Picture Arts and Sciences.

"Miss Loren is": The *New York Times*. Bosley Crowther, March 15, 1960.

"He was right": Charlie Rose with Sophia Loren, July 6, 1999.

"I thought Sophia": *Heller in Pink Tights* clipping file, the Academy of Motion Picture Arts and Sciences.

"Tony is the": *Yesterday, Today, Tomorrow: My Life*. Sophia Loren. Atria Books, New York, 2014.

"Gable and Loren": *Variety*, 1959.

"The story was": *Yesterday, Today, Tomorrow: My Life*. Sophia Loren. Atria Books, New York, 2014.

"the accessories of": *Women & Beauty*, Sophia Loren. William Morrow and Company, Inc., New York, 1984.

"the beauty of": The *New York Times*. Bosley Crowther, May 9, 1961.

"The picture is": *Time*, 1961.

"She's one of": *Biography:* "Sophia Loren: Actress Italian Style." A&E Television Networks, Twentieth Century Fox Film Corporation, 1997.

"My washerwoman hair": *Women & Beauty*, Sophia Loren. William Morrow and Company, Inc., New York, 1984.

"Miss Loren breezes": The *New York Times*. Bosley Crowther, March 21, 1963.

"the most completely": *Variety*, 1962.

"I've got to": *Five Miles to Midnight* clipping file, the Academy of Motion Picture Arts and Sciences.

"When I play": *Five Miles to Midnight* clipping file, the Academy of Motion Picture Arts and Sciences.

"[Loren] creates a": *Variety*, 1962.

"But Vittorio, I've": *Yesterday, Today, Tomorrow: My Life*. Sophia Loren. Atria Books, New York, 2014.

"It's hard to": *Yesterday, Today, Tomorrow: My Life*. Sophia Loren. Atria Books, New York, 2014.

"a beauty that": The *New York Times*. Bosley Crowther, April 2, 1965.

"He makes me": *Women & Beauty*, Sophia Loren. William Morrow and Company, Inc., New York, 1984.

"The experience of": *Women & Beauty*, Sophia Loren. William Morrow and Company, Inc., New York, 1984.

"was too complicated": *Yesterday, Today, Tomorrow: My Life*. Sophia Loren. Atria Books, New York, 2014.

"I have an": *Women & Beauty*, Sophia Loren. William Morrow and Company, Inc., New York, 1984.

"She was very": Turner Classic Movies: Film Article. Jeff Stafford.

"[Sophia] is the": *Cercando Sophia*, Surf Film, 2004.

"I loved Sophia": *A Countess from Hong Kong* clipping file, the Academy of Motion Picture Arts and Sciences.

"Sophia Loren, aside": *Biography:* "Sophia Loren: Actress Italian Style." A&E Television Networks, Twentieth Century Fox Film Corporation, 1997.

"Ill at ease": *Yesterday, Today, Tomorrow: My Life.* Sophia Loren. Atria Books, New York, 2014.

"just a mist": *Vittorio D.*, Surf Film, 2009.

"Sophia Loren reaches": *Variety*, 1970.

"We shared a": *Yesterday, Today, Tomorrow: My Life.* Sophia Loren. Atria Books, New York, 2014.

"dear, eccentric friend": *Yesterday, Today, Tomorrow: My Life.* Sophia Loren. Atria Books, New York, 2014.

"No crap, no": LorenArchives.com, "Entourage."

"for this most": The *New York Times*. Vincent Canby. December 1, 1978.

"I'd be perfectly": LorenArchives.com, "Il viaggio."

"[Sophia] is a": LorenArchives.com, "Verdict."

"The film, frankly": *Il Mondo*, Francesco Savio, March 13, 1975.

"tired, hokey, and": *Variety*, 1976.

"I could never": *Yesterday, Today, Tomorrow: My Life.* Sophia Loren. Atria Books, New York, 2014.

"Miss Loren is": The *New York Times*. Vincent Canby. September 26, 1977.

"In *Blood Feud*": *Globe and Mail*. Jay Scott. March 26, 1980

"*Firepower* is best": The *New York Times*. Janet Maslin. May 4, 1979.

"Sophia Loren, svelte": *Variety*, 1986.

"one thing *Pilgrim*": The *Los Angeles Times*. Terry Atkinson. April 2, 1988.

"Mamma Lucia is": *Yesterday, Today, Tomorrow: My Life.* Sophia Loren. Atria Books, New York, 2014.

"One of the": *Yesterday, Today, Tomorrow: My Life.* Sophia Loren. Atria Books, New York, 2014.

"She's not only": *Grumpier Old Men* clipping file, the Academy of Motion Picture Arts and Sciences.

"Working with my": *Hello*, October 30, 2001.

"I wondered about": LorenArchives.com, "Lives of the Saints."

"a pleasant if": *Variety*, 2004.

"I've worked with": LorenArchives.com, "Too Much Romance... It's Time for Stuffed Peppers."

"when I was": *Yesterday, Today, Tomorrow: My Life.* Sophia Loren. Atria Books, New York, 2014.

"There is a": *Women & Beauty*, Sophia Loren. William Morrow and Company, Inc., New York, 1984.

"Having pride in": *Women & Beauty*, Sophia Loren. William Morrow and Company, Inc., New York, 1984

Acknowledgments

Writing is in many ways a solitary venture, but a book is possible only with the assistance of many. My number-one support: Frankie—thank you for putting up with me every step of the way and helping me through my very hardest moments. Mom and Dad: from day one I owe you my life as well as my career because you took a gamble on my passion for film history and desire to spend my time writing about it. To all my dear family and friends who keep me smiling every day—thank you.

Thank you to my amazing editor, Jess Fromm, for her guidance, support, and making things easy at every turn. To Josh McDonnell for his lovely book design. To Kristin Kiser, Jennifer Kasius, Seta Zink, Katie Hubbard, and everyone at Running Press whose expertise touched this book in some way.

Turner Classic Movies team: Wow, twenty years ago I was a kid who spent very abnormal amounts of time watching classic movies and voraciously researching them. Your one-of-a-kind network has been an indispensable education and dear companion over the years. It is my honor to be associated with TCM and to have written a book that carries your official seal of approval. In particular—Heather Margolis, John Malahy, Jennifer Dorian, Genevieve McGillicuddy, Pola Chagnon, and Susana Zepeda Cagan: Thank you. By TCM association and for being one of my very favorite people to work with: thank you, Aaron Spiegeland.

David Wills, photo editor extraordinaire, thank you for you tremendous help and generosity. Mano-ah Bowman—your extraordinary collection richly enhances this book. Thank you for sharing it with me.

This book was made possible by the comprehensive archives and knowledgeable staffs of the Academy of Motion Picture Arts and Sciences, the New York Public Library, the American Film Institute, the UCLA Arts Library, and the Free Library of Philadelphia.

Lastly, to the great Sophia Loren herself—thank you for the endless inspiration.

Index

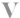

W

Y

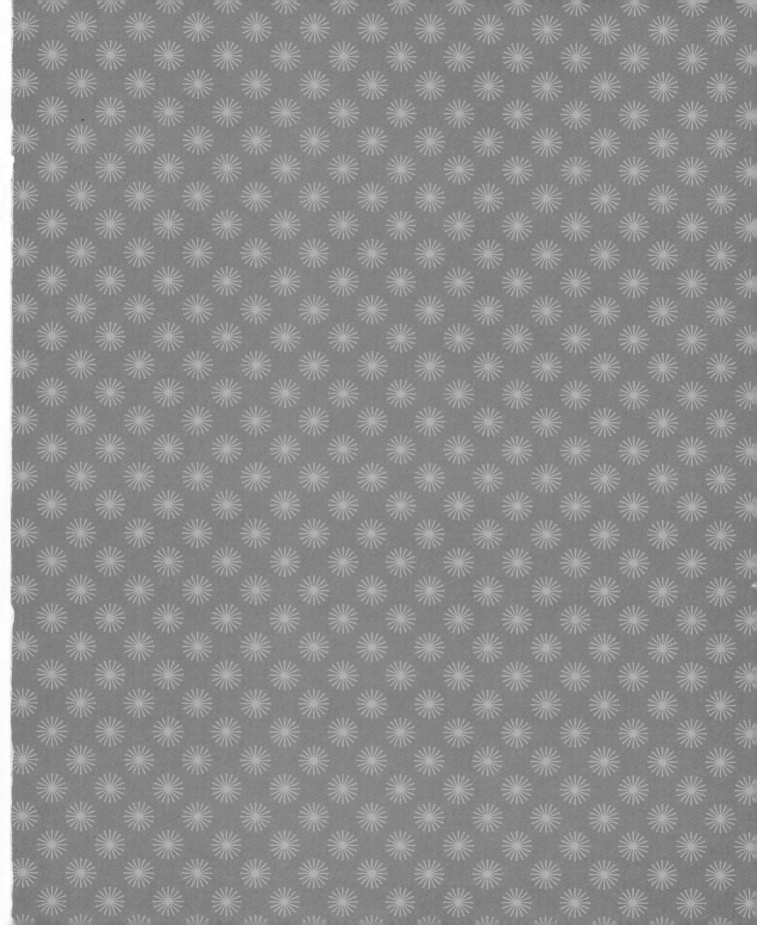